melons

FOR THE PASSIONATE GROWER

melons

FOR THE PASSIONATE GROWER

AMY GOLDMAN

PHOTOGRAPHS BY VICTOR SCHRAGER

DESIGN BY DOYLE PARTNERS

ARTISAN/NEW YORK

For my mother,
Lillian, and my daughter,
Sara; the two links in
my seed chain

On the cover:
Sugar Baby watermelon
(in back) and Golden
Midget watermelon.
Endpapers: Georgia Rattlesnake
watermelon leaf.
Page 2: Retato degli
Ortolani melon.

Copyright © 2002 by Amy Goldman
Photographs copyright © 2002 by Victor Schrager
and Amy Goldman
"Fiesta Melons" from THE COLLECTED POEMS OF SYLVIA PLATH,
EDITED by TED HUGHES. Copyright © 1960, 1965, 1971, 1981 by the
Estate of Sylvia Plath. Editorial material copyright © 1981 by Ted Hughes.
Reprinted by permission of HarperCollins Publishers Inc.

Published by Artisan, A Division of Workman Publishing Company, Inc.
708 Broadway, New York, New York 10003, www.artisanbooks.com

Library of Congress Cataloging-in-Publication Data
Goldman, Amy.
Melons, for the passionate grower / Amy Goldman; photographs by Victor Schrager.
p. cm.
ISBN 1-57965-213-1
1. Melons–Heirloom varieties. 2. Melons–Pictorial works.
I. Schrager, Victor. II. Title.
SB379.M44 G65 2002 635'.61–dc21 2001056716

Printed in Italy
10 9 8 7 6 5 4 3 2 1
First Printing

Book design by Doyle Partners

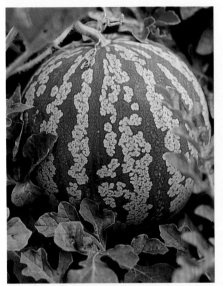

ABOVE: Citron watermelon.
Branched tendril beginning to dry,
signaling approaching maturity.
OPPOSITE TOP AND BOTTOM:
Fordhook Gem. Note the well-
nourished conspicuous flesh fibers.
Early Frame Prescott. Five-lobed
leaf with ridged stem, simple tendril,
and male flower in the leaf axil.

Entering the melon patch is like walking into a candy store. *It's the dessert course, only better.* Easy to grow, melons gratify instantly, producing luscious fruit in one season. The taste of melons at their peak, oozing honey, is incomparable, as is the air, redolent with muskmelon, on an August night.

The Christmas, an heirloom or old-fashioned melon, was my first melon love. For weeks I had waited for the fruit to ripen, and one morning it was ready, lolling in the garden like some outlandish hot air balloon, its hard rind covered with vivid yellow and green streaks. I dropped to my knees and cut it open to taste its delightful green flesh. Since then, I've formed passionate attachments to a number of other melons. I'm devoted to Cob, Fordhook Gem, Petit Gris de Rennes, Prescott Fond Blanc, Snake . . . and the list goes on.

In May or June, scores of heirloom melon plants spring up in my garden, blanketed by tents of spun polyester cloth atop black plastic mulch. They are protected from the elements by diatomaceous earth (an organic pest control), a spritz of Bt (*Bacillus thuringiensis*), and TLC (tender loving care). What more can I do but pray for sun? After the floodwaters of June recede and the first hatch of insect pests has passed, I remove the protective coverings and let the melons sprawl, at ease, until the garden becomes a verdant sea of vines bearing fruit.

The green bowling balls that pass for watermelons or the melons posing as cantaloupes in grocery stores across America don't begin to describe the world of melons. We've all seen melons that are netted, wrinkled, striped, or ribbed; but there are melons with warts, freckles, and stars; melons that look like snakes or bananas; others that smell or taste like pineapple, mango, peach, or perfume. These are extraordinary heirlooms.

Heirloom fruits and vegetables are treasures from the past, carefully tended and preserved by generations of farmers and gardeners. They are beloved for their looks and their taste. I can't count the number of times someone has tasted one of my melons

for the first time and said, "This brings back memories of my childhood," or "I'm in ecstasy." At a taste test of my melons at the Union Square Greenmarket, there was almost a stampede. Until they tasted heirlooms, the crowd didn't know what they were missing. But the delight of melons that taste sublime is only one reason to grow heirloom fruits and vegetables. The other is because we need their germplasm. It's their genes that will help us fend off the potato famines and corn blights of the future. Without their genetic diversity, we will be prey to ever-more virulent pests and diseases.

Unfortunately, countless heirloom varieties are threatened with extinction, and thousands have already been lost. During the consolidation within the seed industry over the past twenty-five years, mom-and-pop operations were gobbled up by giants. A polite term for what happened is *deaccessioning*, and like paintings removed from galleries in museums to make room for new acquisitions, heirloom fruits and vegetables—also things of beauty—were sent to dry dock and oblivion, leaving only faint tracings of their integrity behind.

Filling the void left by heirlooms' departure was easy: Industry makes far more money from hybrids. The bottom line is that first-generation (F1) hybrids are proprietary inbreds that yield unreliable seed. Heirloom seed, on the other hand, breeds true, producing offspring like its parents. You're taking potluck when you save seeds from hybrids, and if you don't want to rely on chance, you need to ante up for fresh seed. Clever these seed companies: Disposable seeds create dependency and repeat business.

The industry promotes hybrids whether they're genuinely better or not. When it comes to melons, even plant breeders admit that hybrids have nothing over heirlooms. They're not bigger, better, or more improved. The development of seedless, or triploid, watermelon seems to be the major "advantage." But breeding the life out of a melon is not exactly a desirable trait.

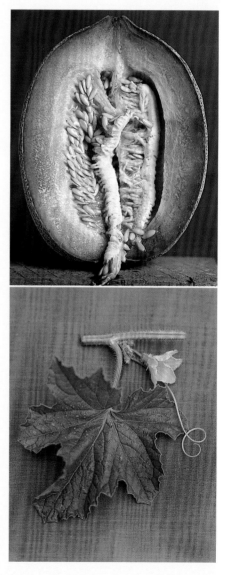

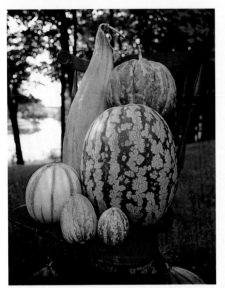

Still life with melons on an heirloom Windsor chair, taken near the pond in front of my farmhouse. CLOCKWISE: Banana, D'Alger, Klondike Striped, two Queen Anne's Pocket melons, and Charentais.

While supermarkets devote whole aisles to hybrids, heirloom varieties are hard to find, and they are becoming scarcer by the day. Still, much remains of our vanishing vegetable heritage, and through the largesse of Kent Whealy and the Seed Savers Exchange, one can plant a garden where the extraordinary is ordinary. Kent gives us the seeds of special things to eat, the seeds of yesteryear. If we sow and grow those seeds, we are nourished; and if in the end we harvest more seed, we ensure next year's bounty. This is the natural history of agriculture, the way our grandparents and great-grandparents fed themselves. But it's not the way we commonly feed ourselves today.

Kent and his wife, Diane, have been working together for twenty-five years to help home gardeners and orchardists keep heirlooms alive. The Seed Savers Exchange, in Decorah, Iowa, is a nonprofit membership organization that collects heirloom seeds, maintains and grows them out in preservation gardens, and distributes the seeds to others. Most of these old-time varieties are not native to North America, but became part of our common heritage when immigrants brought the seeds here, hidden in their suitcases or sewn into their dresses or hatbands. These precious portable possessions spelled breakfast, lunch, or dinner and the comforts of home in an uncertain New World.

Kent Whealy gave me the chance to play a small part in agricultural history when he sent me two cardboard boxes of melon seed by overnight mail. Opening them, I realized I had in my hands a gift of vast magnitude, an irreplaceable wonder, the seeds of yesterday. Kent had only a few seeds of some varieties left, and he wouldn't have given them to me if he felt I couldn't handle them. Still, I was afraid something would go wrong and even had a nightmare about the theft of plants from my garden. I've since regained my composure and harvested hundreds of melons from Kent's seeds. This book attempts to portray them in all their glory.

Heirloom melons taste good. The eating part comes easy—it's the picking and choosing that needs to be taught. If you want to know how to judge when a melon is ready to be harvested from the vine, as well as how to select a fruit of top quality from the market, you've come to the right place. Thumping and sniffing alone don't do it; you need to take other factors into account.

I can't guarantee that you'll be right every time. There is no sure way—apart from nuclear magnetic resonance imaging (NMRI), used on intact melons in Japan—to select a winner before cutting it open and tasting it. There are, however, certain correlates of quality that, when taken together, can help you make your best guess.

According to James D. McCreight at the USDA, melon flavor is a complex interaction of sugar, pH, texture, and volatile compounds. Vine-ripened melon, harvested at maximum sugar content, has the best flavor and texture. Green melons, picked before their time, can become juicier, but they never catch up on flavor. Melons don't have much in the way of carbohydrate reserves; in fact, most of their carbohydrates are sugars, not starch. That being the case, little or no additional conversion to sugar can occur: Melons, unlike squashes, do not get any sweeter once they've been harvested. What you pick is what you get.

The instrument most often used to assess sweetness is a spoon. However, the total soluble solids (TSS) content of melon juice, measured in degrees Brix with a handheld refractometer, provides a more objective measure. Good-quality melons generally have a TSS of 10 percent or more.

Melons start to ripen about thirty days after anthesis (flowering): Total sugars increase along with pH. Sugars such as fructose, glucose, and sucrose make up most of the total soluble solids. I used both methods to assess the sugar content of every melon in the book, and there was almost always agreement between my taste buds and the Brix reading. I'm not advocating that you carry a refractometer in

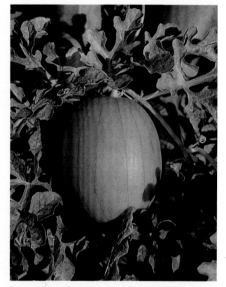

The Golden Midget watermelon has two built-in ripeness indicators: When both melon and foliage turn yellow, it is time to pick.

OH SO SWEET

Sugar content and flavor are nearly synonymous in melons, and both suffer unless the fruit is allowed to mature on the vine. Take the sad case of Honeydew. With one of the highest sugar contents of any melon if well grown, it is routinely prematurely harvested and zapped with ethylene.

Bit O'Honey muskmelon, *almost* too cute to eat.

DIVINING RODS

Those who have mastered the fine art of melon divination do not rely on occult signs. Dismiss as a charlatan anyone who, for example, prescribes the "sink or swim" test: It's simply not true that a piece of stem cut from an unripe melon sinks to the bottom of a bowl of water, whereas a ripe melon stem floats.

your back pocket, but it's an especially useful tool when you're doing taste tests and comparisons.

The other important index of internal quality is flesh texture. Look for melons that have neither the hardness associated with immaturity nor the softness associated with overripeness. Unlike sugar content, melon texture and aroma can improve after harvest. Well-nourished melons generally have conspicuous fibers in their flesh. If fibers are conspicuous and tender, there is a melting quality to the flesh; if they're tough, the texture is stringy. When fibers are large and abundant, without being tough, the melon seems coarse. Mealiness occurs when the flesh is dry and fibers are not evident.

Melons, like all living things, go through senescence and inevitable decline. After picking, the ideal melon keeps its flavor, texture, and sweetness for a few weeks. The best time to eat a melon? Once it begins to soften and before it breaks down. As a melon grows

old, it loses flavor and ascorbic acid; it also develops stem-end cracks and water-soaking of the flesh. Overripeness brings distasteful off flavors and loss of color, sugars, and beta-carotene. Watermelons become mealy and stringy. Avoid overripe specimens, which are more susceptible to decay-causing fungi and bacteria; these melons often sound sloshy when shaken. Rattling is okay—it's just loose seeds.

Judging the worth of many melons is literally right in your hands and under your thumb. Using your sense of touch to detect nuances of softening in a melon is what Loisel (circa 1830) called *tâter un melon* (to feel out or explore a melon). By gentle manipulation, we can all tell fairly easily when a peach or pear is ripe. Melon, with its thicker skin, poses more of a challenge. Go straight to the melon's blossom end: the base of the fruit, opposite the stem. Immature melons do not yield to pressure. A melon is ready to pick or eat when the skin is fairly easy to depress. If your finger finds little resistance or elasticity, and may even break the skin, the fruit is kaput. This method does not work, though, with watermelons or winter melons.

A melon can be soft and ripe and even smell heavenly, yet still disappoint the connoisseur. Some varieties have better flavor—not all melons are created equal. Consumers are at a decided disadvantage; at the mercy of suppliers, they have no one to ask, "Did the grower plant fine-flavored varieties? How well were they grown, and under what conditions? Were they harvested from dead or diseased vines? Were they picked at the proper degree of ripeness, or were they harvested too green? How were they handled after harvest?" Home gardeners are lucky—they can choose melons of fine quality to grow, and they have the luxury of eating vine-ripened fruit.

Whether you're a grower or a buyer, there are a number of signs that can help you select the good and reject the bad. You want a melon whose form is regular and normal. Those that are rounder, more symmetrical, and have a filled-out appearance generally taste better than those that are less so. A well-cultured melon has a small *couche*. That's the portion that lies on the soil and is usually discolored, flattened, and inferior in quality. Neglected melons with prominent *couches* or ground spots weren't propped up or turned over by their growers.

Size and weight are two other reliable indicators. Melons that seem heavy for their size have more abundant juicy flesh. Bigger is often better but it's generally a good idea to avoid giants, which might have been fed too much fertilizer and water. Don't consider bruised or damaged goods even if they're "on special." Select those that are fresh and not faded.

COOL IT

Melons, unlike their squash and gourd cousins, have a short shelf life and must be consumed soon after harvest. You can slow down the ripening process, and keep decay at bay, by removing melons from the hot sun and cooling them down. Cantaloupes and muskmelons can be kept for up to two weeks at 40 degrees Fahrenheit; watermelons last two or three weeks at 60 degrees Fahrenheit; and most winter melon varieties keep two months or more at 50 to 68 degrees Fahrenheit. Relative humidity should be between 80 and 90 percent. Try not to leave melons on ice too long or chilling damage, like pitting, surface decay, and off flavors, can occur.

Some melons abscise or slip from the vine when ripe; others don't abscise until they're overripe. "Persistent" fruit varieties don't separate spontaneously from the mother plant and need to be cut at maturity. When melons are at full slip, a crack completely encircles the stem. At half slip the quality is not quite as good (there is a lower concentration of aroma compounds), but the shelf life is longer. To harvest at prime time, growers need to pay attention to certain changes in the melon's character. As maturity approaches, the primary color of the fruit usually changes from green or gray to brown or yellow. Experienced pickers rely more on color change than the appearance of the "slip."

Many growers and consumers think that a good melon has a ringed stem, but that is not always true. Better for the consumer to consider the color first, and then examine the stem or its cuplike remains to see if it is fresh or faded. As for the skin, fruits in the *reticulatus* group, such as muskmelons and Persians, which generally slip, have a netted rind. The more raised, hard netting or "corking" that is dense and uniformly distributed, the better-tasting the melon.

The perfume or odor of some melons becomes apparent as the fruit ripens. Whether it's musky or floral, for example, depends on many volatile compounds, including alcohols, acids, and their esters; the amount and ratio of these substances vary from one type to another. Aroma volatiles are formed during ripening, and beyond harvest, from free amino acids in the fruit. A sweet smell, neither cucumbery nor sour and fermented, is a good sign. Some melons do, however, smell like cucumber when ripe (see the Snake melon, for instance, on page 112), and many others exude little or no fragrance at all. *Inodorus* melons, such as canary or casaba, lack smell, netting, abscission zone, or softening; and their ripeness is frustrating for the melon lover to decipher. My advice is to leave these on the vine as long as possible; be alert to minute cracks in the rind and very subtle color changes that signal maturity, and let frost be your indicator of when to cut. Melons that don't slip, and watermelons, should be cut—and not pulled—from the vine when ripe, to avoid damaging plant and fruit.

Judging watermelons may make you wish you had extrasensory perception. According to the "thump test," when rapped with the knuckles, an unripe watermelon supposedly has a high, musical, or metallic sound that, according to Mark Twain, says *pink* or *pank*. A ripe one, on the other hand, makes a dull *punk* sound. Unfortunately, they all sound pretty much the same to me. The "press test" doesn't work, either—watermelon rind and flesh are too thick to respond to mild pressure, and if you push hard with your palms, what you hear is the rumble of damaged flesh giving way.

THINKING INSIDE THE BOX

Farmers in Zentsuji, on the Japanese island of Shikoku, have figured out how to grow watermelons that fit comfortably in small refrigerators. They place the fruits into square, tempered glass cases while they are still growing on the vine and harvest them when they reach the exact dimensions of Japanese refrigerators. The cubic fruit costs ¥10,000, or about $82. Regular watermelons in Japan cost $15 to $25 apiece.

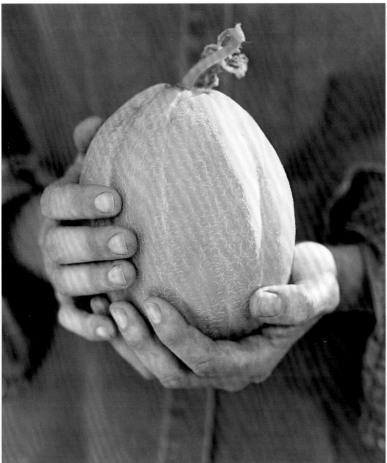

A proud bearer of a Maine, the still-warm first melon of summer. Its yellow color and pungent fragrance practically screamed that it was ready. So I cut it from the vine rather than allowing it to "slip" and become overripe. Note the crack in the stem end and the melon's fine netting, features that may or may not be present at maturity.

Happily, the gardener has several more reliable clues to go by. Is this a watermelon of substance, weighty, generally rounded, and of normal proportions? Tendril withering is also a dependable sign: When the tendril closest to the stem turns brown and dry, the fruit is likely to be fully developed. Don't rely on just one sign, though. Consult your calendar for average days to maturity to see if you're in the ballpark. Examine the ground spot, or *couche,* on the belly of the beast—cream or yellow is encouraging; white is not. The rind should be dull rather than shiny. Dark-rinded fruit feels a little rough to the touch.

If you really need to keep track of growth, keep a scale in the garden to measure daily weight gain. Harvest watermelon when it stops putting on weight—but not in the early morning, when fruits are bloated and likely to crack; wait until later in the day. Consumers, who arrive on the scene after harvest, must rely most heavily on the "eyeball test" for form, weight, volume, and color. They can only hope that the picking was good.

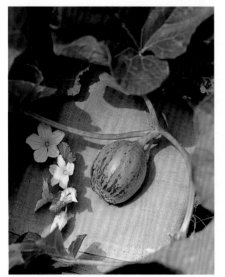

ABOVE: A very early Early Frame Prescott melon. The large blossom end scar is typical of the Prescott family of cantaloupes. The linen here is for effect only—it acts as a mask for the black plastic mulch. OPPOSITE: It's easy to tell when this winter melon, Cavaillon Espagnol, is ready for the table: Its primary or background color turns yellow and cracks appear. As the fruit ripens, foliage dies back and exposes more of it to the sun.

My goal is nothing less than to see a melon patch in every *potager:* an area consecrated to the growing of heirloom melons in kitchen gardens across America. Melons are not as easy to grow as tomatoes, but you don't need a staff of gardeners and a greenhouse, either. They are a luxury nearly everyone can afford to grow, and if you are blessed with a long, dry summer, they produce luscious fruit in just a few months. The main ingredient for success is what the astute seedsman and melon connoisseur Pierre-Joseph Jacquin long ago called the vigilance of the gardener. Gardeners need to be more vigilant in some areas of the country than in others. Liberty Hyde Bailey referred to a certain "line of perfection" at the latitude of Georgia and Texas; every deviation north or south of this golden mean spells trouble for would-be growers. Geography needn't determine destiny, though. I'm willing to test the limits, and you should be, too.

Through the wonders of modern technology, you can duplicate the growing conditions of melon's native Africa. These fruits like it hot and bright: sunny days in the eighties, nights in the sixties. Melons mature 80 to 120 days after seeding; some watermelons need about a month longer (up to 150 days). None of the melons takes kindly to frost, but if you don't have a decent interval between spring and fall freezes, there are ways to stretch the season.

The first step is to make a comfortable bed for your melons to lie on. If you're lucky, your soil is light, deep, and well-drained; sandy loam is best. If not, you can provide enough plant nutrients by adding soil amendments. Most of this soil preparation is done in the fall: incorporating leaf mold and compost, or sowing and tilling in a green manure or cover crop, such as hairy vetch and rye. Rotate your melons to a new area every year, especially if the soil is infected with nematodes or *Fusarium.*

Watermelon does well in soil that's somewhat acidic (pH 5 to 7); melon, on the other hand, prefers it basic or alkaline (pH 7 to 8).

The root systems of both are large but relatively shallow. These melons abhor wet feet (waterlogging) and soil compaction, which severely limit growth of the roots. A melon patch that slopes gently southward has the distinct advantage of warming more quickly, as well as shedding excess water. North and west winds can wreak havoc with trailing melon vines. Consider planting trees or providing some other windbreak, but *never* obscure the sun.

The biggest mistake beginners make is rushing the season. Plant your melons after the threat of frost has passed and the soil has warmed to at least 60 degrees Fahrenheit. The average safe planting-out date in my Zone 5 area is Memorial Day weekend. If you live in northern latitudes, I suggest that you concentrate on short-season varieties that mature in seventy-five days or less.

To those who say melons can't successfully be transplanted outdoors, I say nonsense. Though bare-root plants may have a hard time, seedlings grown in four-inch-diameter containers transplant beautifully, with their root balls intact. Because I can count on only 120 frost-free days, I get a jump on the season by starting my melons inside two to four weeks before setting them out in the garden. I protect melon seeds from the vagaries of cold soil, disease, and weather by starting them in a moist, sterile potting mix and keeping them in a dark, warm place until they emerge. Melons germinate in about a week at 75 to 85 degrees Fahrenheit. Watermelons can take longer; they are tougher nuts to crack, so nick or file the seed coat gently and presoak the seeds.

After germination, rig ordinary grow lights with a timer to provide sixteen hours of light a day, keeping the plants two or three inches from the light source. When the plants begin to look overcrowded in the pot, thin them to the three most vigorous per container. Sprouts can be fed diluted fish emulsion once or twice a week until they're ready to be placed in the garden.

I've been growing melons since I was a teenager, and black plastic mulch has always carpeted my melon patch. True, it's not a thing of beauty, but if you want a garden that *really* produces, the six-millimeter-thick polyethylene is the ticket. The rationale: It raises soil temperature, conserves moisture, eliminates weeds—and weeding— and keeps fruits clean and free of rot. Melons grow faster, flower sooner, and produce more fruit. Use earth staples (U-shaped pins), stones, and bricks to anchor the plastic to the ground and cut holes two feet in diameter at ten-foot intervals. Space them more widely if you live in the South, where things grow bigger. Watermelons can also be given wider berth, since their vines are usually longer than melons' vines.

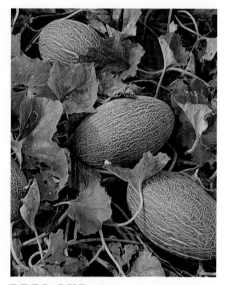

BEES AND POLLINATION

Melon plants will not produce fruit without the assistance of bees and other insect pollinators. As bees forage for pollen and nectar among melon flowers, they transfer the large sticky pollen grains from anther to stigma. Within hours, the pollen grains germinate, and by the next day, fertilization occurs. In order to grow melons in a big way, keep a hive for better fruit set and seed production. Melon blossom honey is a bonus.

Mix a shovelful of well-rotted manure into the soil (it's best done just before planting), and plant melons in "hills," a grouping of three or four plants that may or may not be elevated above the field surface. If your soil tends to become compacted or waterlogged, it's a good idea to mound the soil. Some of the smaller varieties can be supported with a trellis.

Melons need a regular supply of water throughout the season. I recommend drip irrigation, which prevents diseases caused by overhead watering.

Since the advent of spun polyester row covers, melons have never been happier. I install galvanized steel hoops to support polyester covers over each hill. These "tents" protect the vulnerable transplants from drying winds, cold, and insect predators. Three weeks later, I remove the covers and let the plants sprawl and flower, securing the vines loosely with earth staples so they don't blow around on the slick plastic.

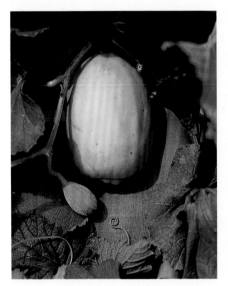

Honey Gold #9, a *conomon* melon from Japan, golden enough to harvest. The up-and-coming fruit displays the pubescence, or "short hairs," common at this stage of development.

Diatomaceous earth: An organic pest control made from sea fossils; also called fossil shell four. *Bacillus thuringiensis* (Bt): An endotoxin, or poisonous substance that is present in bacteria, usually applied as a spray.

The best way to fight pests and diseases is to stop them before they get started. Early in the season I sprinkle diatomaceous earth around the young plants to kill slugs, and I use Bt to eliminate caterpillars. I'm very careful to remove plants, even single leaves, that show signs of disease. It's surprising how effective the modern-day version of a scarecrow can be: Large yellow balloons, with eyes painted on and silvery streamers trailing behind, truly do scare off crows. I also find that loosely wrapping the developing fruits in spun polyester cloth prevents them from being defaced by marauding cucumber beetles. They are one of melon's mortal enemies, transmitting bacterial wilt when they feed—injury that's more than skin deep.

Some experts advise pruning the growing tips of melon vines to produce earlier and more abundant crops in the vegetable garden. It simply doesn't work. Nipping or pinching is a European practice for growing melons under glass; the technique isn't effective in the open field—it does not yield more fruit. In fact, it can cause harm in two ways: One, melons need a leaf canopy to prevent sunscald; two, leaves enable carbohydrates to enter the fruit, where they are transformed by enzymes into soluble sugars, making melons sweet.

Once fruits have formed, prune off the "cull" melons (the defective ones) and leave only two or three fruits on each plant. This will make the melons bigger and sweeter. After you've done all this, you can sit back and let the melons do what they do best—vine and branch out.

If you can grow melon for the fruit, you can grow it for seed, too. In order to save pure seed, you must prevent bees from leaving traces of pollen from other varieties, thereby contaminating the seed stock. There are two basic ways for the home gardener to exclude foreign pollen: isolation and hand pollination (pages 18–19). Isolating single varieties of a species by distance is the easiest way, the one I recommend for starters. You'll have to limit yourself to one melon and one watermelon that you value and know to be heirlooms rather than hybrids. Since they don't cross with each other, you can grow them in the same plot. You must ensure, however, that they are at least a half mile from other melon varieties, with which they could cross-pollinate. Check with your neighbors to see if they're planning to grow melons. If not, you can let nature take its course. When your fruit is ready, so are the seeds.

There's no need to sacrifice the fruit for the seed. When you're ready to eat the melons, cut them open. It's easy to scoop the seeds from the center of a muskmelon or honeydew. But because watermelon seeds are scattered throughout the flesh, they present a bit of a challenge. Put the seeds in a colander, discard attached flesh, and rinse them, gently rubbing to remove stickiness and tissue. Shake off the water, blot extra moisture from the bottom of the colander with a paper towel, and turn the seeds out onto sturdy, absorbent paper plates. Dry the seeds at room temperature for a week or two, occasionally turning them over on the paper plate, until they can be cracked or easily broken in two.

Heat and humidity will cause the dried seeds to lose their vigor, so store them in airtight containers, in a cool, dark, dry place such as a refrigerator or freezer. Seeds that are well cured and stored remain viable for about five years, but don't let them languish in your freezer. If you share your seeds with other dedicated gardeners, you'll be doing your part to ensure that heirloom melons do not vanish from the earth.

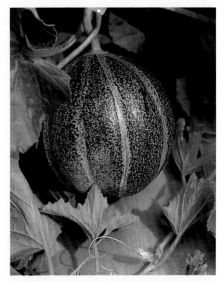

Petit Gris de Rennes, the champagne of French cantaloupes. On the way to maturity, this cantaloupe goes through many color changes. After it turns mustard and olive colored, pick it.

DRYING SEEDS

Air temperature for drying melon seeds should not exceed 110 degrees Fahrenheit. In humid climates, use a dehydrator or the low heat of a lightbulb or pilot light, keeping it at about 90 degrees. Or, simply turn on a fan to move the air in the room. Never dry the seeds in the oven: They may shrink or crack.

HAND POLLINATION

Melon (*Cucumis melo*) and watermelon (*Citrullus lanatus*) belong to different genera and species and cannot cross-pollinate, but varieties within each species will cross. So, when you grow more than one variety of a species at the same time and want to maintain maximum seed purity, hand pollination is the way to go. You'll control pollination, excluding bees with pollen from other varieties, by transferring pollen by hand from the male flower to the female flower.

Melon flowers are fragile and tiny and require a gentle touch. You'll need patience and high frustration tolerance, because you'll fail more often than you succeed. Bees themselves are successful with melons only 20 percent of the time. Only about 10 percent of hand pollinations of melons and 50 percent of watermelon pollinations "take" and set fruit.

Keen powers of observation are essential. You'll need to know all about the growth habits of flowers: when males are ready to release their pollen—indeed, what fresh pollen looks like—and when females are receptive. Watermelons are mainly monoecious, with separate staminate (male) and pistillate (female) flowers. Most melon varieties are andromono-ecious and have staminate and

hermaphrodite (perfect) flowers. Hermaphrodites have male parts that need to be emasculated before hand pollination, by removing the pollen-producing anthers; they function as females.

Female flowers are vastly outnumbered by males. You'll recognize the female by the immature ovary (that becomes the fruit) at the base of the flower; males have a straight, simple stem. After plants start flowering in early summer, producing new flowers that open every day, there's a brief opportunity for the pollinator. Pollination happens early in the season and early in the morning. Wait until the dew dries and the flowers are ready to open. Don't pollinate on a rainy day, when pollen is unlikely to shed.

Every good pollination kit should contain forceps with fine, pointed tips, rubbing alcohol, three-quarter-inch masking tape, clips or paper fasteners, surveyor's or pollination flags in two colors, surveyor's tape, gel capsules, and notebook and pen for recording data and observations. You're now ready to proceed.

The following is based in part on the work of Cornell University's Henry M. Munger.

EARLY EVENING DAY ONE

1. Any fruits that have already set, and any open female or hermaphrodite flowers, must be removed, thereby "stripping" the plants and eliminating the competition.

2. Find both male and female flowers of the same variety that are likely candidates to open for the first (and only) time the next morning. Size and color changes provide a clue; look for buds that appear fresh and not faded. Try to select two males for every female.

3. Tape the buds shut with a small piece of masking tape, leaving the ends separated to make it easier to remove in the morning. Clips can be used instead to keep the blossoms closed. The trick is to get all of the petals inside without inflicting damage to the pollen-bearing anthers or to the stigma (that part on the female where the pollen lands).

4. To make blossoms easier to find the next morning, place brightly colored pollination flags beside them. Use different colors for male and female.

EARLY MORNING DAY TWO

1. Pluck the male flowers, leaving stems intact if possible to serve as handles, and make a beeline to the females.

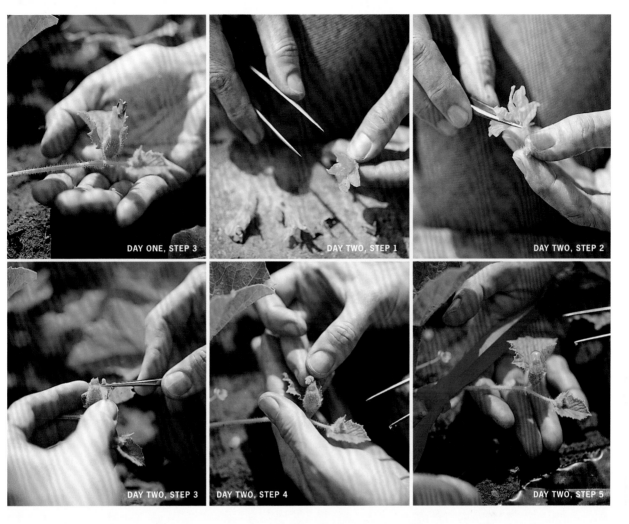

DAY ONE, STEP 3 | DAY TWO, STEP 1 | DAY TWO, STEP 2

DAY TWO, STEP 3 | DAY TWO, STEP 4 | DAY TWO, STEP 5

2. Remove the tape or clip from two male blossoms. Using forceps, carefully slit them, one by one, down to the base and remove the petals and the entire calyx (ring of sepals). It's something like peeling an orange. This will expose the sides of the anthers where the pollen is borne. Set the males aside and cover with the petals for protection from bees.

3. Remove the tape or clip from the first female; when receptive, the petals will slowly expand. Use forceps to remove the petals. If you see any yellow anthers covering the green stigma, remove them cleanly with the forceps and discard by brushing against a leaf.

4. Watch out for bees and work quickly and carefully. Transfer the loose pollen from the anthers of the two males onto the receptive stigma. Be sure to completely coat the stigma in pollen, but don't damage it with an overzealous application.

5. Protect the fertilized female with a fresh piece of tape or a gel cap, being careful not to constrict the stigma. Tie surveyor's tape near the adjoining leaf. Keep the pollination flag in place for easy identification.

6. If more blossoms are available, repeat the process. Don't do more than three or four pollinations until you see if there are results.

7. If you intend to pollinate more than one variety that morning, make sure to sterilize your hands and equipment with rubbing alcohol before proceeding.

8. Be encouraged if after a few days ovaries appear slightly enlarged and the stem attachments are still green. Fertilized fruits can abort spontaneously, however; don't count your successes until later.

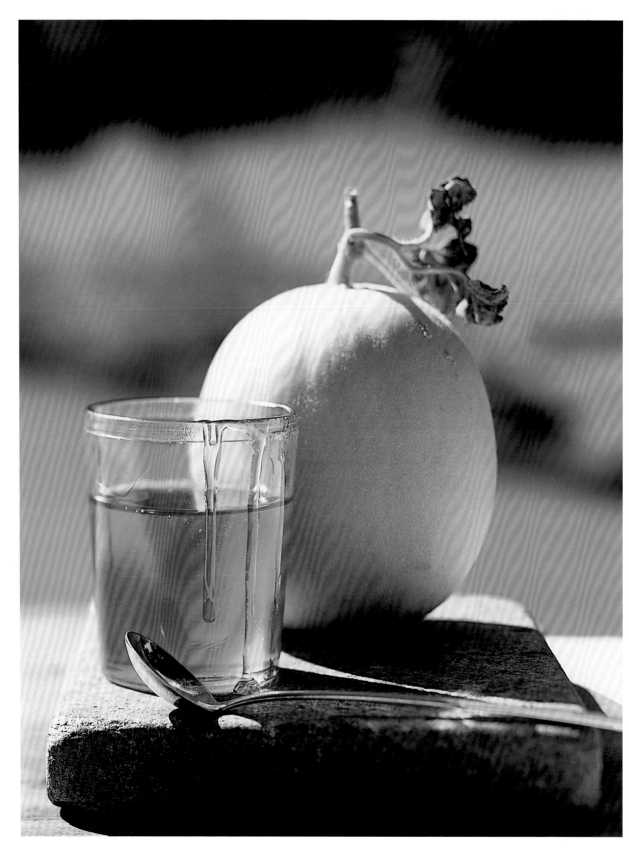

A TASTE OF MELON

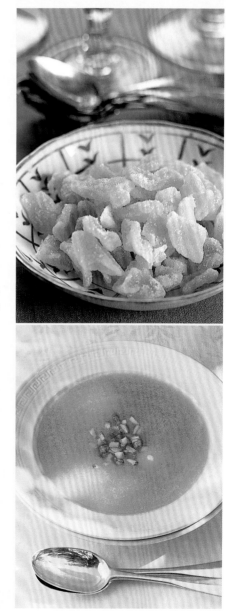

Some of the best melon recipes are the simplest—for example, very thinly sliced prosciutto draped over melons, a drizzle of lime juice, a sprinkle of salt and freshly ground pepper, or perhaps a dusting of sugar, ginger, or paprika for emphasis.

MELON BLOSSOM HONEY If you've done everything right—cultivating, fertilizing, and irrigating—but still have poor melon fruit set, more often than not the answer is a strong hive of bees. Place the hive within two hundred yards of your melon patch so the bees won't have far to fly; provide a good source of water, too. Honeybees will do double duty by moving pollen around and producing honey. All you have to do at season's end is harvest the honey—if the robber bees don't beat you to it. *Pictured left.*

CANDIED CITRON WATERMELON Prepare 2 quarts of peeled, seeded, and cubed (½ inch) Citron watermelon. Combine 1½ cups of sugar and 3 cups of water and bring to a boil; add the Citron cubes and cook for 20 minutes. Cover and let stand overnight.

The next day, remove the melon and set aside. Drain all but 1 cup of liquid, to which you will add 1½ cups of sugar and the juice of 1 lemon. (Thin slices of fresh ginger can be added to give a zippier taste.) Boil and then return the melon to the pot. Keeping a watchful eye to prevent scorching, cook until most of the syrup is absorbed.

Drain the melon and roll the pieces in granulated sugar. Place the candy on waxed paper and let it dry for several days, turning occasionally. Use this confection as you would Turkish delight or as an ingredient in fruitcake. *Pictured top right.*

MELON SOUP Peel, seed, and chunk 6 pounds of melon of your choice. Combine with 2 cups orange juice and 2 tablespoons lime juice and puree in a blender or food processor. Finely mince additional melon pieces to make melon confetti and sprinkle over the soup. Serves 4 to 6. *Pictured bottom right.*

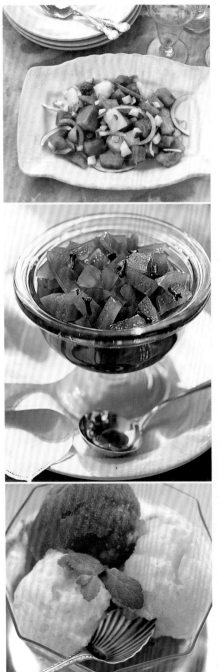

WATERMELON SALAD Cut a 10-pound watermelon into bite-sized pieces and place in a large bowl. Add 1 small red onion, thinly sliced, salt and freshly ground black pepper, extra-virgin olive oil, and Vinaigre de Banyuls to taste. Chill, drain excess liquid, and serve. *Pictured top left.*

PICKLED WATERMELON RIND Use only the white rind of one or more watermelons. Peel the outer skin and remove the meat; you should have 7 pounds of prepared rind. Cut the rind into pieces 1½ inches by ½ inch in size.

In a large pot, combine 4 cups water, 5 pounds sugar, 10 cinnamon sticks, a large handful of cloves, 1 tablespoon salt, and 3 cups white vinegar; boil until the sugar dissolves.

Place the watermelon rind in the pot and let sit, covered, overnight.

Twenty-four hours later, remove the rind and bring the syrup and spices to a boil. Remove from the heat, return the rind to the pot, cover, and let sit another 24 hours. Repeat this process for 2 more days. On the fifth day, heat both the rind and the syrup together. Remove the cinnamon sticks and place the pickles in eight pint jars. Process in a hot water bath for 20 minutes. *Pictured middle left.*

MELON SORBET You can create an easy palate refresher or wonderful light dessert using any sweet melon. Cut up your favorite sweet melon and, in a blender or food processor, puree enough to yield 3½ cups. Combine the puree with 1¼ cups of simple syrup plus 1 tablespoon lime juice. Freeze in your ice cream machine for 20 minutes and serve. *Pictured bottom left.*

SNAKE MELON GAZPACHO Peel, seed, and coarsely chop 3 pounds each of Snake melon and ripe tomatoes. Coarsely chop 1 small onion and 1 clove of garlic. In a blender or food processor, puree the chopped vegetables in batches. Transfer to a large bowl and add 1½ teaspoons kosher salt, 1½ teaspoons ground white pepper, minced jalapeño pepper to taste, and 3 tablespoons each olive oil and wine vinegar. Refrigerate. Serve very cold, garnished with additional chopped melon and tomatoes. *Not pictured.*

CHARENTAIS AU PORTO Charentais and Porto were meant for each other. Because port is sweeter and more viscous than Charentais, it accentuates the melon's fruit acid and delicacy. Charentais returns the favor by intensifying the sweetness of port and making it less rich, like a syrup. Warre's 1983 Vintage Porto is classic: Simply pour it into the melon and serve. *Pictured opposite.*

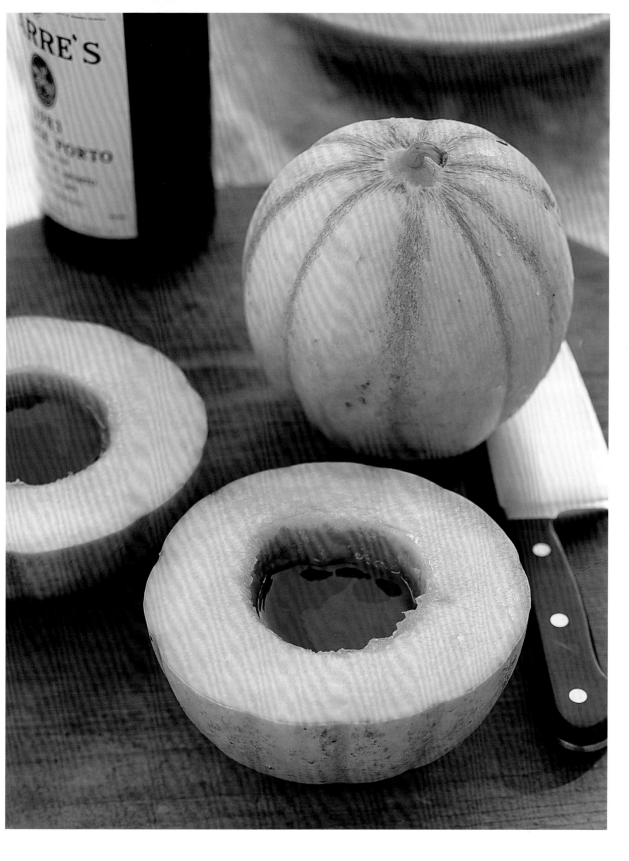

Moon and Stars watermelon. Plant breeders suspect that the speckles on fruit and leaf are due to genetic, not viral, factors. Whatever way it acquired its spots, the Moon and Stars is guaranteed to bring a smile to the lips.

The heirloom melons in this book represent the best the world has to offer. Unless we act soon to save them, they'll be gone. All of these melons have at least two other things in common. They are members of the Cucurbitaceae family of plants and specifically include what is commonly known as melon (*Cucumis melo*) and watermelon (*Citrullus lanatus*). All are capable of reproducing themselves true to type from seed, with the aid of bees, of course. If they are not allowed to cross, heirlooms produce plants that grow, look, and taste like their parents. They are known as open-pollinated or standard varieties, and they differ from hybrids, whose offspring don't resemble the parent.

Melons will not save us from starvation, but they do quench our thirst and give us a taste treat. They are at least 90 percent water. Orange-fleshed melons are more nutritious than most because they are high in vitamin A and beta-carotene. The most nourishing part of melon is what we usually discard: the seeds. Watermelon seeds, for example, have nourished people in Africa and China for thousands of years, providing needed calories, protein, and fat. Chinese people grow more watermelons than anyone else, but unlike most of us in the West, they eat the seeds and often discard the melons. In fact, many Chinese people have hollows in their incisors from years of prying these seeds open. Africans also value melons for their protein- and lipid-rich seeds; in addition, they rely on these "canteens" as a source of uncontaminated water.

Wild melons and watermelons can be bitter, sour, or bland; most modern varieties are sweet. Americans enjoy the sweet varieties, but there's a world of other kinds awaiting us and myriad ways to indulge. Melons can be quite unmelonly: Some have cornlike cobs or a cucumber-like tang; others are apple impersonators, sized just right for the lunchbox. We've hardly begun to understand their potential in cookery. For starters, you can roast watermelon seeds for a snack, use Snake melon any way you'd use a cucumber, and make candied Citron watermelon for a special treat.

Melons have come a long way, in terms of both flavor and geography. They got their start in Africa, where diverse forms and wild species of melon, watermelon, and their relatives can still be found. No one knows precisely when, where, and how melons were domesticated, but gatherers apparently selected and saved the seeds of the sweetest ones. Historical records, such as wall paintings, and seeds and leaves found in Egyptian

tombs, place melon and watermelon in Egypt at least four thousand years ago. Then, about three thousand years ago, they left Africa via trade routes. The area in Asia bounded by Turkey and Japan—including Iran, Afghanistan, India, south central Russia, and China—is a hotbed of melon diversity. According to Michel Pitrat (1999), melons were probably introduced in Europe during Greek and Roman times. The Moors from North Africa later brought melons and watermelons to Spain during their occupation (711 to 1492).

Columbus set sail September 25, 1493, from Cádiz, Spain, on his second voyage of discovery. According to Washington Irving's 1828 account in *The Life and Voyages of Christopher Columbus,* when the navigator and his crew disembarked in Haiti in mid-December, joyful at "treading the firm earth, and breathing the sweetness of the fields," they loosed cucumbers and melons, as well as cattle and horses upon the land. By the spring of 1494, the first crop had ripened in Haiti and was fit for the table.

The transfer of flora and fauna between Spain and the New World became known as the Columbian exchange. Columbus apparently didn't bring any watermelon, but early European colonists and African slaves introduced melons of all descriptions to Brazil, the West Indies, and North America. Colonial records of Spanish Florida show that watermelon was grown there in the sixteenth century. Court documents from 1576 quote farmer Juan Serrana, who testified that Santa Elena Island was fertile ground for *maíz, calabazas, y sandías*—maize, pumpkins, and watermelon. A generation later, watermelon had spread into the interior. Native Americans grew so many that some settlers believed they were indigenous.

Melon (*Cucumis melo*) and watermelon (*Citrullus lanatus*), like most other cucurbits, are annuals that grow on long, tendril-bearing vines. The fruits are a specialized type of berry with a leathery rind. Melon plants have ridged stems and simple tendrils; their leaves can be round, oval, or kidney-shaped, and angled or shallowly lobed. Watermelon stems are hairy, angular, and grooved; the tendrils are branched; the leaves are divided into pairs of lobes.

Watermelon fruits differ considerably from one another in size, shape, color, and patterning. The range of melon fruit types is astounding. In fact, melons vary to such an extent that they have confounded taxonomists since the eighteenth century, when Carolus Linnaeus created the modern botanical classification system. Classification of melons into groups based on fruit characteristics seems arbitrary at times, and indeed they are not true botanical subspecies.

Since melons are the most variable species in their genus and there are no reproductive barriers between them, intermediate forms are forever developing, making the task of orderly classification difficult. A recent study that used DNA fingerprinting concluded that differences between groups are not strong or clear cut (Stepansky, Kovalski, and Perl-Treves, 1999). Nonetheless, classification serves a useful descriptive purpose; the melons in this book fit into eight recognized subgroups.

MIDDLE AGES

During the late Middle Ages, melon shared the fate of many other vegetables in Europe and nearly disappeared, except in Spain, where the Moors had introduced superior agricultural practices and a diversity of crops. Around 1250, Europe entered a "little Ice Age" and the climate turned much colder and wetter. Depletion of soil nutrients, and too much acreage given over to wheat, left the soaring population vulnerable to famine and malnutrition in a series of disastrous crop failures. Europe was suffering from economic recession, war, and civil disorder when the Black Death, or bubonic plague, arrived in 1348 to claim one third of the population. Whole villages, rural areas, and less than ideal croplands were abandoned.

CANTALUPENSIS

CANTALOUPE. When Americans refer to cantaloupes, most of the time they don't know what they're talking about. The true cantaloupe, rarely seen in the United States, is much more common in Europe. The vast majority of the cantaloupes on these pages hail from France, where cantaloupes have been grown for more than five hundred years. They are generally rounded in shape and often have prominent ribs (the "elevated" portions) and sutures (the troughlike vein tracts); and netting, if any, is sparse. Their rinds can be smooth like the Charentais's or warted and scaly like Prescott Fond Blanc's. Most are orange-fleshed, luscious, and aromatic and do not abscise, or slip from the vine, when ripe. These include some of the melons most dear to my heart: Noir des Carmes, Early Frame Prescott, and Petit Gris de Rennes. Cantaloupes are dessert melons par excellence.

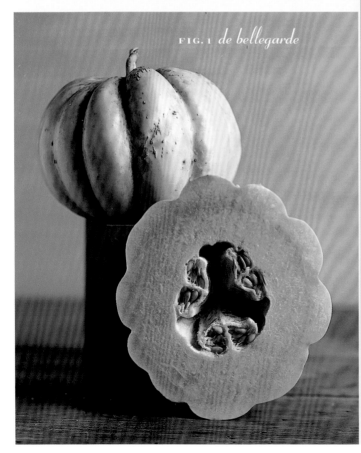

FIG. 1 *de bellegarde*

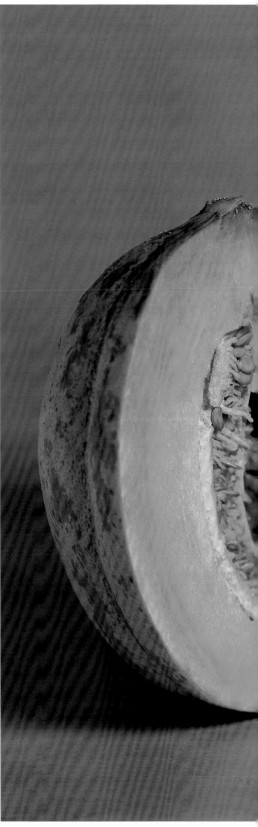

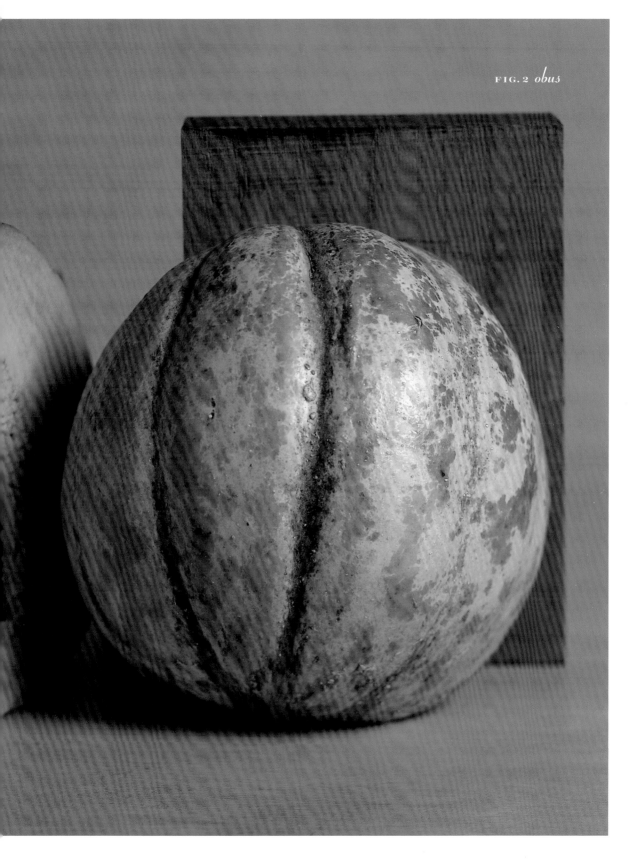

FIG. 2 *obus*

cantalupensis

N O I R D E S C A R M E S

Noir des Carmes is an uncommon melon. Long ago named for the Carmelite monks who once tended it in France, the melon has become rare in our lifetime. Daniele Gespert, a Belgian friend who is now a chef, wistfully recalls the Noir des Carmes of her youth, served as a dessert sprinkled with sugar. Ordinary melon, eaten as a first course, merited only salt and pepper. Esteemed in Europe, Noir des Carmes and other true cantaloupes never made it into the American lexicon. Cantaloupe as we know it is a misnomer for muskmelon.

Thought to be the province of rich men with legions of gardeners and greenhouses, rock melon or cantaloupe is surprisingly easy to grow. Noir des Carmes was routinely "forced" by the English and French in January or February to meet the demand for unseasonable fruit, or for what some might say was unreasonable whim. Cultivating melons in this manner is an effort that only the melon-obsessed can appreciate. There's no need to test the limits, however; simply grow it in season in the open air as you would any muskmelon. The reward will be an early crop of more melons than you can imagine.

There's nothing quite like the Noir des Carmes in America today, where the market is dominated by netted melons. It looks different, tastes different, and smells different. Both *recherché* and remarkable, Noir des Carmes should easily find a niche. Dark as a monk's frock when unripe, Noir turns tantalizingly sunny as it nears perfection. Rifts appear in the stem end as it bursts open with goodness. I prefer my melon like this, *à point*. But it can be harvested somewhat younger to preserve its integrity, with no real loss in flavor. The flavor is complex and deeply satisfying.

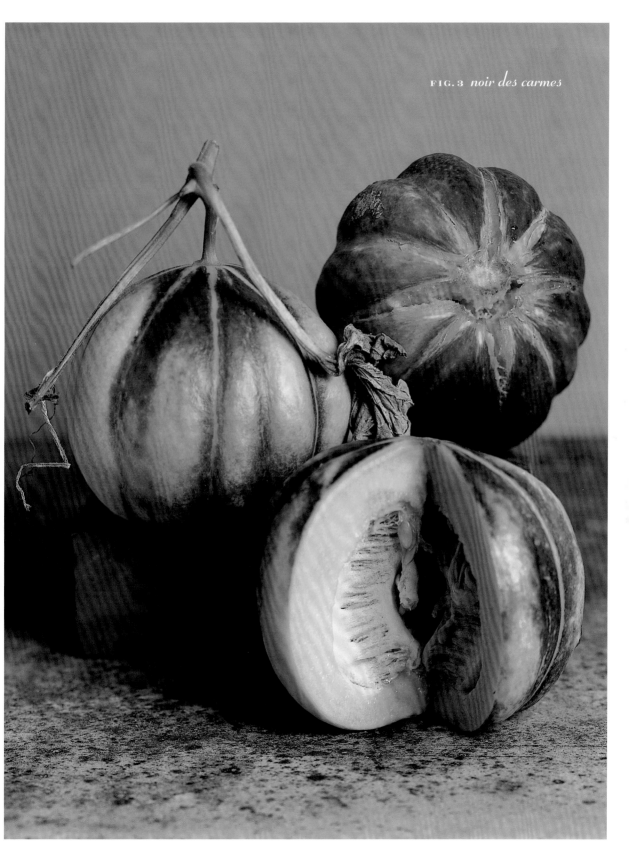

FIG. 3 *noir des carmes*

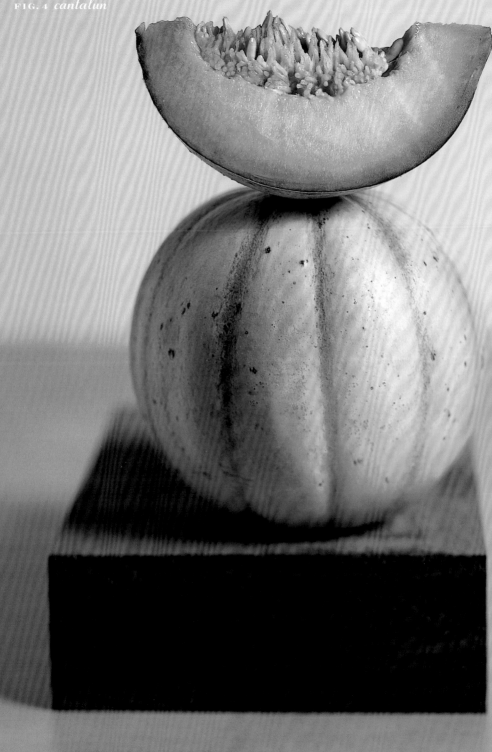
FIG. 4 *cantalun*

FIG. 5 *vieille france*

cantalupensis

EARLY FRAME PRESCOTT

Delectable is the word for Early Frame Prescott. Its aroma doesn't hit you in the face as the aromas of some muskmelons do; rather, it is more subtle and fruity. Within the creamy pumpkinlike shell, marked by streaks of green and occasional warts, lies what I can describe only as melon confit preserved in its own sweetness.

This member of the Prescott family of cantaloupes, with its vigorous branching habit, is suited for growing under the frost protection of bell jars and frames, as well as head to wind in the open. Along with Noir des Carmes, it was once preferred by gardening zealots who forced melons to do their bidding on cold wintry days. Frame culture is also conducive to getting a main-season crop when heat and light are in the ascendant in northern latitudes.

If you decide to grow these melons, set the stage in early spring by digging a hotbed: a mass of fermenting manure and unfinished compost mounded over with topsoil. The warmth and sustenance generated will speed the melon on its way when planted out in late spring. Complete the scenario with glass (panel type) cloches or polyester tunnels that permit air and bees to enter.

To get fruit to grow within such confines of space and time, Early Frame Prescott must first be cut short. If you prune it into a double cruciform, the plant will produce an early crop of four melons. Remove the growing tip after at least four true leaves have formed, and allow a pair of laterals, or side branches, to grow, trained in opposite directions. Nip again after the vines run the length of the frame, and permit one sublateral to grow from each side. Since flavor is in direct proportion to foliage—remember, photosynthesis happens in the leaves—don't sacrifice too much. Cut judiciously.

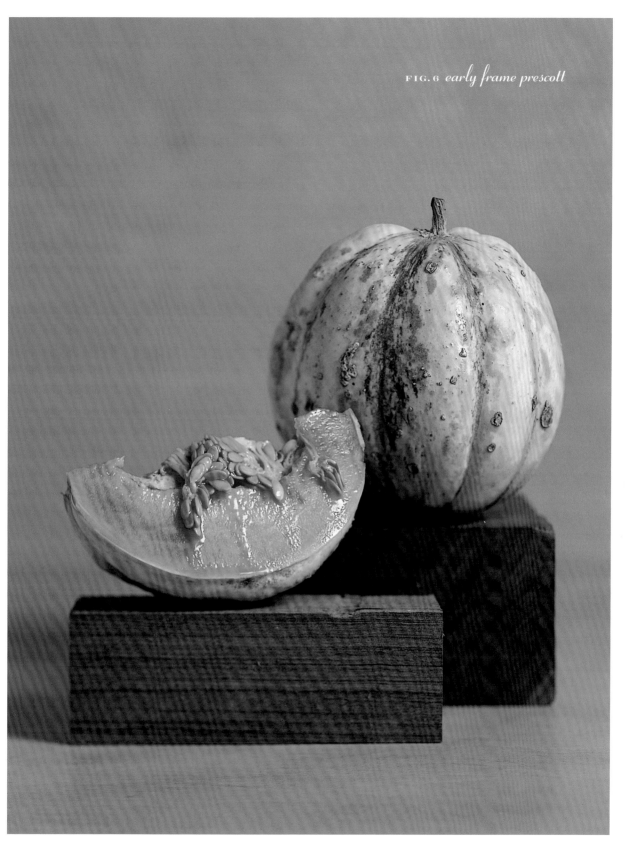

FIG. 6 *early frame prescott*

cantalupensis

D'ALGER

D'Alger is a melon that belongs on a pedestal, the better to view its fantastic form. Is it melon or mirage? Decide for yourself. Its ten very pronounced ribs and deep sutures are reminiscent of pumpkin; its raised spots, or galls, are like clouds. During ripening, D'Alger turns several shades of orange and gives off an intoxicating aroma that can perfume a room.

D'Alger is a true cantaloupe, with a thick shell and persistent stem. But sometimes the boundary between cantaloupe and muskmelon blurs, as in this case, with the appearance of slight netting or reticulation. The French refer to these as *melons brodés* or *melons écrits,* melons with embroidery or writing.

Cutting a D'Alger open can be disappointing: The interior is a large vacant space enclosed by a thick rind and a paltry amount of bland flesh. The taste is described as reliably sweet and good in the classic *Les Plantes potagères* (Vilmorin-Andrieux, 1883). D'Alger was never popular with market gardeners near Paris, though it was much appreciated in the Midi, the south of France. So much depends, of course, on the land and the climate where the melon grows. It may be particularly well suited to a southern exposure.

D'Alger was widely grown in Algeria and is named after the seaport city Algiers. It's not difficult to imagine how the melon might have made its way from Africa across the Mediterranean to the southern shores of France. Whatever its provenance, D'Alger is certainly worthy of a place among the other fruits in the Koran's Garden of Paradise or Delights.

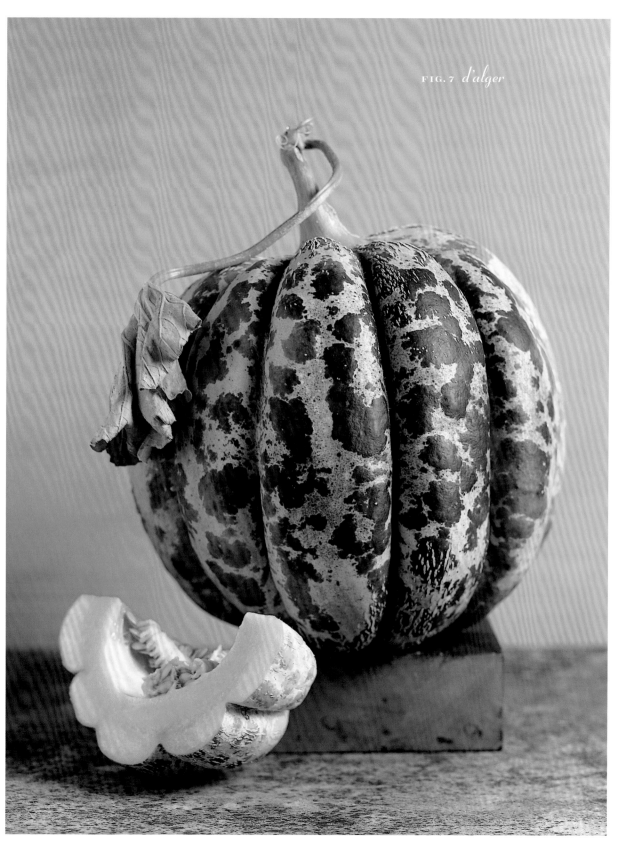

FIG. 7 *d'alger*

cantalupensis

PRESCOTT FOND BLANC

Once a favorite of French market gardeners, the Prescott Fond Blanc is now a favorite of mine. This ethereal, deeply furrowed, puffy-looking melon reminds me of dough rising. I love to run my fingers over its wrinkled, warted, rock-hard shell and to smell true cantaloupe—a cross between a wonderful floral bouquet, wild muscat grapes, and a squeeze of verjuice. A rare commodity these days, the Prescott deserves to be brought under wider cultivation. Although it is less meaty than the more efficient modern melons, tasting one is an experience not to be missed.

The white-skinned Prescott is one of a number of similar varieties, named after an English gardener, that range in color from silvery metallic to blackest green. Like all the Prescotts, it has a recessed stem and a large round scar on the blossom end; it grows on vigorous vines with dark toothlike leaves. Prescott has the telltale signs of a true rock melon or cantaloupe: It is thick-skinned, warted, and bumpy, displays no netting, and does not slip from the vine when ripe.

Cantaloupe comes to us through a circuitous route. Native to Armenia, it was taken by missionaries to the gardens at Cantalupo—which means "singing wolf"—the papal country home near Rome, from which it derives its name. Refined and perfected under the warm Italian sun, it was then exported to France in 1495. As François de Malherbe, the official poet of Henry IV and Louis XIII, put it, "Renaissance France smelled of melon." From there it found its way to Spain, England, Holland, and beyond.

Prescott's savory flesh is dense and sweet, and the fruit itself is strikingly attractive. Artists have been inspired by this melon—antique French ice cream molds in the shape of Prescott are collector's items; I have cast them in bronze. Prescott à la mode: food for thought.

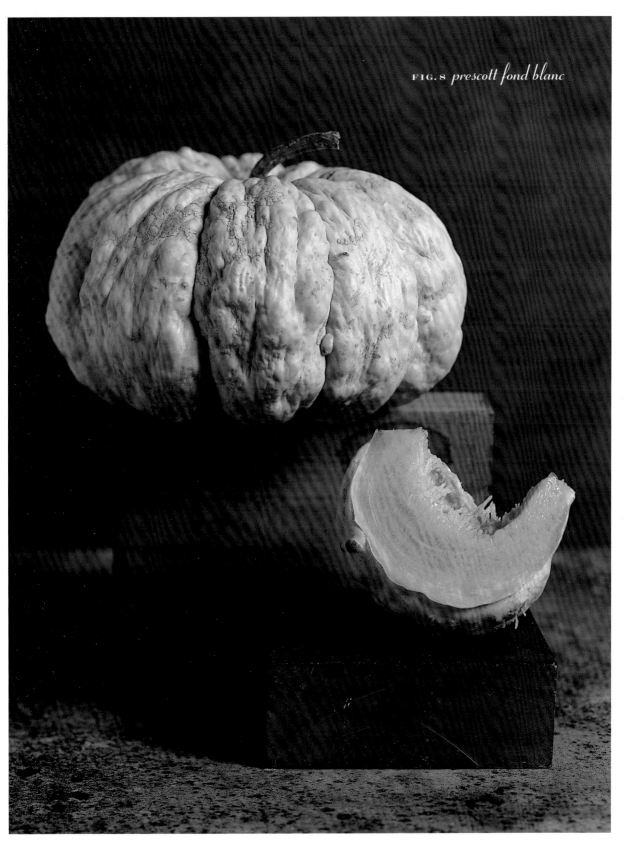

FIG. 8 *prescott fond blanc*

cantalupensis

PETIT GRIS DE RENNES

The Petit Gris de Rennes is so good it gives me the chills. As wonderful as Charentais is, Petit goes a baby step further, making it *la crème de la crème* of French melons. You will blink your eyes with disbelief when you sample its sweetness, which is more like brown sugar than white. It will melt on your tongue, and your mouth will water for more.

The melon is a *tableau vivant* of Impressionistic mustard and olive, and it inspires devotion in France. The little gray melon, named for its appearance before ripening, was first noted in the garden of the Bishop of Rennes nearly four hundred years ago. It thrived in the mild climate and horse manure of the garrison town, but is now cultured in hothouses and polyester tunnels. It is both labor-intensive and costly to produce.

Despite the best efforts of a handful of farmers and chefs, Petit Gris is menaced by market forces. That doesn't discourage the Rescan family of Cesson-Sévigné, who has grown Petit Gris for more than seventy-five years. Marie-Thérèse Rescan is the president of the Syndicate of Producers of Petit Gris de Rennes, and a champion of the melon. For this group of preservationists, quality control is critical, so they've made a science of what once came naturally. Melon plants are grafted onto squash rootstock to confer *Fusarium* wilt resistance and then espaliered to keep them off the ground.

Grown this way, Petit Gris de Rennes doesn't see the light of day or touch the earth, but it's hardly factory farming. Kid gloves guide the process every step of the way. Maybe it's not as easy to grow as other melons, but you *can* cultivate it in your own garden. Protect it from cucumber beetles, and coddle it with spun polyester. It's worth the extra effort.

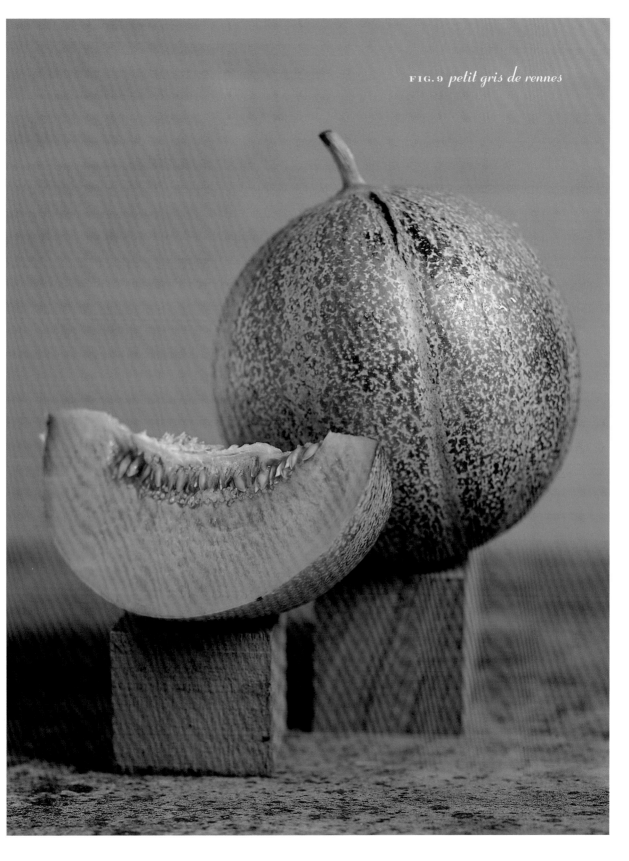

FIG. 9 *petit gris de rennes*

cantalupensis

HA'OGEN

This melon is generally identified with Kibbutz Ha'Ogen in Israel. Ha'Ogen got its commercial start on the kibbutz, but a melon can adopt a place and a name even when far from its roots, as in the case of the Galilee watermelon grown near the great freshwater sea. Ha'Ogen has another meaning as well: It is Hebrew for "the anchor."

The late Jane Grigson, an English cookbook writer and an expert on fruits and vegetables, acknowledged the kibbutz connection, yet she believed that Ha'Ogen was of Hungarian descent; the Israeli plant breeder Harry Paris has confirmed the Hungarian connection. Watermelon (*görögdinnye*, literally, Greek melon) is much preferred in Hungary, but sweet melon (*sárgadinnye*, yellow melon) is certainly grown. There was a tale told by János Lippay, in the seventeenth century, about a Hungarian noblewoman who loved sweet melons so much that she lent them her marten fur to ward off the chill. Tragedy struck in the night, however; thieves made off with the fur, and the melons were claimed by frost.

Hungarians prefer their melon for dessert, sprinkled with paprika. Sweet or hot, the pulverized pepper pods add color and flavor to the native cuisine. If that's not daring enough, try smokeless tobacco or snuff on your melon, as old-timers used to do. These are just diversions, though—Ha'Ogen needs no flavor enhancers, natural or artificial.

The melon most resembles Ananas d'Amérique à Chair Verte, one of the best of melons, in flavor and appearance. Were I to speculate, I'd say Ha'Ogen is the perfect marriage of Ananas Verte and a green-fleshed cantaloupe (Cantaloup à Chair Verte), although we'll probably never know. Israeli? Hungarian? French? Perhaps it's all three.

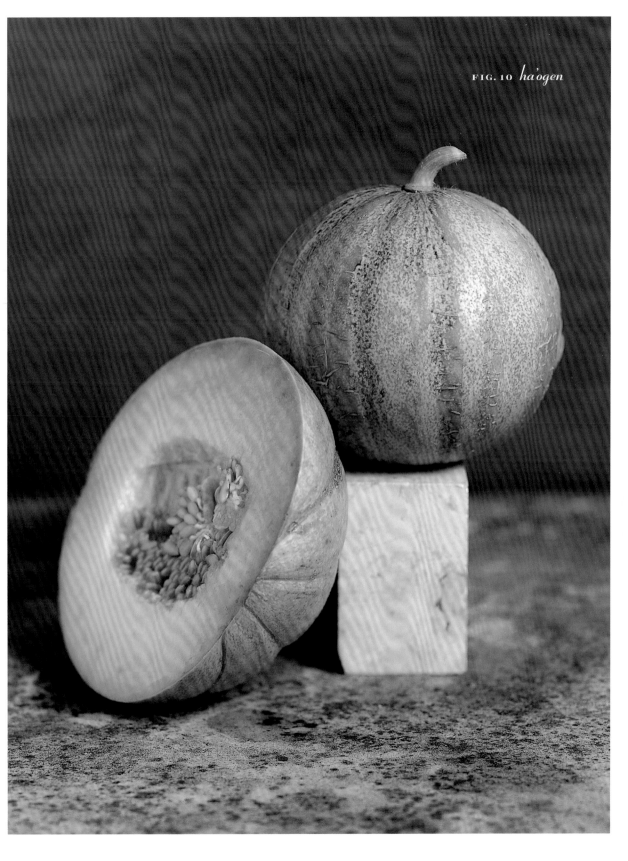

FIG. 10 *ha'ogen*

cantalupensis

CHARENTAIS

When Montaigne said, "I am not excessively fond of salads or of fruits, except melons," he might well have been talking about the Charentais. It's the melon the French adore above all others, and for good reason. The scent is divine, the flavor ambrosial. Who can resist this melon reverently nestled in fancy tissue paper on a bed of straw in the marketplace? Where Frenchmen disagree is on how best to serve it: Slightly chilled or not? Alone, savory with sliced ham, or saturated with port, muscat, or Ricard? One can almost hear the cacophony of cutlery and opinion.

Charentais is a type of melon (there are many commercial varieties) whose point of origin was the Poitou-Charentes region of western France circa 1920. It is a refined cantaloupe, smooth-skinned and free of the blemishes and warts of its ancestors. Round or sometimes flattened at the poles, it shows only faint traces of ribs; its green meridional sutures guide the knife where to cut. The melon is sometimes called a Cavaillon, which creates a bit of confusion. Cavaillon, a town (far from Charentes) in the South of France noted for the quality of its melons, has lent its name to many melons simply because they were grown there. It's like the *Good Housekeeping* Seal of Approval.

You don't have to go to France to enjoy the Charentais. Dare I say it can be grown equally well in the United States? As a francophile, I know there is something mysterious about the air of the Vaucluse, scented with herbs, and the tang of the soil near Châtellerault in the Berry, which imparts a subtle flavor to the fruit. Let's accept with pleasure this gift of French patrimony and make it our own.

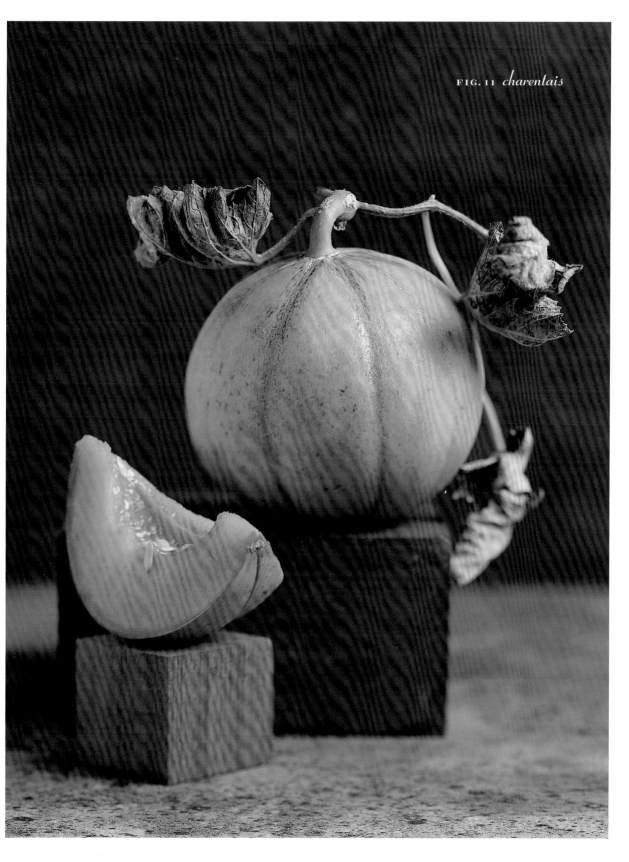

FIG. 11 *charentais*

RETICULATUS

RETICULATUS: MUSKMELON AND PERSIAN MELON
The hallmark of this grouping of melons is the
reticulated or netlike tissue that covers the rind.
Americans have taken the muskmelon and run
with it, creating a striking array of fruit with distinct
personalities and flavors. You'll never think about
a muskmelon in quite the same way again after
reading about Jenny Lind, Anne Arundel, Fordhook
Gem, or Schoon's. Muskmelons are usually ribbed
and sutured, and often slip or fall from the vine when
mature. Most are sweet, orange-fleshed, and have
a musky odor; the green and white ones provide
a different kind of taste treat. Muskmelon is a breed
separate and apart, yet we persist in mislabeling
it "cantaloupe."

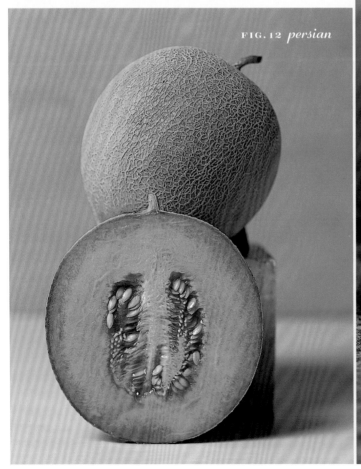

FIG. 12 *persian*

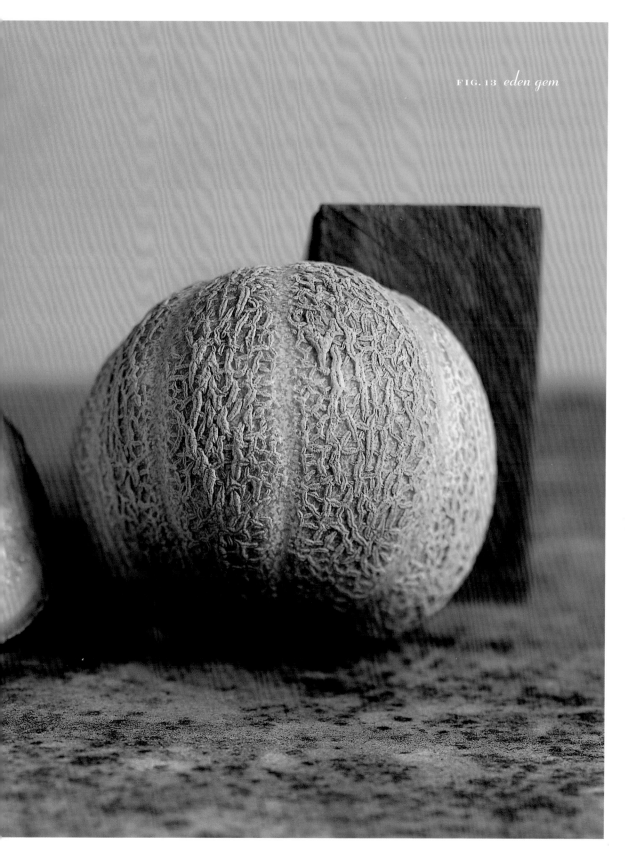

FIG. 13 *eden gem*

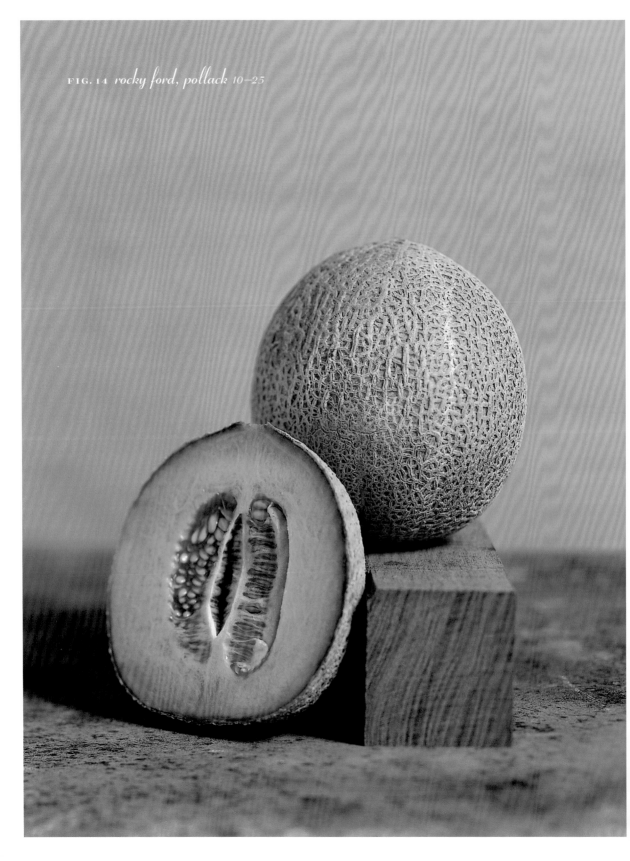

FIG. 14 *rocky ford, pollack 10–25*

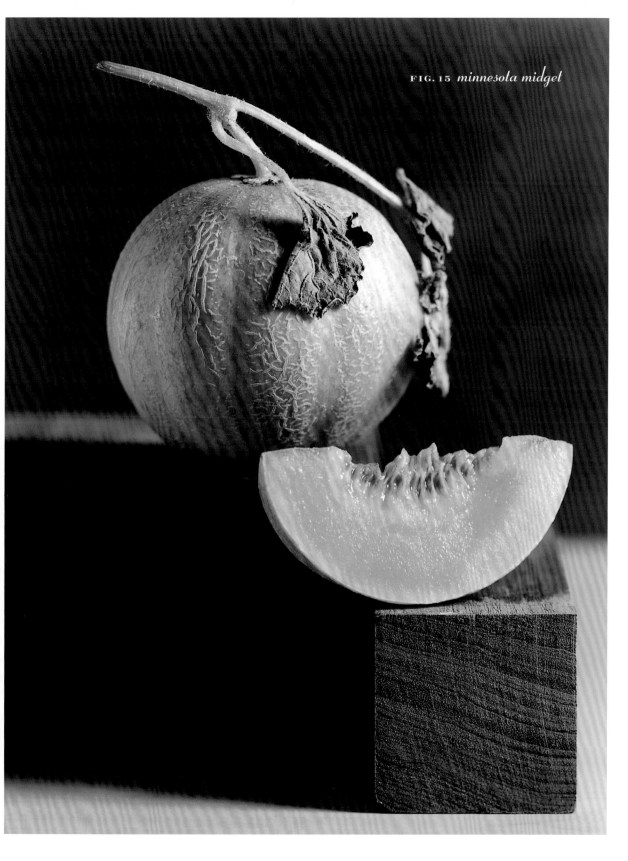

FIG. 15 *minnesota midget*

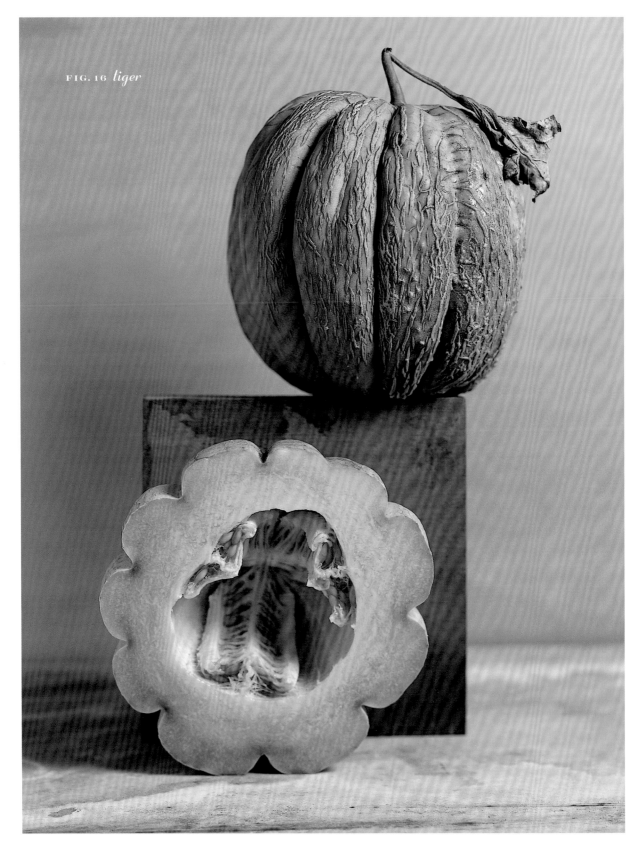

FIG. 16 *tiger*

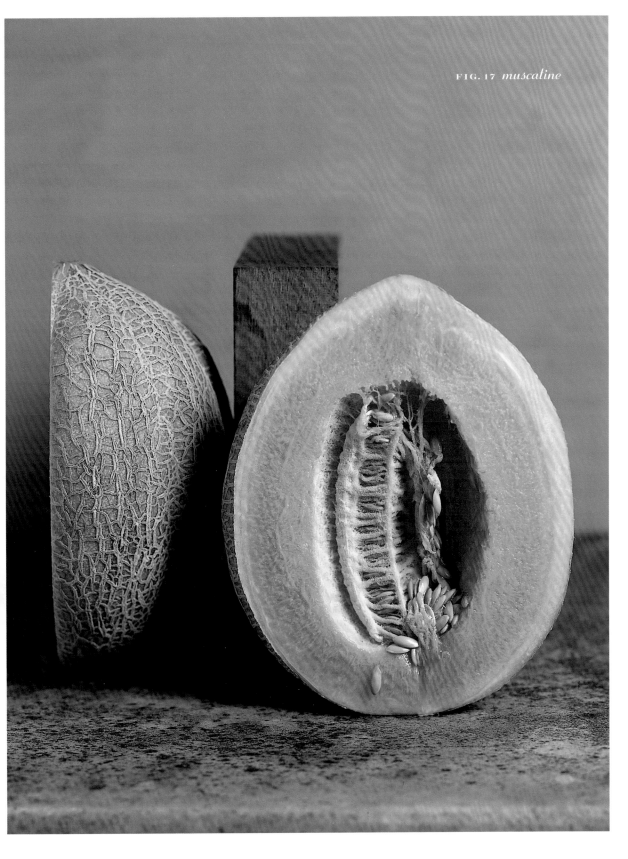

FIG. 17 *muscaline*

reticulatus

HERO OF LOCKINGE

The Hero of Lockinge melon is no longer politically correct in its native land. Restrictive licensing laws in England make it a crime to sell vegetable seeds that are not on the approved National List. To belong to the in-group means paying dearly: Lockinge meets the prerequisites as a distinct, uniform, and stable variety, but the exorbitant registration and annual fees are beyond the means of its vendors. The melon was dropped from the list in 1995 and, like so many other unsung heroes, has been replaced by hybrids that bring in prettier pence.

This sorry state of affairs would furrow the brow of Scotsman Robert Loyd-Lindsay (1832–1901), perhaps better known as Lord Wantage of Lockinge, a founder and the first chairman of the British Red Cross. He is the hero of our story, and the man behind the melon. His greatest claim to fame was earning the Victoria Cross, bestowed upon him by Queen Victoria herself in 1857, for two separate acts of bravery and valor in the Crimean War.

The melon was introduced to the public in 1881 by Sutton's Seeds. The House of Sutton, founded in 1806, was one of the first mail-order seed companies, and it retains its royal warrant today "for seeds of the highest purity." Lord Wantage's head gardener, Mr. Atkins, developed the melon at the family seat, Lockinge Park, the biggest estate in Berkshire, by crossing Read's Hybrid, Colston Bassett, and Victory of Bath.

With such a noble heritage, the Hero of Lockinge should be winning blue ribbons—just as it did in Victoria's day. Its pint-sized mien, delicately laced, is appealing; the translucent white flesh hints of fig. Thanks to the Henry Doubleday Research Association, Europe's leading organic gardening organization, the melon seeds can now be gotten legally, through membership.

FIG. 18 *hero of lockinge*

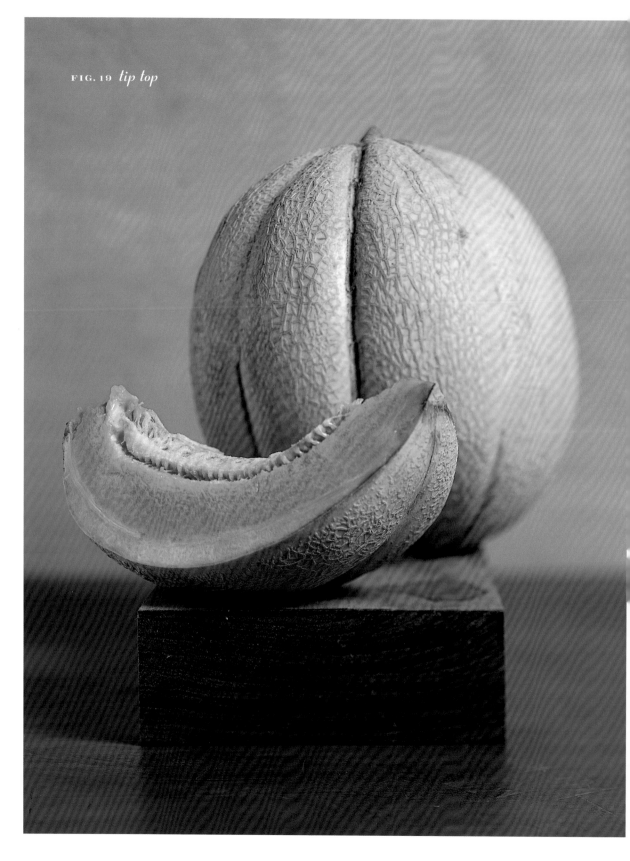

FIG. 19 *tip top*

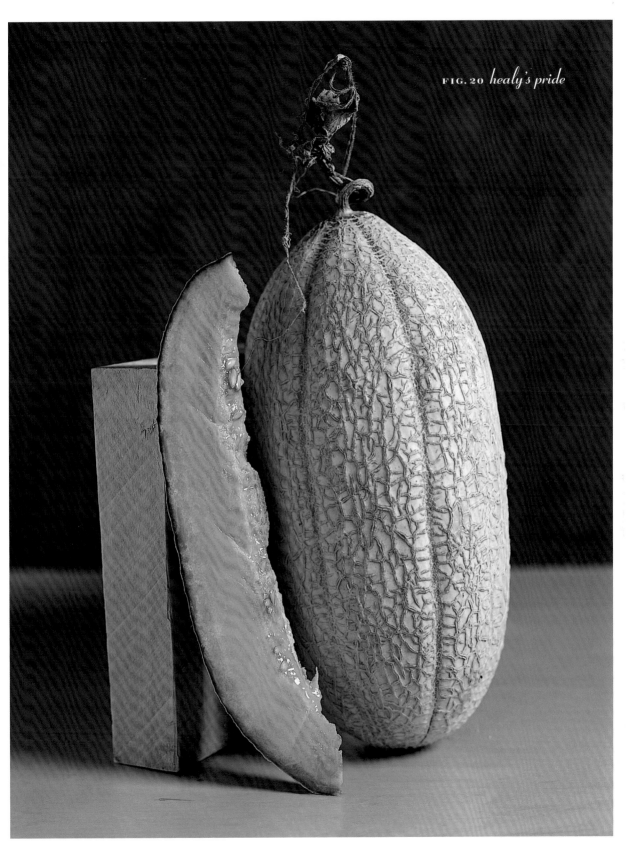

FIG. 20 *healy's pride*

reticulatus

JENNY LIND

This melon was named after "the Swedish Nightingale," Jenny Lind (1820–1887), a coloratura soprano promoted to stardom in the United States during the early 1850s by the prince of showmen, P. T. Barnum. Already a sensation in Europe, Miss Lind bewitched American audiences a hundred times over from New York to Natchez. She was exalted for her voice, piety, and charitable giving; but when she broke her contract with Barnum and married her pianist, the spell broke too.

Although Jenny Lind's glory faded, memorabilia flourished. She was immortalized in song and poetry, and her bust, with bertha collar and brooch, adorned everything from shawls to glass whiskey bottles in the shape of a calabash. The Jenny Lind melon was introduced around 1846, according to her contemporary Dr. Robert P. Harris of Philadelphia, and was probably selected from the old variety called Center, or from an unnamed melon of Armenian origin. It bears a striking resemblance to the Melon de Malte Très Hatif, documented by Pierre-Joseph Jacquin eighteen years before Lind made her American debut.

One of the melon's claims to fame is the "outie" belly button at its blossom end, a bit of whimsy that helped make it a best-seller for fifty years. Burpee's 1907 farm annual touted the button as the best part—a delicious morsel, intensely sweet. I don't know if I buy that, since the nearer the middle the sweeter the melon, but I can and I will wax enthusiastic over Jenny's other fine virtues. This melon is a very early maturer and when given ideal growing conditions the netting is more regular than that pictured here and the flesh is sweeter and more saturated with green. Maybe it's time for Jenny Lind to make a comeback.

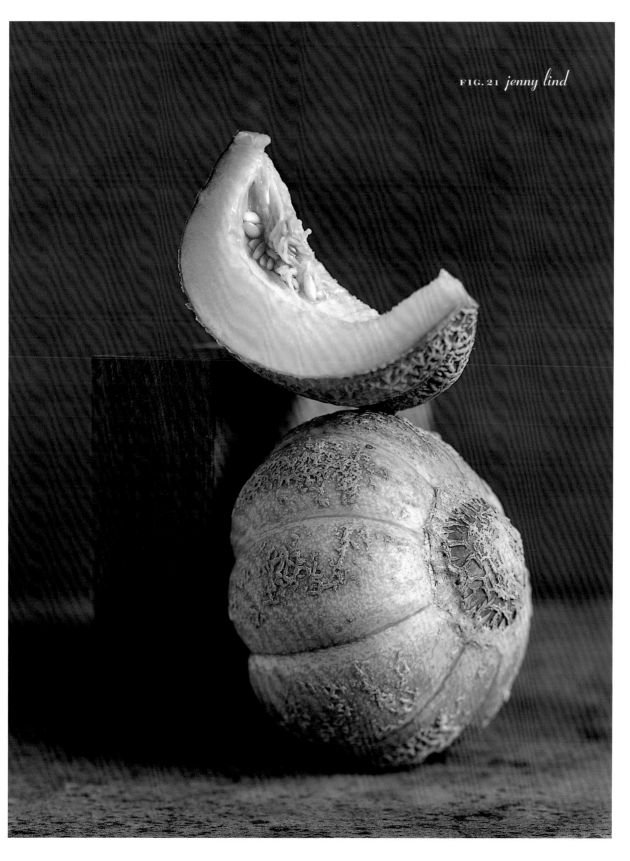

FIG. 21 *jenny lind*

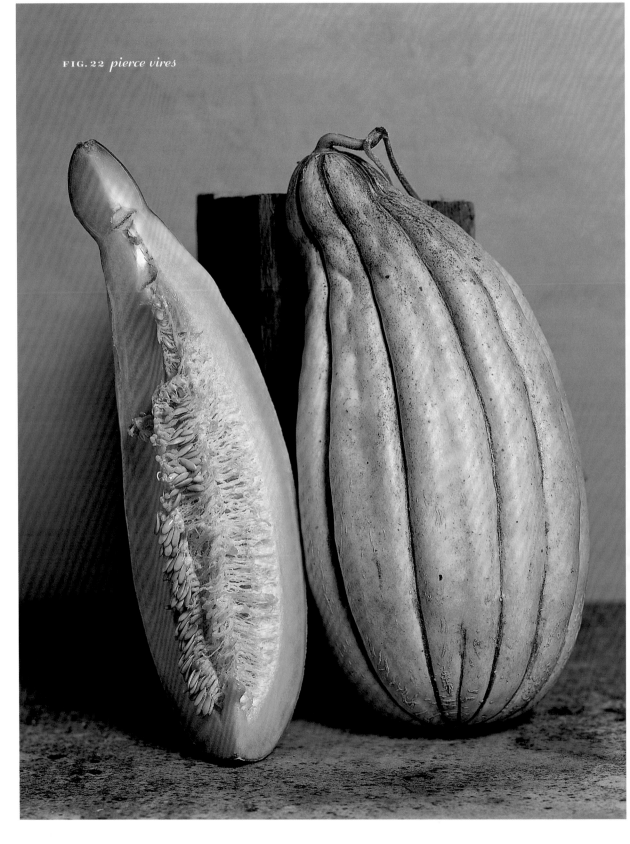

FIG. 22 *pierce vires*

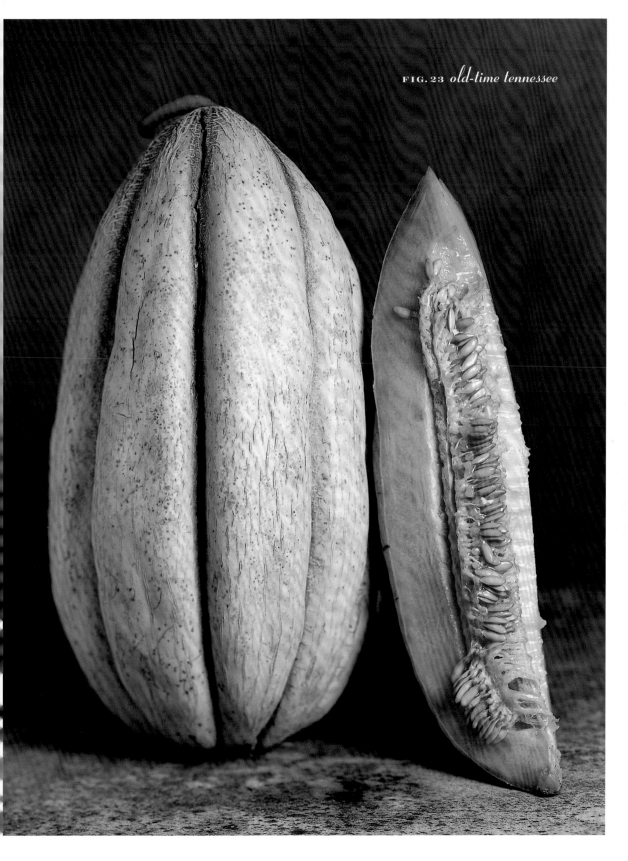

FIG. 23 *old-time tennessee*

reticulatus

BANANA

The Banana seems to defy most people's definition of melons.
Not even vaguely round, it conjures up images of long things such as
loaves and fishes as well as bananas. The melon is elongated and
finely tapered at both ends, just like a banana, but those who say it
tastes and smells like one too are stretching the truth a little. Its taste
is pure melon, and its scent is splendid, like a fine ripe pineapple.

The Banana is a looker and has been pleasing audiences for more
than a hundred years. In 1883, when James Gregory of Marblehead,
Massachusetts, exhibited it at the Essex Agricultural Society's fall
show and created a sensation, most Americans had never even laid
eyes on a banana or plantain. Three years later, banana plants were
shown at the Centennial Exposition in Philadelphia, and only a sentry
could dissuade pilferers from taking home souvenirs. At a recent
Dutchess County Fair exhibit in Rhinebeck, New York, my Banana
melon stopped fairgoers in their tracks.

The Banana does not readily fit into any one category of melon,
sharing features common to three: *reticulatus, cantalupensis,*
and *flexuosus.* The authors of *The Vegetables of New York* (1937) noted
that the Banana is "rather unique" and intermediate between the
muskmelons and the Snake melons. Their physical descriptions still
hold, although the Banana, split, we see here is a bit more zaftig.
Some specimens have longitudinal netting or deep sutures or seams
and prominent ribs; in others those traits are completely lacking.
Whatever its cosmetic variations, it's easy to understand why the
Banana has always been a crowd pleaser.

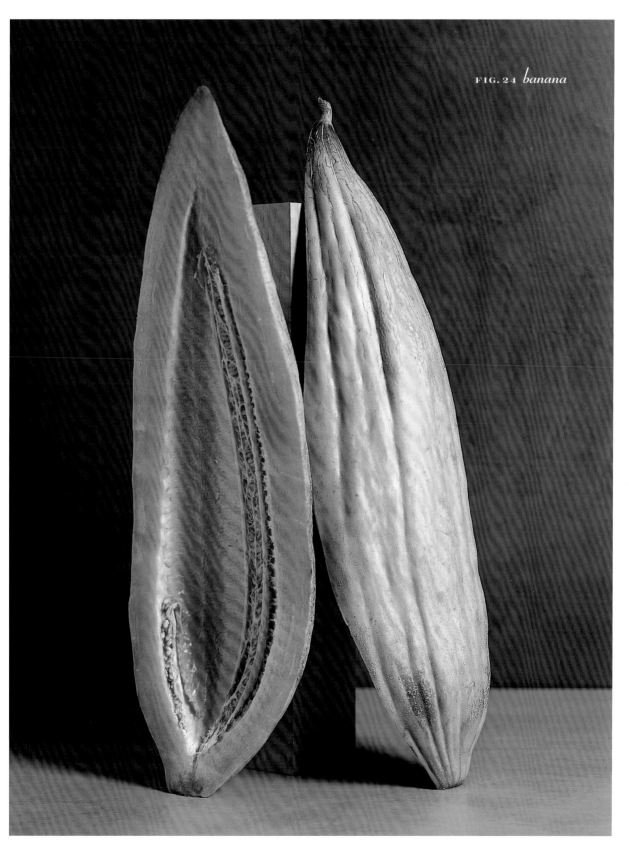

FIG. 24 *banana*

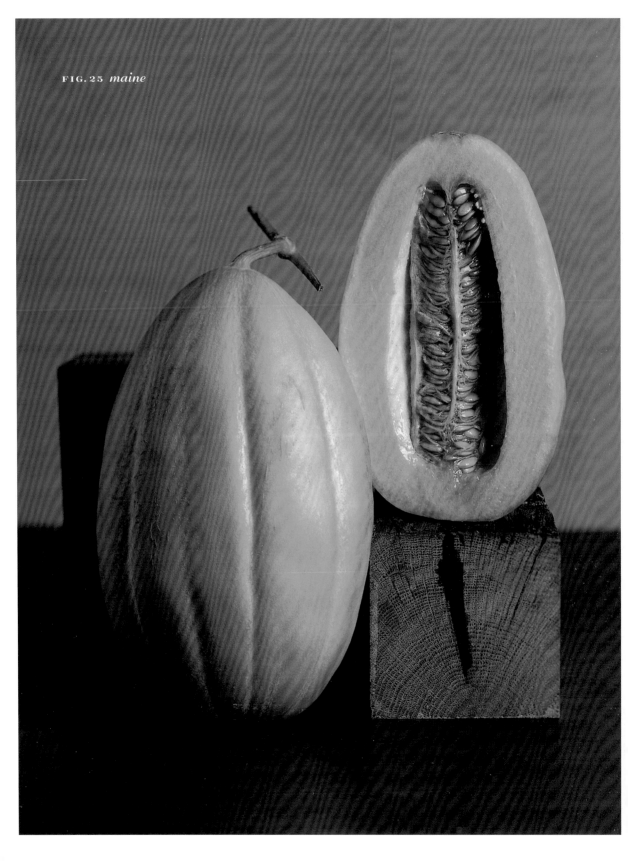

FIG. 25 *maine*

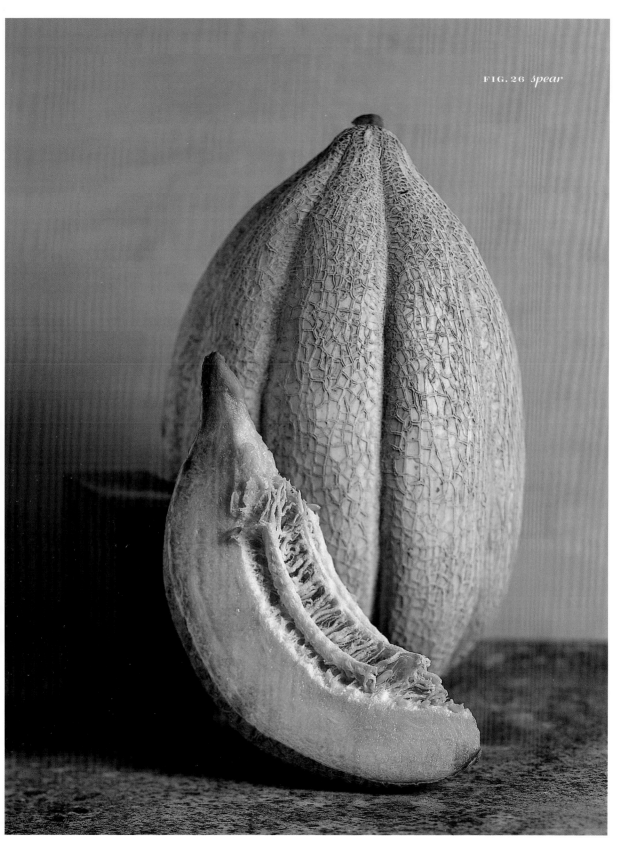

FIG. 26 *Spear*

reticulatus

FORDHOOK GEM

A rush of superlatives comes to mind when I envision Fordhook Gem. This is a melon that's easy to love. Looks, taste, and pedigree combine to make it the winningest. Green-fleshed muskmelons were once the rage, but they've been supplanted by orange melons designed for the long haul. What a pity. As our grandparents knew, better than we do, the green has no musk and tastes sweeter. Fordhook's green flesh, encased in silvery filigree, varies between shades of sea foam and growing grass, with a salmon lining for emphasis. Your eyes conjure melting, sugary, peachlike flavors. Your nose discovers Riesling. This Gem is dessert material; lime juice is optional.

The Fordhook Gem belongs to a class of muskmelon known as nutmeg. Its shape, netting, and aroma mimic the seed of that evergreen tree (*Myristica fragrans*). It may actually descend from a melon known as Nutmeg or from the similar Pineapple; both were well-known European types grown in the United States prior to 1850.

Introduced by Burpee in 1967, and named for the family farm, Fordhook Gem is a cross between two noteworthy heritage varieties. Netted Gem, an 1881 Burpee introduction, is the celebrity parent. Considered the most important melon of its time, it was the progenitor of the Rocky Ford melons and the basis for the modern muskmelon industry. The other parent was Extra Early Knight, quite possibly a large-fruited selection from Netted Gem. Extra Early Knight was first offered by George Tait in 1908, but its popularity was limited to the Chesapeake Bay area.

Fordhook Gem combines the best of both parents, which were similar in appearance, flavor, and earliness. It owes its nutmeg shape to Extra Early Knight and its prodigious output and thicker rind to Netted Gem. Fordhook Gem is no longer available commercially. It would be a shame to let this jewel of a melon join the ranks of the extinct.

FIG. 27 *fordhook gem*

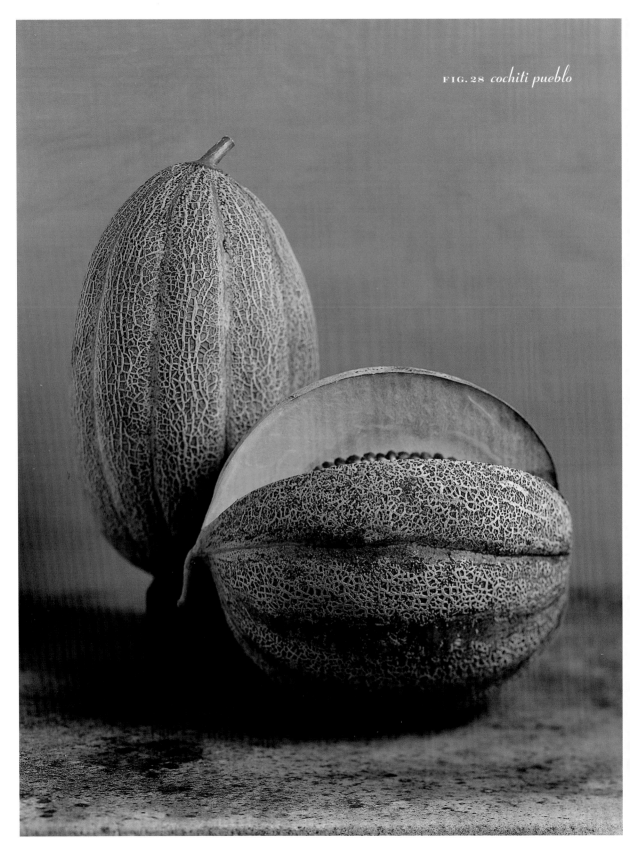

FIG. 28 *cochiti pueblo*

FIG. 29 *hollybrook luscious*

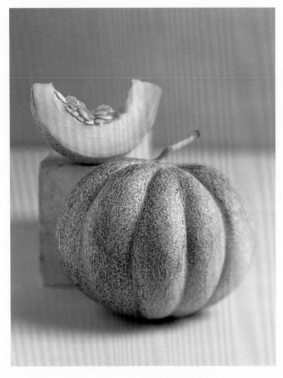

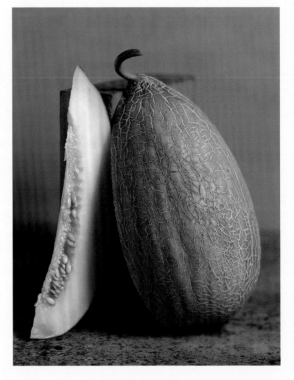

FIG. 30 *vert grimpant*

FIG. 31 *ananas*

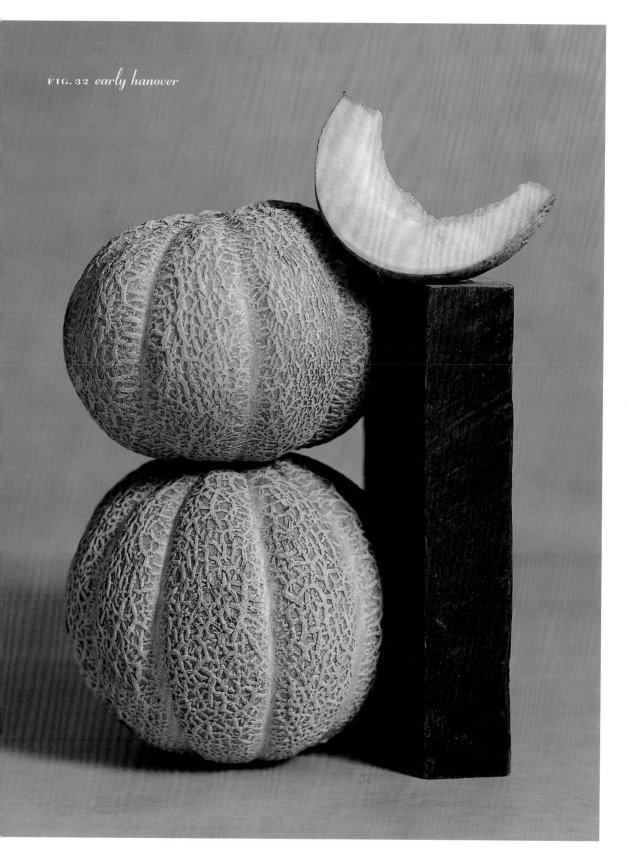

FIG. 32 *early hanover*

reticulatus

EMERALD GEM

Washington Atlee Burpee (who preferred to be known as W.) introduced Emerald Gem to the public in 1886 with justifiable pride. He penned copy for his mail-order seed catalogs in longhand by the light of a coal-oil lamp. "Sweet and luscious beyond description," he wrote, and the melon became the most popular variety of its time.

Emerald Gem is what might be called a happy accident. William G. Voorhees of Benzie County, Michigan, discovered the melon, a mutant, or natural hybrid. He sent the seed to Burpee, who had a reputation for paying top dollar, and, presumably, money changed hands.

In those days, farmers and gardeners were more active than seedsmen in selecting and developing new varieties. The old-time practical breeders didn't attempt to control pollination, but like their forebears, they were careful observers and saved seed from genetic accidents.

W. knew well the cardinal rule: Save your best for seed. Applying lessons learned in his youth as a renowned breeder of pedigreed fowl, he excoriated those seedsmen who cut and marketed melon seed from rejects while selling short the most excellent for fresh eating. This was an all too common practice at the time, and it was, of course, self-defeating; seeds from inferior stock beget inferior stock.

The Emerald Gem needs to be homegrown, because its rich, musky flesh is too perishable for commerce. It matures late in the summer, in sync with Rocky Ford, in my garden. The unripe skin is emerald green, hence the name; as it ripens, it turns yellow and brownish. Cut in half, a sliver of emerald remaining, it's the perfect vehicle for a scoop of vanilla ice cream.

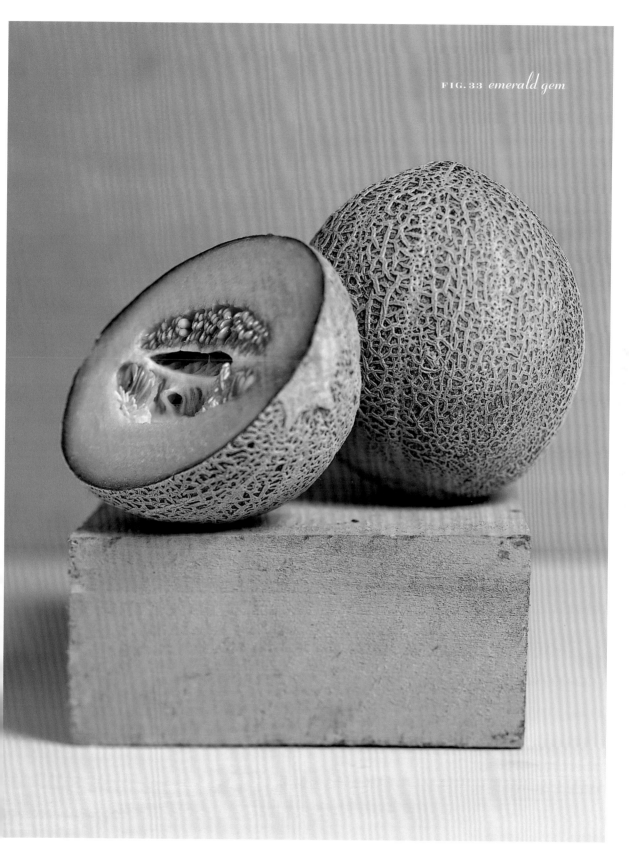

FIG. 33 *emerald gem*

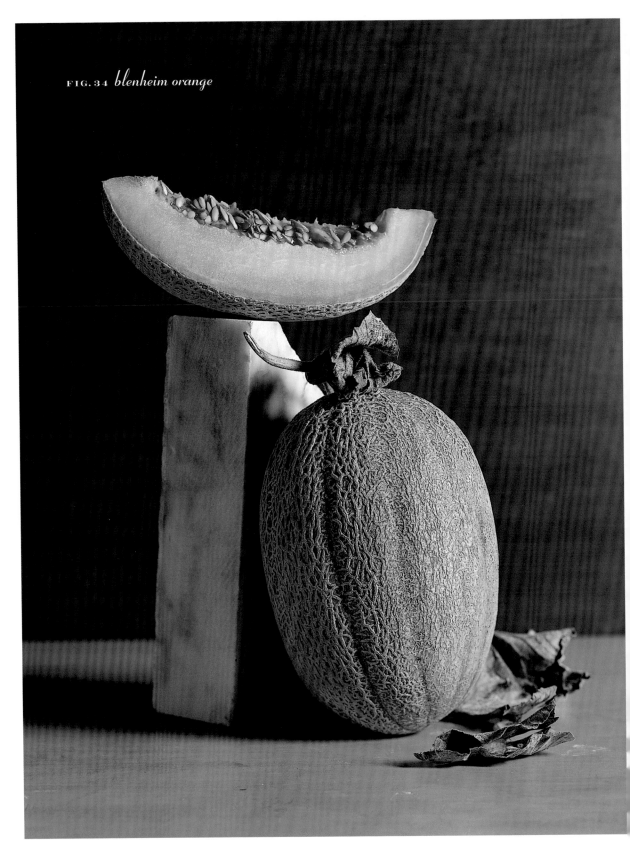

FIG. 34 *blenheim orange*

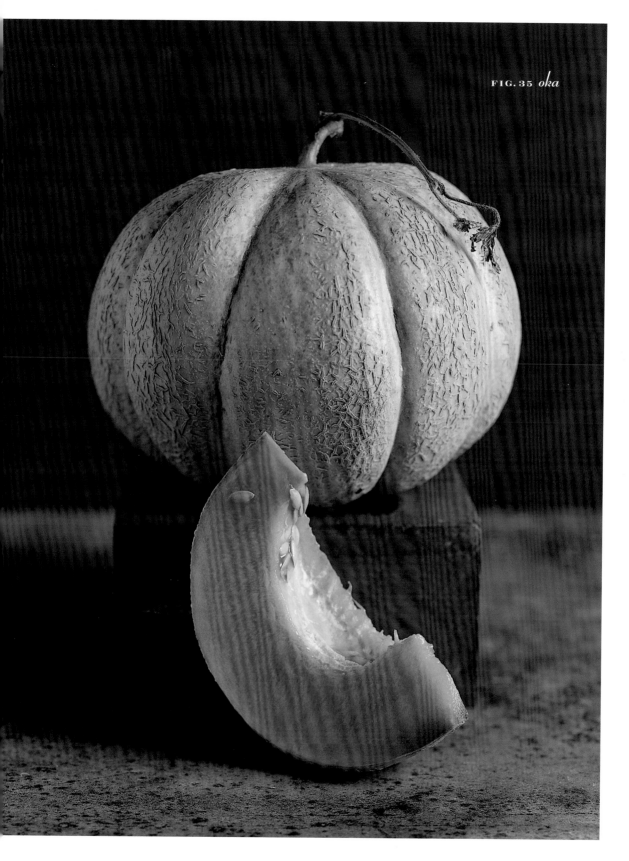

FIG. 35 *oka*

reticulatus

ANNE ARUNDEL

When the Anne Arundel melon made its commercial debut a little more than one hundred years ago (introduced by Griffith and Turner of Baltimore, 1890), it was already known to the denizens of Anne Arundel County in Maryland. Both the melon and the place where it grew were named in honor of Countess Anne Arundell of Wardour (circa 1610–1649). Anne became Lady Baltimore after marrying Cecil Calvert, the first Lord Proprietor of the Maryland Colony.

Tobacco was the main crop in the Chesapeake colonies until the Civil War. When slavery ended, farmers diversified and Anne Arundel County became the nation's strawberry capital. Muskmelons were grown in private gardens and didn't appear much in the marketplace until after 1870. Starting with improved nutmeg melon or muskmelon varieties, such as Burpee's Netted Gem (1881) and Landreth's Baltimore Market or Acme (1884), these melons were then more widely grown and shipped farther afield.

The precise origin of the Anne Arundel melon is lost to history. For all we know, it might have been carried to Maryland in 1649 by the first European settlers bound for Anne Arundel County aboard the *Ark* or the *Dove;* it could have been grown even earlier by the Algonquin tribes along the Patuxent river. Elsewhere in Maryland, muskmelons were purportedly grown by the first settlers, according to *A Relation of Maryland,* published in London in 1635.

Although some experts say that Anne Arundels are typically smooth-skinned and sparsely netted, I disagree. According to descriptions in *The Vegetables of New York* (1937), a photograph in Johnson & Stokes's 1899 garden and farm manual, and my own experience growing Anne Arundels from the collection of Seed Savers Exchange, the melon has uniformly interlaced webbing. Perhaps it's not surprising that its history raises questions; farmers stopped growing it in the early twentieth century, and replaced it with other varieties.

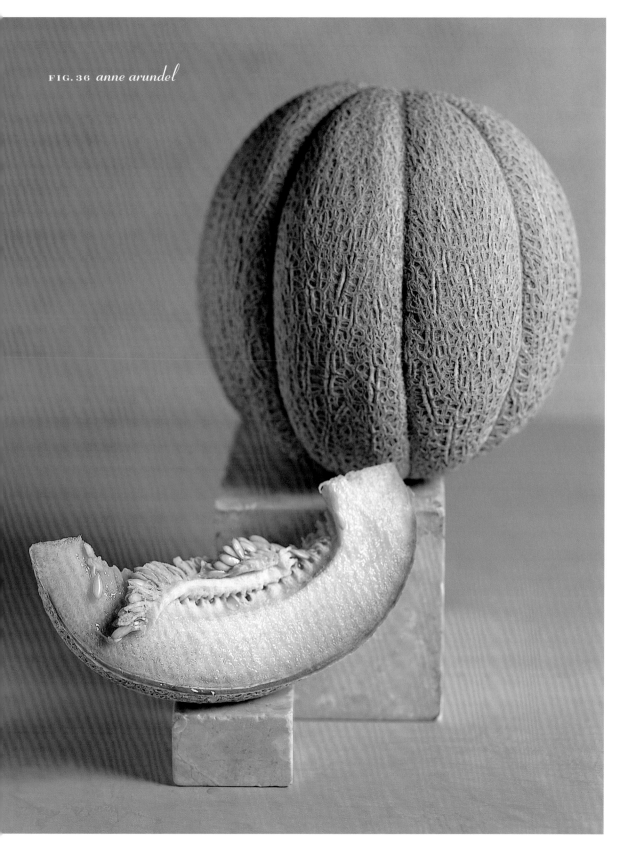

FIG. 36 *anne arundel*

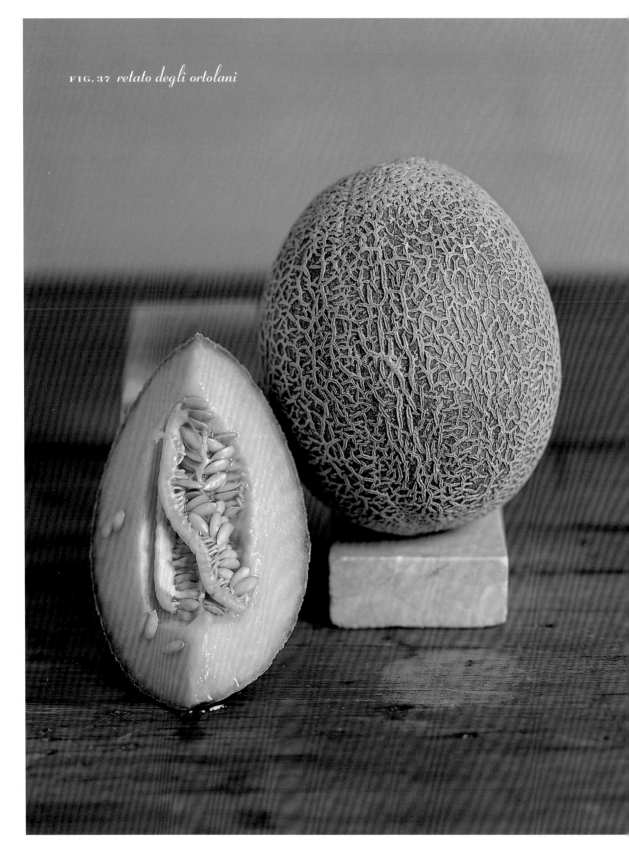

FIG. 37 *retato degli ortolani*

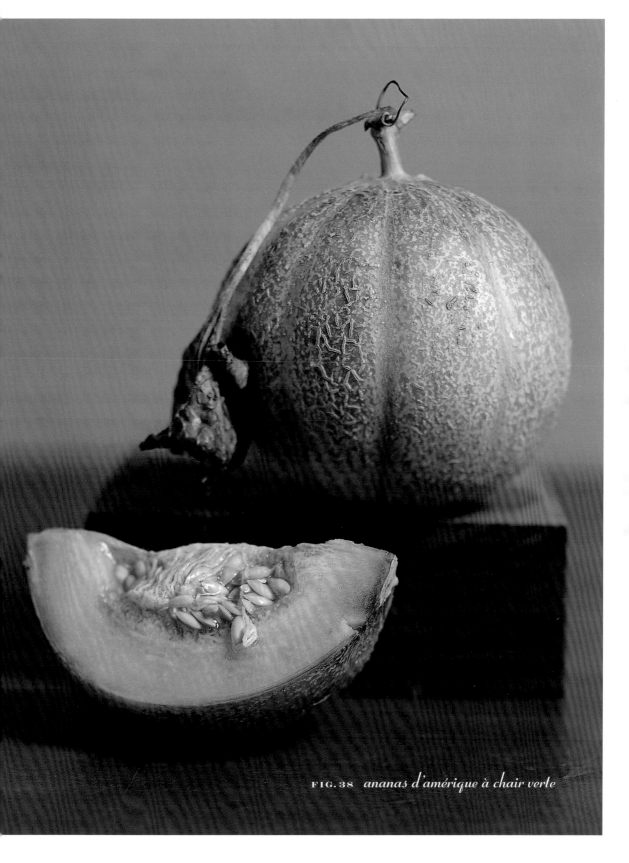

FIG. 38 *ananas d'amérique à chair verte*

reticulatus

SCHOON'S HARD SHELL

Schoon's Hard Shell is an excellent melon for eating. I eagerly watch it mature on the vine as it changes from celadon green to warm ivory. Introduced around 1947 by F. H. Woodruff and Sons of Milford, Connecticut, it has a fine flavor and aroma that last long after harvest. The handsome hard shell, interwoven willy-nilly with ropelike netting, sets it apart from other muskmelons. These qualities, plus the plant's vigor, make it ideal for commercial production.

Schoon's never obtained a wide following. Or did it? Point for point, it is a dead ringer for the Bender melon, which in the 1930s was the number one melon grown in New York State for local markets and short-haul shipping. The parallels are striking enough for me to surmise that Schoon's (also tellingly known as the New Yorker) has Bender in its blood. There were many names for and strains of Bender; Schoon's may have been one of those variants.

Not far from where I live now, at the foot of the Helderberg Mountains near Albany, New York, in a place where Schoon is a common last name, Charles Bender began growing melons in 1884. Using three muskmelon varieties—Surprise (introduced 1876), Irondequoit (1889), and Tip Top (1892), all descended from Sill's Hybrid (1870)—he bred a melon with the best qualities of each. He named the resulting variety for himself in 1900. It was a melon earlier in maturity than Surprise, more heavily netted, and less susceptible to cracking than the other two. Its parents were noted for flavor, but I'm sure that Schoon's surpasses them all. It will always have a place in my pantheon of melons.

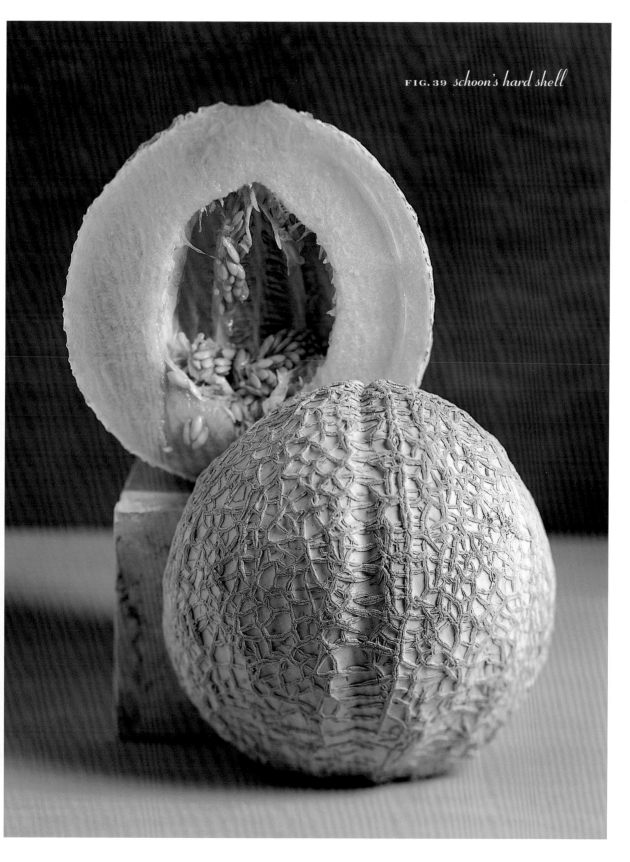

FIG. 39 *schoon's hard shell*

INODORUS

Inodorus: Winter Melons: Canary, Casaba, Crenshaw, and Honeydew.
Honeydew's popularity is well earned, but it need not be the only
winter melon we adore. Winter melons, bigger than most, take longer
to grow and often cost more—but they're worth it. What they lack in
fragrance, as the name *inodorus* implies, they more than make up for
in sweetness. The firm juicy flesh is most often white or green, but
can even be tricolored like Amarillo Oro's. The hard rinds, which
may be smooth or wrinkled, help preserve them until winter arrives.
Crenshaws, such as Crane and Sweet Freckles, are traditionally
included, but they are the most perishable of the lot. Spanish melons
are well represented in this group, as are melons from Turkey all
the way to Turkmenistan. Knowing how to judge a ripe one is an art.

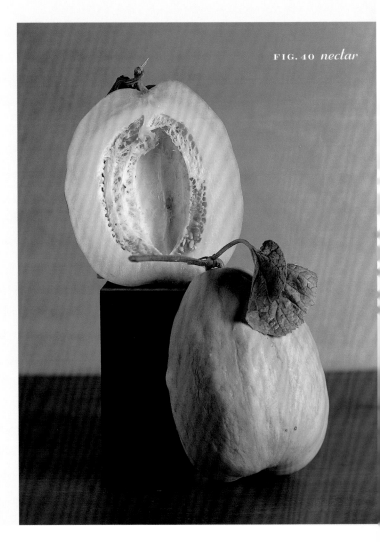

FIG. 40 *nectar*

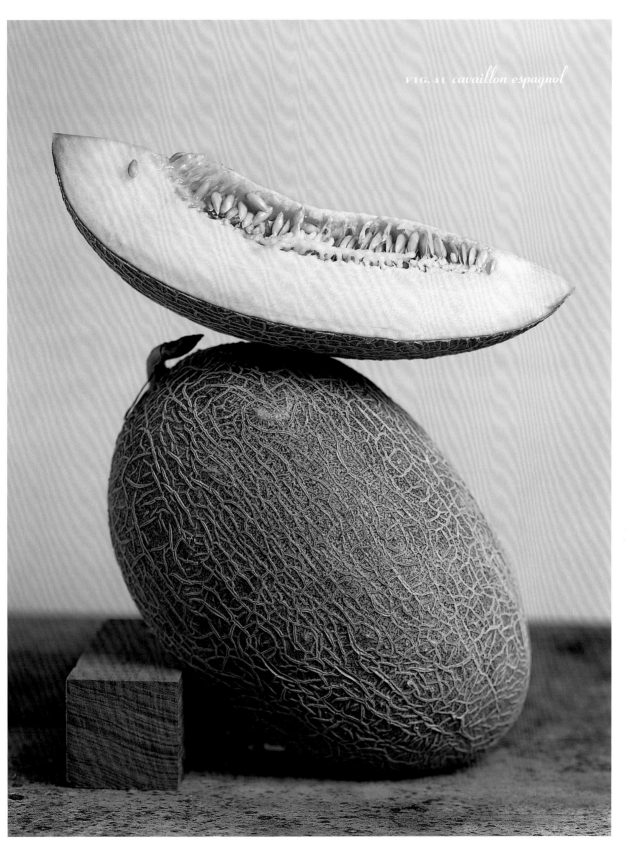

FIG. 41 *cavaillon espagnol*

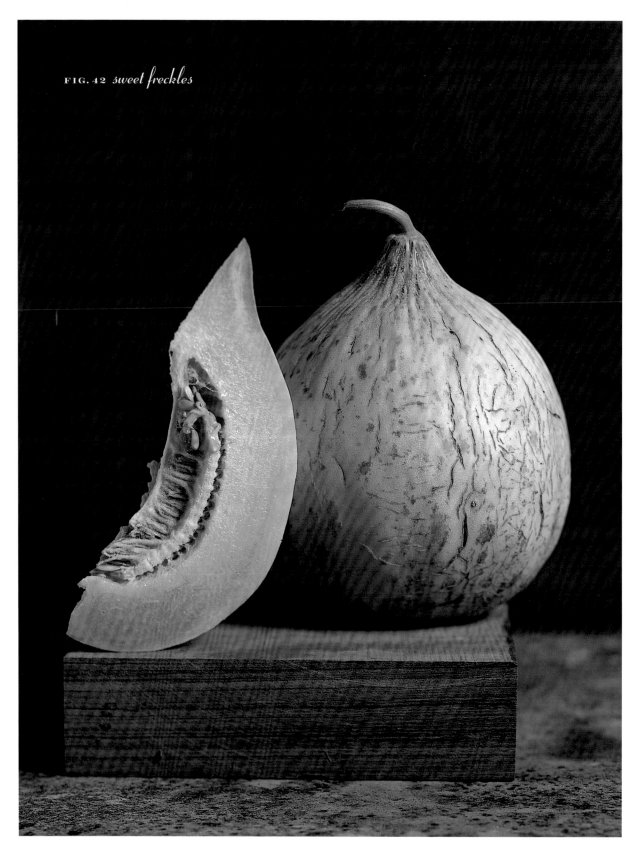

FIG. 42 *sweet freckles*

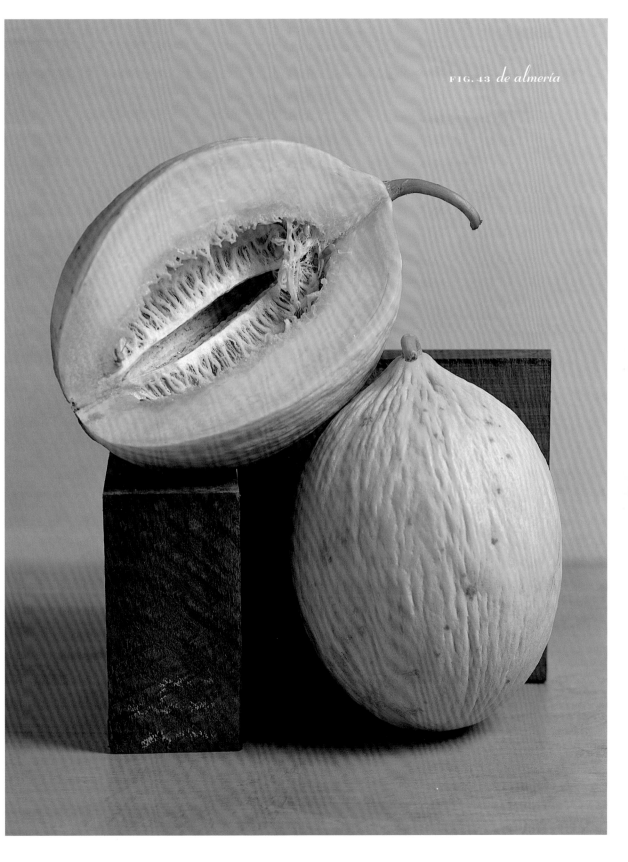

FIG. 43 *de almería*

inodorus

ORANGE-FLESHED HONEYDEW

Who's the sweetest of them all? Many say Honeydew. Originally known as Melon d'Antibes Blanc d'Hiver (White Antibes Winter), this melon has delighted connoisseurs for at least a century. None was more agreeable or pleasing to the senses among the dozens cited in an anthology by Vilmorin-Andrieux (1891). Modern-day measures of sugar content confirm—with refractometer readings of up to 16 degrees Brix—that Honeydew has few peers.

Grown for decades in the Midi of France near Antibes and in Algeria for export, White Antibes Winter has the ability to retain its goodness for several months. One of these melons found its way onto the menu at a fashionable New York hotel in 1911. A dinner guest was so besotted that he saved the seed and sent it to Melodew breeder John E. Gauger in Swink, Colorado, to grow. The melon was identified as White Antibes Winter by Dr. Shoemaker of the USDA, and, in 1915, Mr. Gauger aptly renamed it Honeydew.

Honeydew quickly became America's most popular winter melon, a position it still holds today. Most Honeydew is green fleshed, but the Orange's star is rising. If asked to choose between them, I'd be stumped. In 1929, the Aggeler and Musser Seed Company thought the Orange positively more delicious; its color, character, and caratenoids came from a liaison with Tip Top, a leading variety of muskmelon at the time.

We've all tasted Honeydew that was less than honeyed. For a fruit of this caliber, that's almost a sin. The fault lies not with the melon but with the way it is grown. If it's left on the vine to catch the last surge of sucrose and not gassed with ethylene, then the melon will truly earn its name.

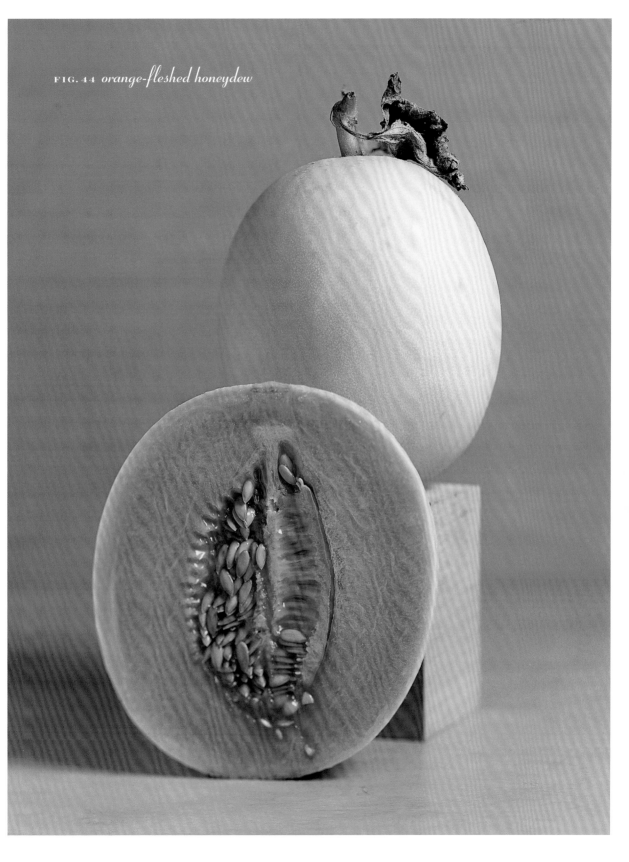

FIG. 44 *orange-fleshed honeydew*

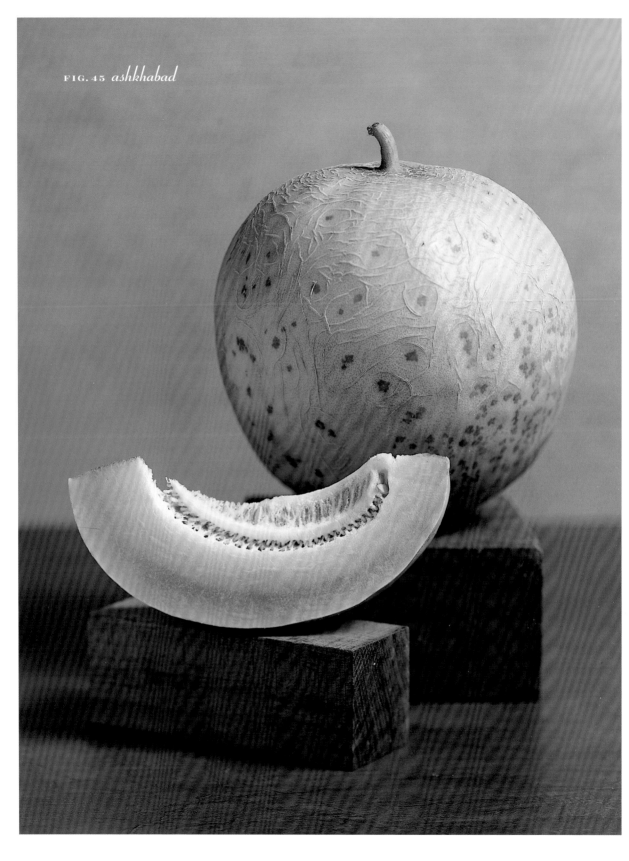

FIG. 45 *ashkhabad*

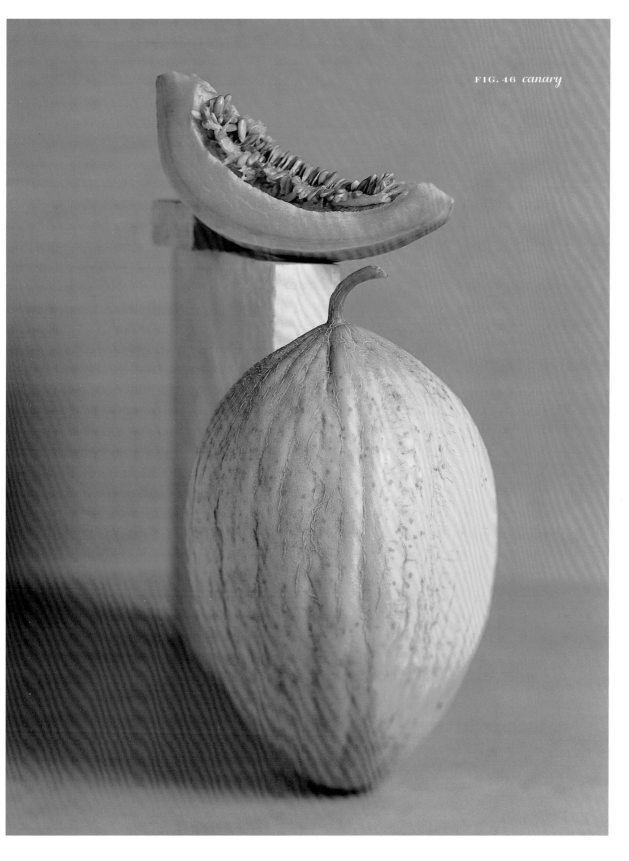

FIG. 46 *canary*

inodorus

CRANE

The Crane melon speaks volumes about the land and people who fostered it. Over the course of 150 years, six generations of Cranes have farmed the black adobe soil of Santa Rosa, California. Oliver Crane introduced the melon in the 1920s; his descendants are dedicated to growing and preserving this family heirloom. The family has resisted development pressures on what is now prime Sonoma county real estate and set aside one hundred acres for growing the melon. They apparently agree with their old friend and neighbor, Luther Burbank, who said, "This is the chosen spot of all this earth as far as nature is concerned."

Oliver Crane hoped to produce "the perfect melon," according to his great-grandson Richard, by crossing a number of favorite varieties. Although Oliver left no records, one of the varieties might well have been the Japanese melon. Popular in the local markets of California at the time, this melon was similar in many respects to the Crane, and was itself an apparent cross of Persian and Golden Beauty Casaba. Written on the face of the Crane are the netting of the Persian, the blotches of the Japanese, and the pear shape of the Casaba. The Crane is known today as a Crenshaw (or Cranshaw).

The Crane is a rare commodity in a world filled with colorless, odorless, and tasteless melon. It is everything the mass market will not allow. Fragile and short-lived, it's bred to taste good—an almost revolutionary concept. "The sad part today is, most people don't know how good a melon can be," Mr. Crane says. The locals in Sonoma know. They come from miles around to shop at the Crane Melon Barn on Petaluma Hill Road. We should all be so lucky.

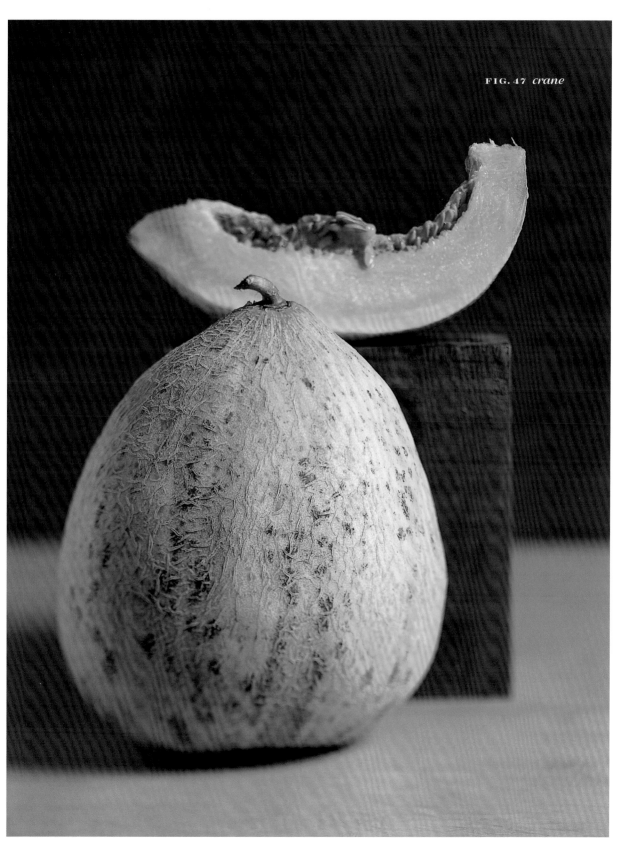

FIG. 47 *crane*

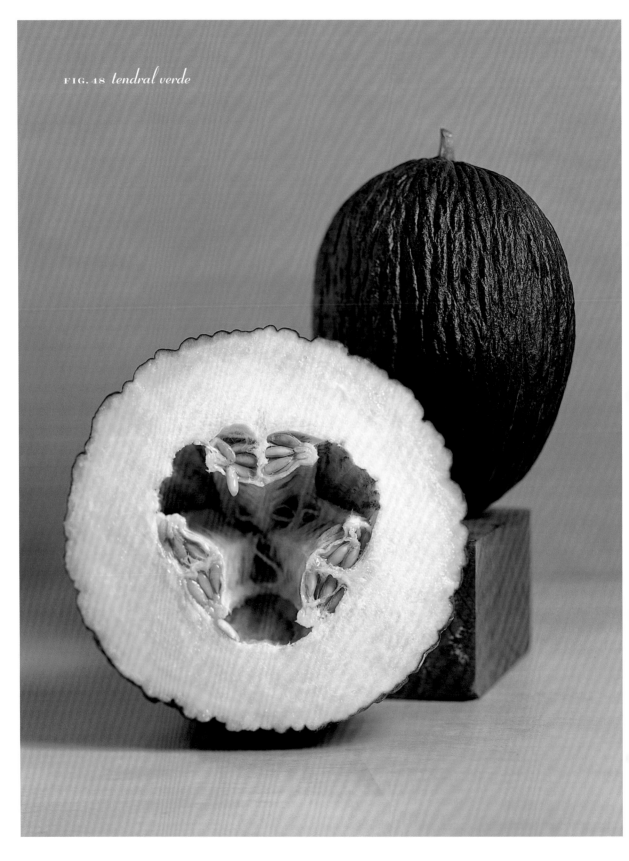

FIG. 48 *tendral verde*

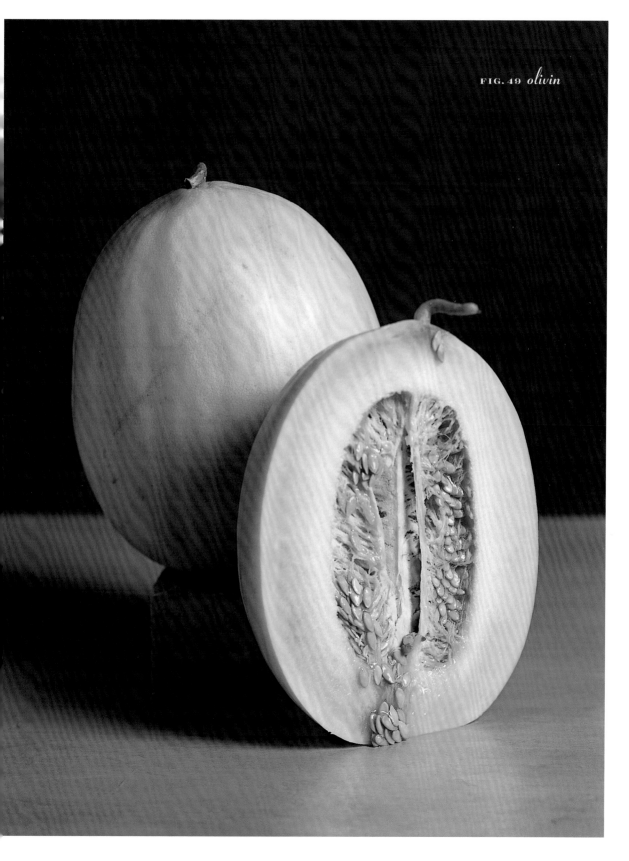

FIG. 49 *olivin*

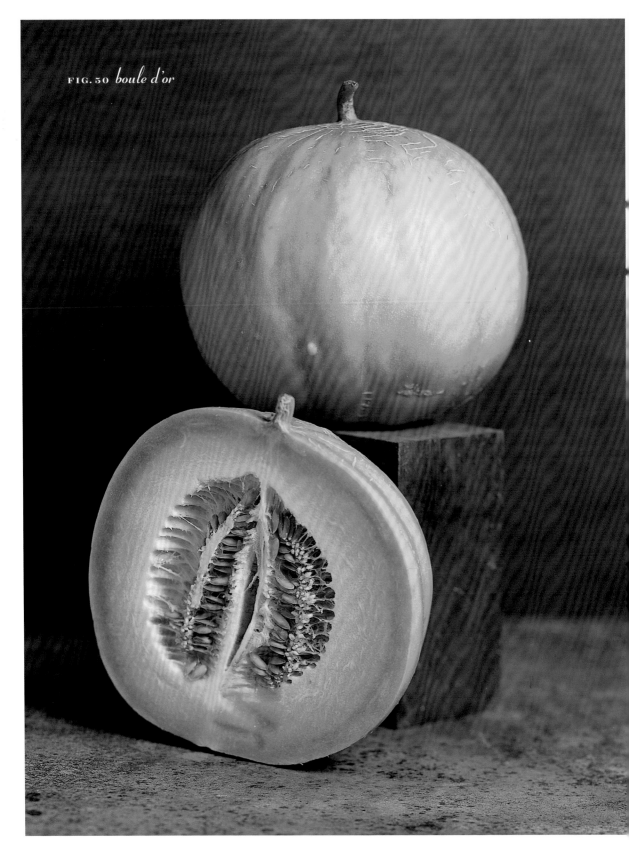

FIG. 50 *boule d'or*

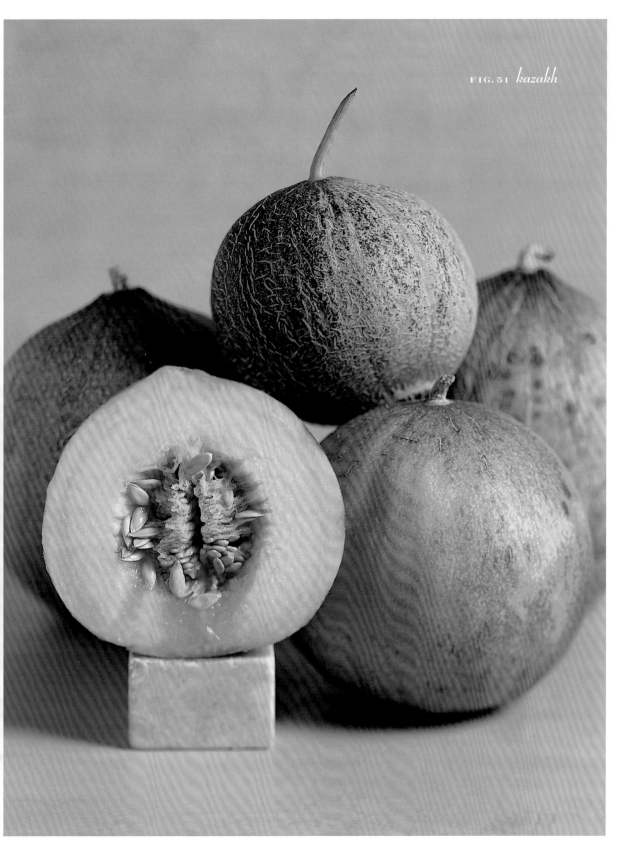

FIG. 51 *kazakh*

inodorus

SANTA CLAUS

The Santa Claus is a keeper. Not only decorative but delicious, it holds its quality for months, long after the melons of summer are gone, and with a bit of luck it will still be around in December to grace your holiday table. Rough-skinned winter melons such as Santa Claus are known as casabas. They can be oval or pear-shaped (and larger than the specimen pictured here), with green or white flesh. Their most distinguishing feature is wrinkles. Santa Claus is typically bicolored, embossed with green blotches on bright yellow skin.

The light green Winter Pineapple was the prototype of casaba in America, introduced in 1878 by Messrs. Stillman and Flood. The Pineapple (offered by Peter Henderson and Company in 1893) was two-toned, but unlike Santa Claus, the yellow segregated to the bottom and the green to the top. Santa Claus, also known as Christmas melon, has always been of secondary importance in the casaba trade despite attempts to popularize it with a catchy name. Coarse and barrel-shaped like a true pineapple (*Ananas comosus*), not pot-bellied like the "jolly old elf," "Santa Claus" is something of a misnomer.

Casaba is native to Turkey, the ancient cradle of many food crops. Relatives of lentil and chickpea, spontaneous barley, and wheats such as einkorn and emmer can still be found there in the wild. Casaba hails from the fertile valley of the Gediz River, which runs to the Aegean through former Ionian lands. In places such as this, along the Tigris and Euphrates, growers plant melon in the tried-and-true way. After floodwaters recede and it's hot enough, they dig deep holes in the sand by the wayside and top them off with pigeon dung. It's not easy to duplicate these ideal growing conditions. What casaba needs most is the luxury of time on the vine.

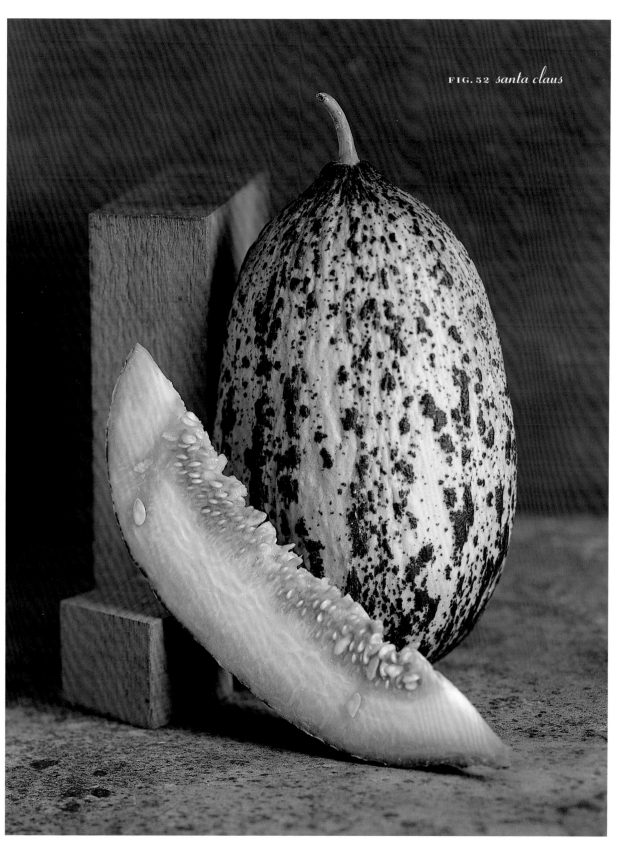

FIG. 52 *santa claus*

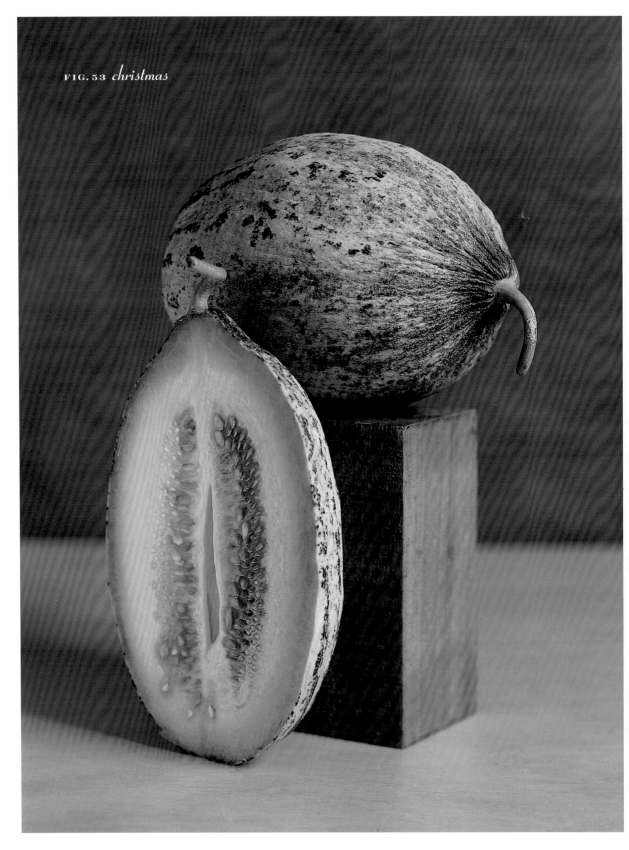

FIG. 53 *christmas*

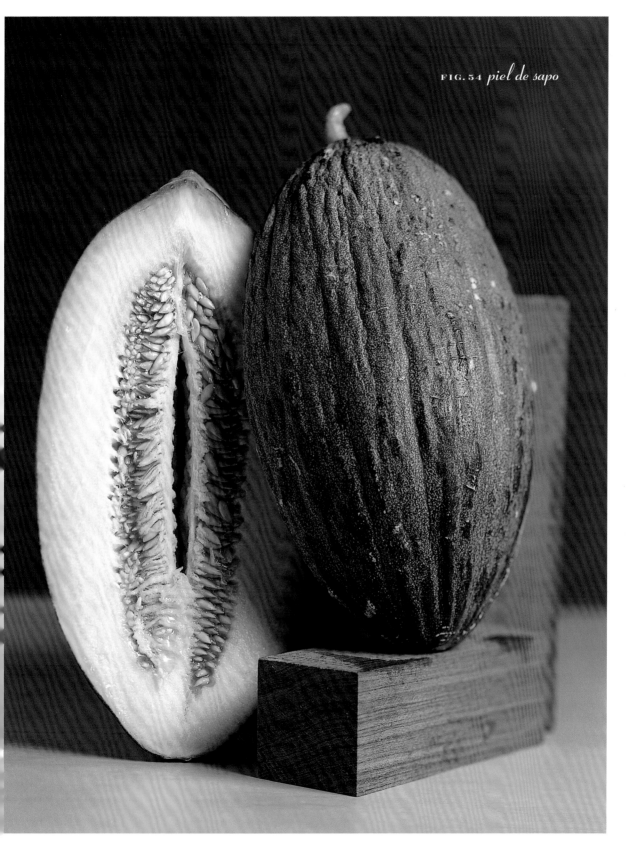

FIG. 54 *piel de sapo*

inodorus

AMARILLO ORO

There are lots of good melons; Amarillo Oro is a great one. I always hesitate a little before cutting it open—the anticipation of biting into its succulent, juicy flesh is almost as enjoyable as actually doing it. Almost. Seeing Amarillo's texture and subtle gradations of color, from salmon to white to green, is as fascinating as looking into a kaleidoscope. Tasting it is sheer delight.

No one values Amarillo Oro melon more than the Spanish, who grow it along the Mediterranean, northeast of Gibraltar. Spain is a land blessed with melons in abundance, particularly the *inodorus* canary or casaba types. Spain's melon region, bounded by Almería and Valencia, is covered with miles of plastic mulch and yields tons of Amarillo Oro (as well as Rochet, Piel de Sapo, and Tendral) for export and local markets. Whether it's dusted with powdered ginger, wrapped with Serrano ham or salami, or washed down with Manzanilla sherry, the Amarillo Oro is a melon the Spanish take to heart.

The Romans may have brought melons to Spain two thousand years ago. According to fifth-century church documents in Navarra, melons were used as religious offerings. But by most accounts, the melon first arrived in Spain with the Moors, during their tenure between 711 and 1492. Muslims of mixed Berber and Arab heritage, the Moors also brought sugar, rice, oranges, and saffron, transforming the landscape and the scope of Spanish cuisine. The twelfth-century *Kitab al Filaha,* by Sevillian Ibn al-Awwam, documents melon among the agricultural and arboreal crops cultivated in the Iberian south. Columbus brought melons from Spain to the New World on his second voyage. Their conveyance throughout the Old World and to the New was true Spanish gold— as precious as any doubloon.

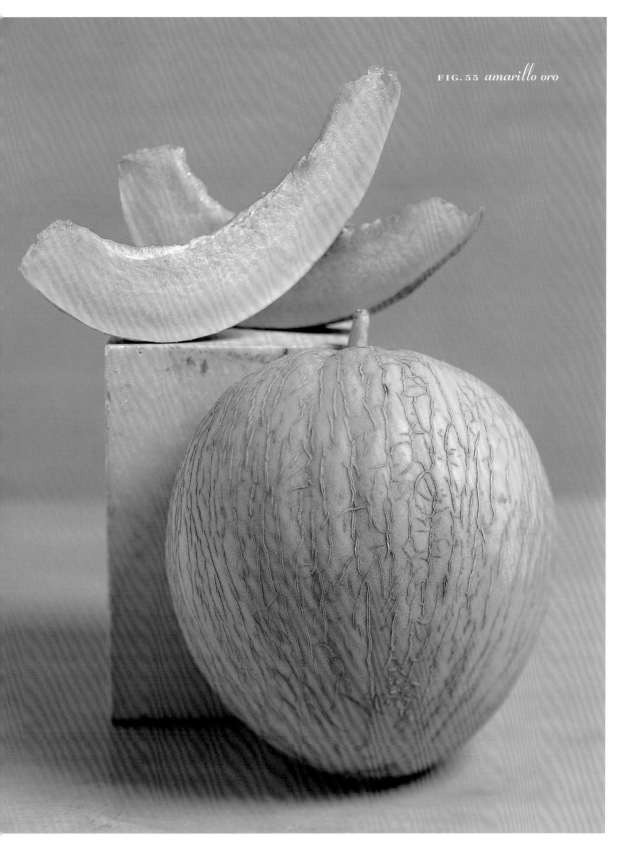

FIG. 55 *amarillo oro*

inodorus

COLLECTIVE FARM WOMAN

Add Collective Farm Woman to your list of must-have melons. The first time I tasted one, I had low expectations. It doesn't look luscious from the outside—in fact, the whole fruit is as hard and dense as a baseball—and gives off only the mildest fragrance when ripe. As with a can of ground coffee, the first clue to its goodness comes when you open it and inhale. It's floral and crunchy and sweet. I gnaw it right down to the nub.

As a winter melon, Collective Farm Woman shares many features with casaba, Honeydew, and Santa Claus. Melons of this kind, belonging to the *inodorus* group, are generally larger, later, and longer-lasting in storage than muskmelons (*reticulatus* group) and have little if any netting. Collective Farm Woman is most akin to Honeydew in appearance, although the skin is waxy (not velvety) and shallowly wavy; what sets it apart from its comrades is smallness and early maturity.

This melon originated in the arable soil of the Ukraine, a soil once bloodied by the purges of Stalin: Millions of farmers and others perished from starvation, mass execution, and exile. When the farms of the Ukraine were collectivized, many traditional food crops were lost, making the taste of this melon both bitter and sweet.

In founding Seed Savers International in the early 1990s, Kent Whealy's goal was to collect plant varieties in danger of extinction in Eastern Europe and the former Soviet Union. The situation was critical because of the influx of Western seeds and agricultural technology. His liaison in Russia was Marina Danilenko, the proprietress of Moscow's first private seed company. As you may have guessed, her source for the melon was none other than a woman from a collective farm.

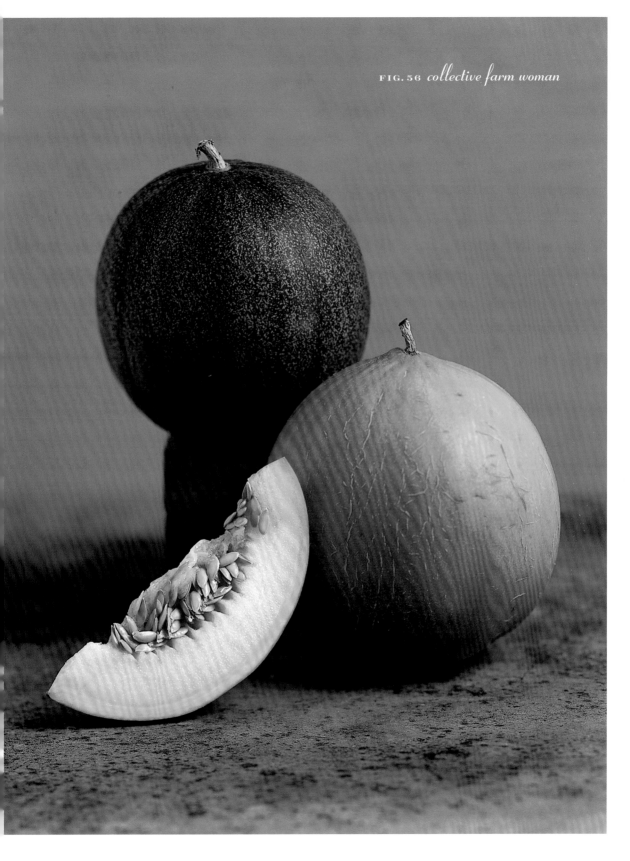

FIG. 56 *collective farm woman*

inodorus

BIDWELL CASABA

The first time I saw a Bidwell Casaba, it nearly took my breath away. As melons go, this one is big. Its tawny, leathery coat has the look and feel of pigskin or perhaps the carapace of a turtle. What's inside tastes like heavenly orange sherbet. With soft, wet flesh similar to a crenshaw, it's much sweeter than an objective measure of its sugar content would indicate.

Like so many things from Chico, California, the melon derives its name from General John Bidwell (1819–1900). This Paul Revere of the Gold Rush trumpeted the news of the mother lode from Sutter's Fort to San Francisco, and he struck it rich himself. He was a general in the Civil War and a U.S. senator, but for our purposes, at least, he is most fondly remembered as the father of the Bidwell Casaba.

Using seeds he had procured from the Department of Agriculture in 1869, Bidwell planted Casaba on his domain in the hot, arid Sacramento Valley. The original melon was purportedly similar to Green Persian and Bay View, not to the wrinkled casabas from Turkey. It has changed in two ways: The netting is gone and the flesh is orange (rather than recessive green). No other grower who was tendered seeds by the USDA succeeded like the general. The melon was his pride and joy, but not everyone concurred. One houseguest, General William Tecumseh Sherman, was exasperated with the menu: "My God, casabas for breakfast, casabas for lunch, casabas for dinner!"

Robert Miller has been guardian of the seed for years, growing the Bidwell to enormous proportions. He is the latest link in a seed chain that leads directly back to Chico: If not for local melon farmers Zea Sonnabend, and Clara and Lowell Stringfellow, now eighty-some years old, there would be no more Bidwell Casaba.

FIG. 57 *bidwell casaba*

CONOMON

Not all melons are designed to be sweet. For Western palates, the *conomon* melons are an acquired taste. This group is made up of two distinct sorts, both Asian in origin. *Conomons* have crisp white flesh and very little, if any, fragrance. The *makuwa uri*, despite some predictions, are in no danger of replacing the apple as a sweet treat since most are bland and have bitter flesh. These are charming and decorative little melons, early and prolific. *Tsuke uri*, which look more like Cocozelles or Marrows (*Cucurbita* spp.), are best used as salt pickles. The Japanese are mad about them.

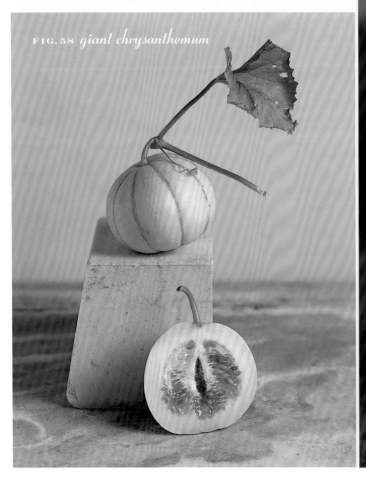

FIG. 58 *giant chrysanthemum*

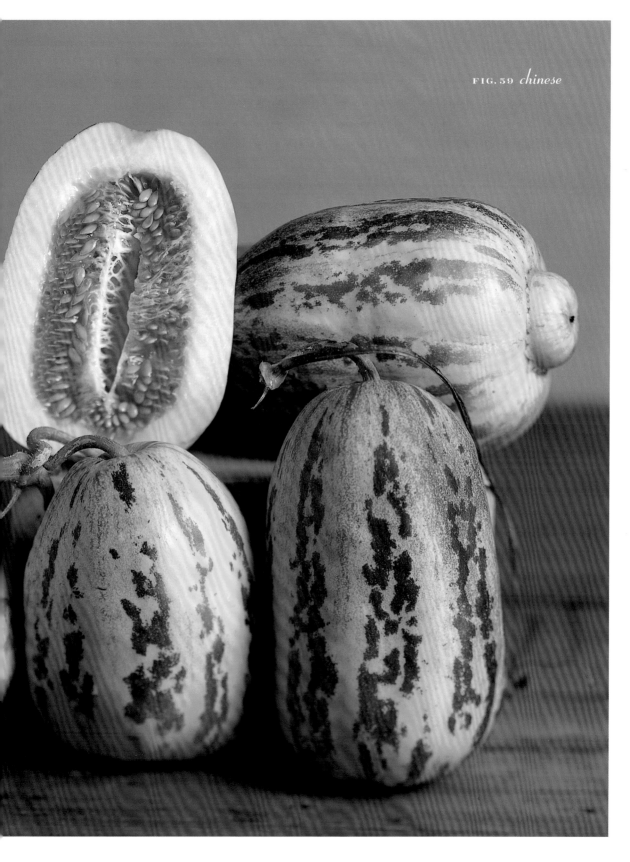

FIG. 59 *chinese*

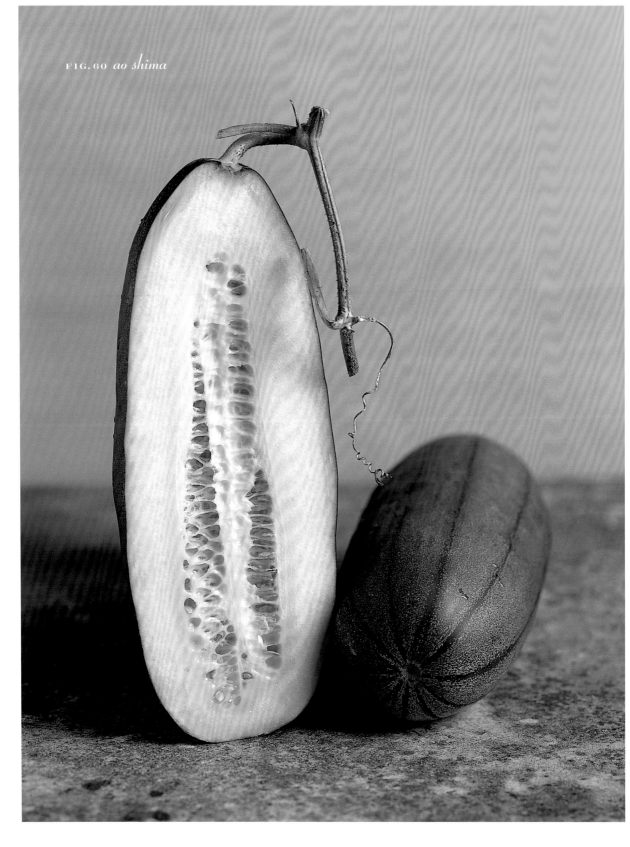

FIG. 60 *ao shima*

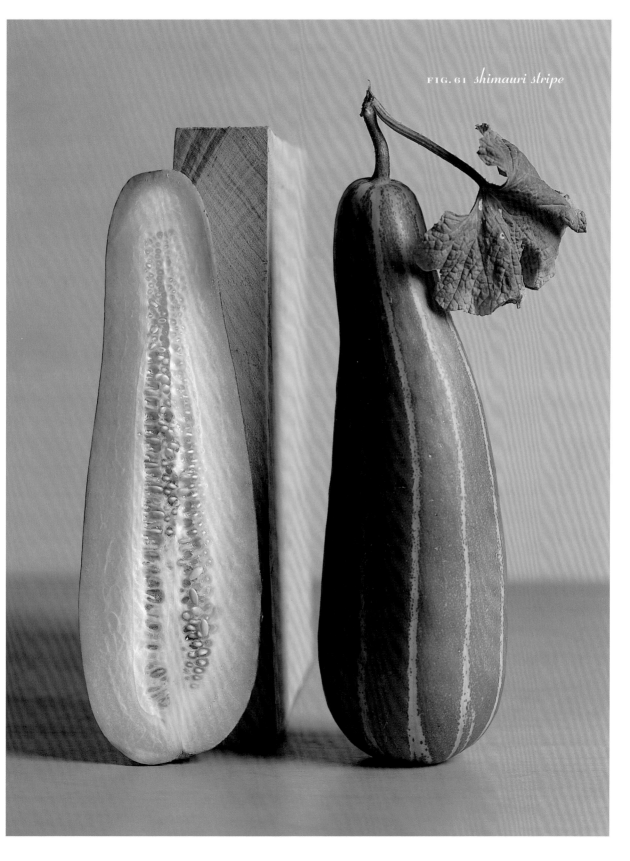

FIG. 61 *shimauri stripe*

KATSURA GIANT

If Americans know the name Katsura at all, it is as a tree native to Japan or an imperial villa in Kyoto. Katsura is also a melon, and it is unlike most we've ever encountered. It passes easily for squash or cucumber. Paillieux and Bois (*Le Potager d'un curieux,* 1892), who made a point of cultivating exotic comestibles in France, didn't quite know what to make of this sort of melon, either. So they cut it in rondelles, fried it, and made beignets. Had they established their garden in the American South, they would have called them fritters.

Katsura Giant is an Asian pickling melon that belongs to the *conomon* group. This type of melon probably originated in China and Japan; it was first noted in Chinese literature in 560. The fruits are smooth, generally oblong, and come in white, green, or stripes. They, too, are unpalatable raw, but make a fine pickle. The Japanese know the melon as *uri* and the pickles as *tsukemono* or *koko*. The name *conomon* is likely a play on the words *koko no mono,* which translates as "material for making *koko*."

Pickles are a big deal in Japan—not an afterthought, as they are in the West. No meal is complete without them. For centuries, the Japanese have pickled everything in sight: from roots to shoots, and flowers to seeds. Visit any Tokyo food emporium or small-town covered market and you'll smell and see the pungent and dazzling *tsukemono*.

Pickles increase the appetite and delight the palate; they provide fiber as well as lactobacilli and friendly flora to enhance digestion. To make *koko*, don't use vinegar—*uri* is traditionally salt-pressed. After the melon is deseeded and sliced, salt it well and place it in a pickling pot. Crown it with a wooden pressing lid with heavy stones on top, and let the melon form its own brine.

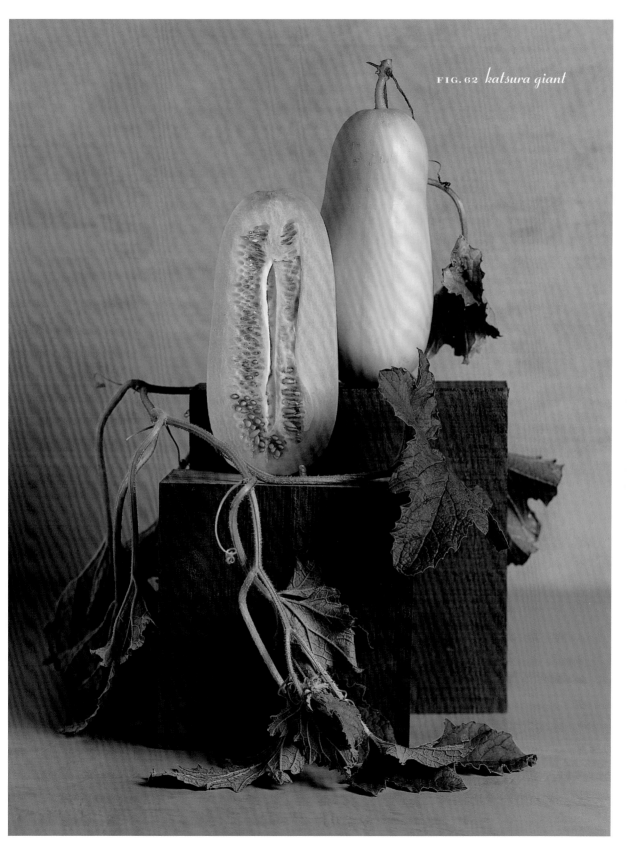

FIG. 62 *katsura giant*

SAKATA'S SWEET

Melons like Sakata's Sweet are new on the American scene, but in the Far East they've been known for thousands of years. According to Japanese scholar Noriyuki Fujishita, they probably originated in the Manchuria area of China and traveled to Japan through Korea. The melons are small and crisp and sometimes eaten with their rinds, and they are still very popular in Korea.

Archaeological evidence suggests that melon has been mainstream in China since 3000 B.C.; today that country leads the world in melon (and watermelon) production. There are two types of *conomon* melons: the sweeter ones, including Sakata's, called *makuwa uri* in Japanese; and the bland pickling sorts called *tsuke uri*. The raw and the cooked. At the molecular level, *conomon* melons are quite distinct from other groups, which is not surprising, given their separate history of domestication.

Makuwa uri first appeared in Japan in the Kyushu area near Korea; excavations from the Yayoi period have unearthed 2,100-year-old *makuwa* seeds. Minoru Kanda, of the seed company that bears his name, believes that the melon was named for a small village in Aichi prefecture, where farmers grew the finest *uri* fruits. Ironically, as American palates grow more sophisticated and receptive to *makuwa uri,* the Japanese are embracing Western fare and forgetting the ancient melon.

Sakata's Sweet was introduced by Sakata's Seeds of Yokohama. It is unfortunate that the variety was dropped from mail-order seed catalogs in 1994 and is no longer available commercially. This melon is fun to eat—it's like an apple without the core. Most *makuwa uri* are not nearly as sweet; this is one of the best. The one drawback is that, like any melon with stratospheric sugar, it can sometimes taste saccharine or metallic.

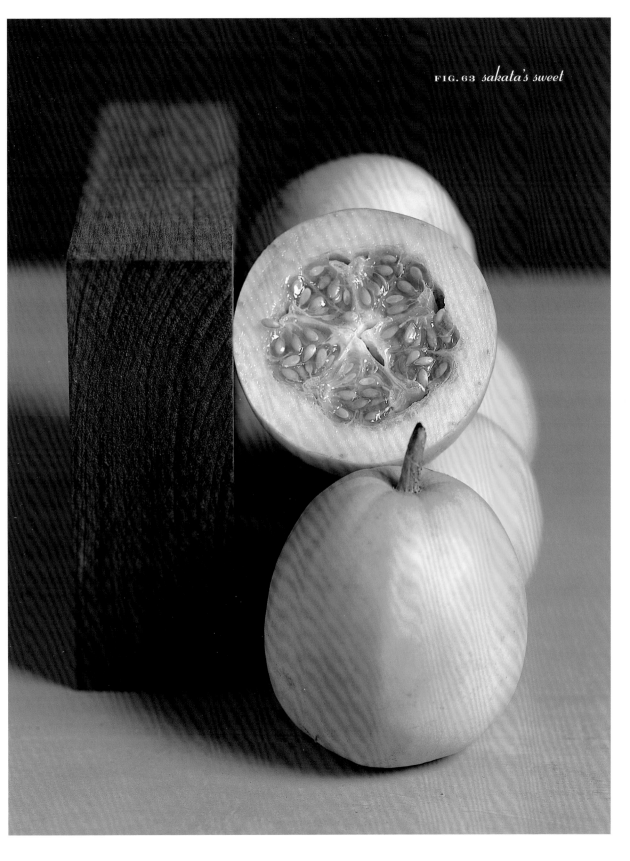

FIG. 63 *sakata's sweet*

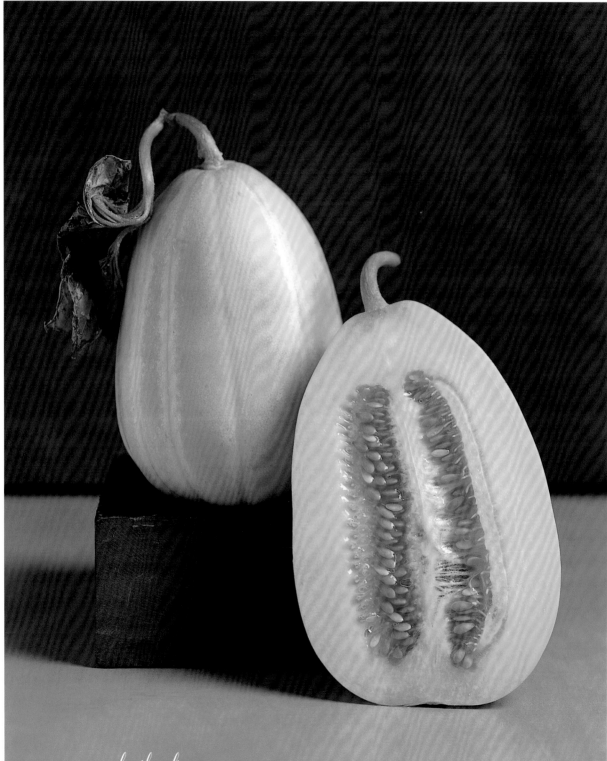

FIG. 64 *early silver line*

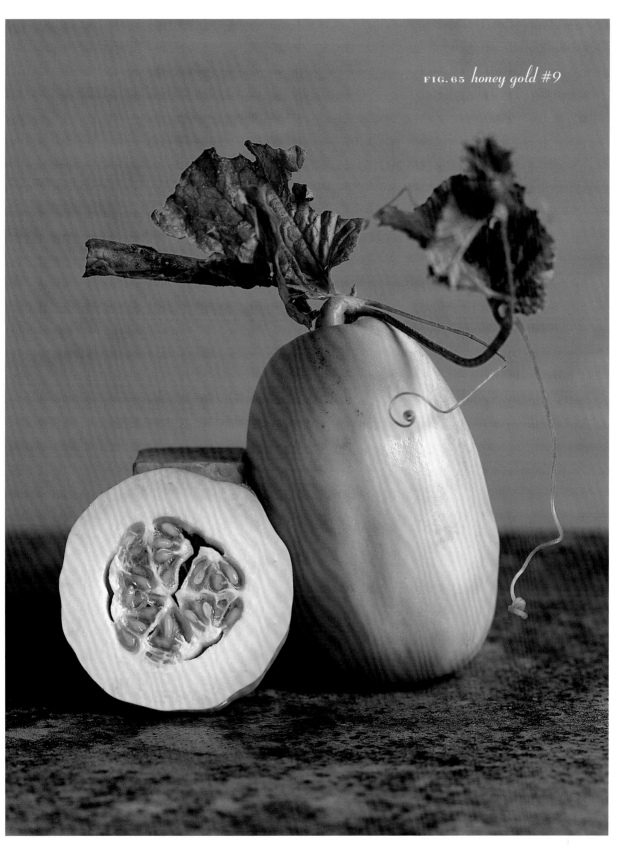

FIG. 65 *honey gold #9*

FLEXUOSUS

Snake Melon or Armenian Cucumber: If you like cucumbers, you'll love the Snake melon; it's everything a cucumber is and more. Unlike most other members of its species, *flexuosus* melon plants are monoecious. This longest of melon fruits should be harvested "green" so it's crisp and not corky. When trellised, it grows along the straight and narrow, but just like a snake, if left to its own devices it coils groundside. Snakes come in light green, or green on green, and are finely wrinkled or ribbed. They make a *mean* "cucumber" salad.

SNAKE MELON

The Snake melon is often mistaken for a cucumber—and for good reason. It looks like one and tastes like one, but botanically it is, in fact, a melon. There are two basic sorts: the light green and striped. The Snake's many monikers, such as Armenian or Serpent Cucumber, simply add to the confusion. Melons and cucumbers are members of the same genus and share certain traits, but they belong to different species and depart from each other in significant ways. Snake melons, for example, have no spines or warts. Snakes *(Cucumis melo)* and cucumbers *(Cucumis sativus)* do not cross species boundaries to breed, but the Snake will mingle freely with other melons, no matter the group.

Long viewed as just a garden oddity or ornament, the Snake melon has been sorely misunderstood. Perhaps because of its sinuous snakelike appearance, people have been reluctant to bite into it, for fear of being bitten back. Courage will be rewarded with a taste of something that surpasses mere cucumber in sweetness and crispness. When the melon is cut in cross-section, the raised ribs confer beautiful scallops, making the melon even more desirable. There's none of the bitterness or burping that can accompany cucumbers; the flesh is drier, so melon pickles are crunchier.

This elegant long-necked creation hails from Armenia, an area rich in melons. It arrived in Italy during the fifteenth century, but never caught on big-time in Western Europe or the United States. It's a very popular item in the Middle East, where the plant sets fruit more reliably than cucumbers at the prevailing high temperatures. Early maturity, prodigious output, and staying power in storage all tip the scales in its favor. All this makes Snake a natural for venturesome gardeners everywhere.

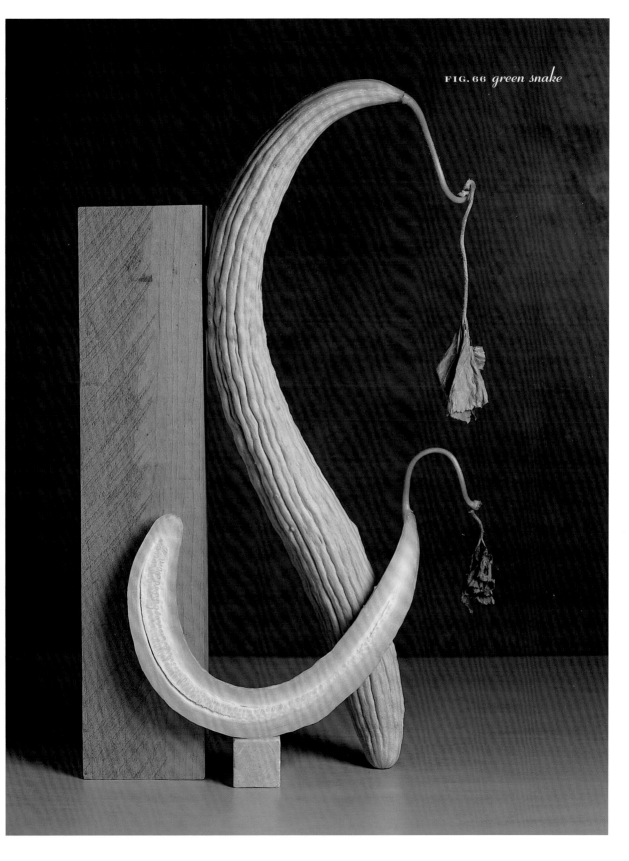

FIG. 66 *green snake*

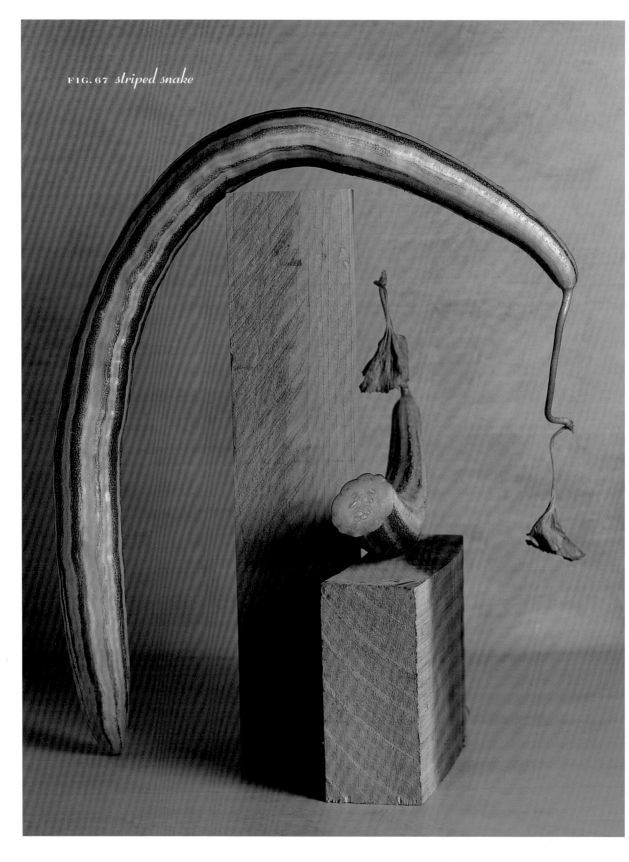

FIG. 67 *striped snake*

CHITO

MANGO MELON: This melon has inspired names such as Garden
Lemon, Melon Apple, and Vine Peach—but its resemblance to these
fruits is in form only; Mango is neither sweet nor aromatic.
Chito melon occurs as a wild type in Central America, where it was
probably introduced by African slaves.

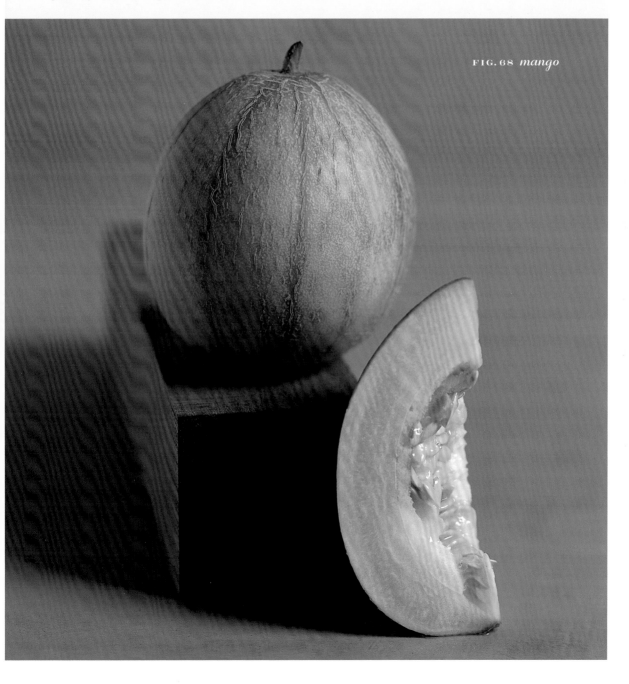

FIG. 68 *mango*

MOMORDICA

Phut or Snap Melon: *Momordica* melons are unseen in the United States; they're grown mostly in Asia. Yet, of all the melons in this book, these intrigue me the most. They come in various shapes and sizes, but most have flesh as white as snow (or very pale orange) and just as fluffy. They've got a peculiar habit of splitting or cracking as maturity approaches. The story of the Cob melon illustrates the important role that individual seed savers play in preserving our vanishing melon heritage.

COB

This is a melon that's full of surprises, inside and out. Though the heart of it looks like cotton candy, the melon is anything but sweet. The flesh is devoid of water, very mealy, almost crystalline. Underneath the fluff is a fibrous cob with seeds clutched tightly together. Muskmelons have corklike netting tantamount to expansion cracks, but this melon has none. The Cob tends to split open before maturity and must be harvested green.

The Cob type, extremely rare in the Western world, is common in India and some parts of Asia. Diverse melons have been cultivated for hundreds of years in India, where inedible forms are also found in the wild. Cob is an example of a *momordica* melon, known in Hindi as "phut" and in English as "snap." This sort is closer in genotype and phenotype to *chito* and *dudaim* melons.

We owe our acquaintance with Cob to individual seed savers. Pat Crill, the breeder of the Morgan melon, has kept the Cob seed alive, from stock his great-great-great-grandfather John apparently brought from Germany more than two hundred years ago. According to Lillian Remmick, another cache of Cob seed came to our shores in 1910 on the ship *Main,* in the apron pocket of her mother, Christina Schweikert Hein (1885–1982). An immigrant from Borodino, Ukraine, near Odessa on the Black Sea, Christina wanted a taste of the Old Country, where melon was served (like everything else) with bread. She settled near Terry, Montana, raised a family, and grew a garden. Grover Delaney, who lived in nearby Baker, got hold of some seed and passed it to August Schuman in Bassett, Nebraska, in 1960. Active in the Seed Savers Exchange, August dispersed Cob melon to countless members, ensuring Christina's legacy.

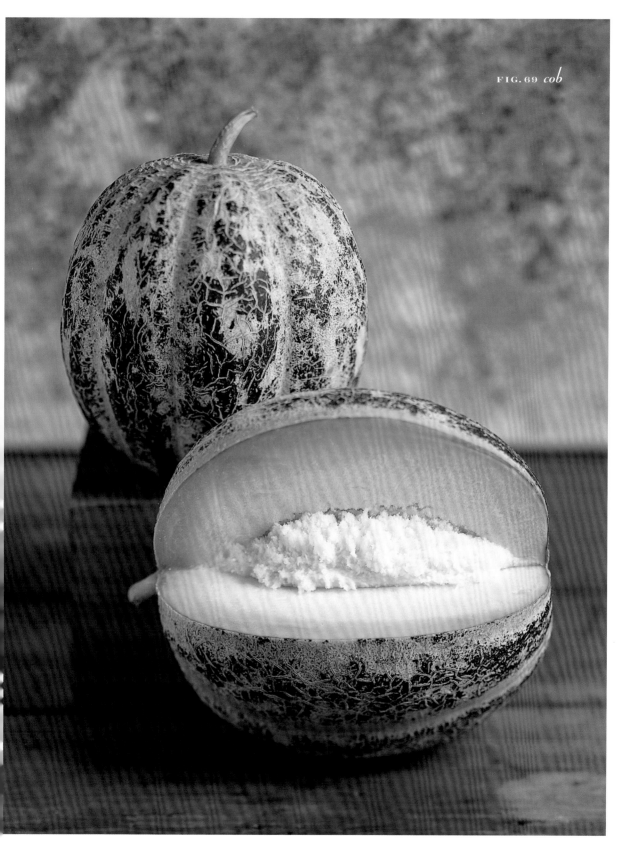

FIG. 69 *cob*

DUDAIM

QUEEN ANNE'S POCKET MELON: It has enchanted melon fanciers for centuries, and it's easy to understand why. The pocket-sized melon is not only beautiful to behold, but it gives off an unforgettable perfume. Flavor is not its strong suit, however. Other *dudaim* melons, found in Egypt, may be more palatable, but it would be hard to imagine another one so aromatic. Queen Anne's isn't often cultivated in the United States, but it has naturalized or escaped into the wilds of Texas and Louisiana.

QUEEN ANNE'S POCKET MELON

Queen Anne's Pocket Melon has an illustrious history, although it is not known which Queen Anne lent it her name. The melon has been known and grown for at least a thousand years. Well before the reign of Queen Anne of England (1702–1714), the Egyptian melon Destbouyeh was described by Temini (circa 980) as a look-alike: small, round, with red and yellow stripes. Carolus Linnaeus (1753) attributed the melon to Egypt as well as Arabia, and used the Hebrew word *dudaim* to classify.

Once thought by the Egyptian lower classes to be a mandrake with narcotic properties, the *dudaim* is now mostly viewed as a harmless curiosity or a pesky weed. If you were to judge the melon solely on taste, you'd say, "Why bother? It's like a cucumber without the crunch." But take one in your hand and bring it to your nose, and you'll know why it is revered. It's better than a tussie-mussie.

Eau de melon de poche—if only we could bottle it. That would be much more convenient than carrying it around in your pocket, and that's precisely what women used to do when daily bathing was not de rigueur and aerosol deodorants were undreamed of. Wily fruit mongers have also been known to hide them in crates of inferior fruit to impart their perfume.

If not Queen Anne of Austria, then certainly her son the Sun King, Louis XIV (1638–1715), must have been well acquainted with the melon. It is illustrated in the *Codex Miniatus 53* (circa 1670), a ten-volume florilegium he commissioned of plants in the royal gardens, where Jean-Baptiste de La Quintinie, the king's renowned chief gardener, grew melons surrounded by espaliered figs—Louis's favorite fruit. Something for the lord to eat out of hand, and something for the lady's pocket.

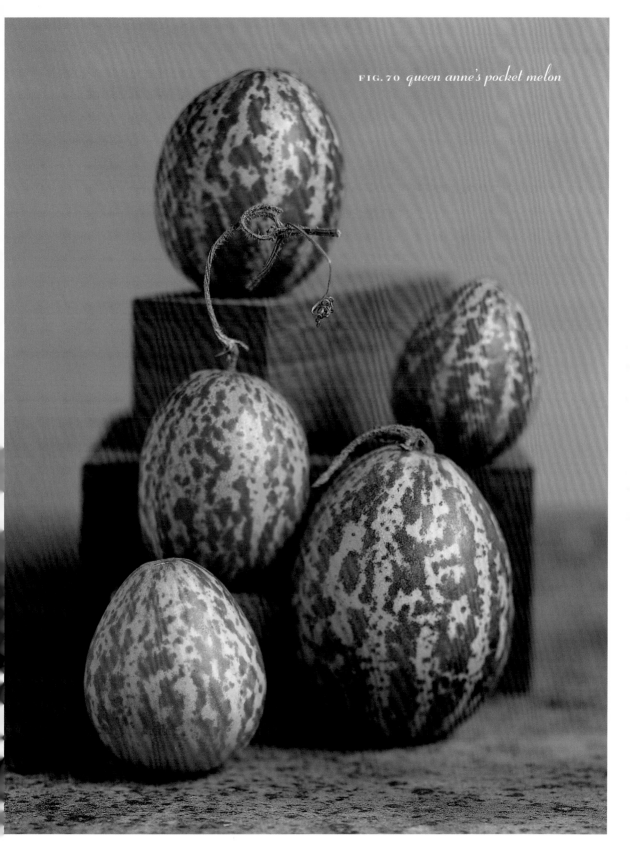

FIG. 70 *queen anne's pocket melon*

WATERMELON

CITRULLUS LANATUS: WATERMELON

This gallery of watermelons is living proof that you don't need a southern zip code (in California, Florida, Georgia, or Texas) to cultivate them in your garden. There's a watermelon for every place, occasion, family size, and inclination. What appeals to me most about watermelons, apart from devouring a good one, are their coats of many colors and patterns. I have a fondness for watermelons with scudding clouds, scaly bark, rattlesnakes, and stars and stripes. And there's nothing more stunning than a platter of sliced watermelon with flesh tones of creamy white (Cream of Saskatchewan), salmon (Golden Midget), canary yellow (Honey Island), psychedelic orange (Orangeglo), and pink lemonade (Wintermelon).

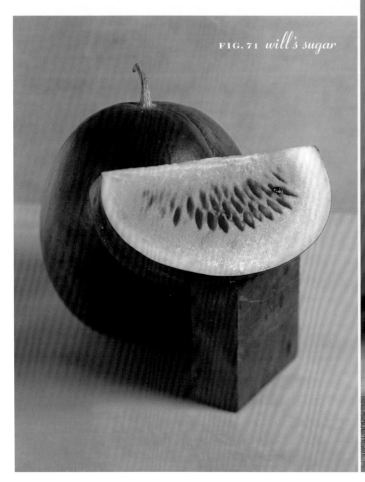

FIG. 71 *will's sugar*

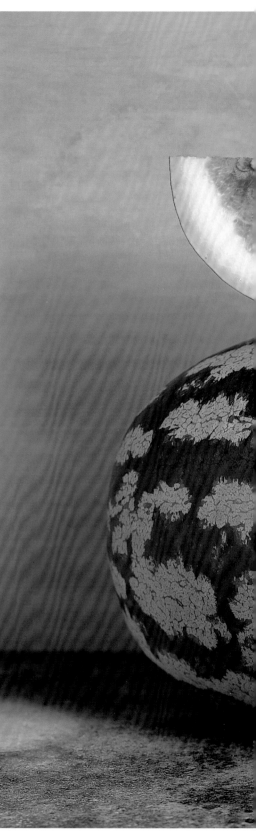

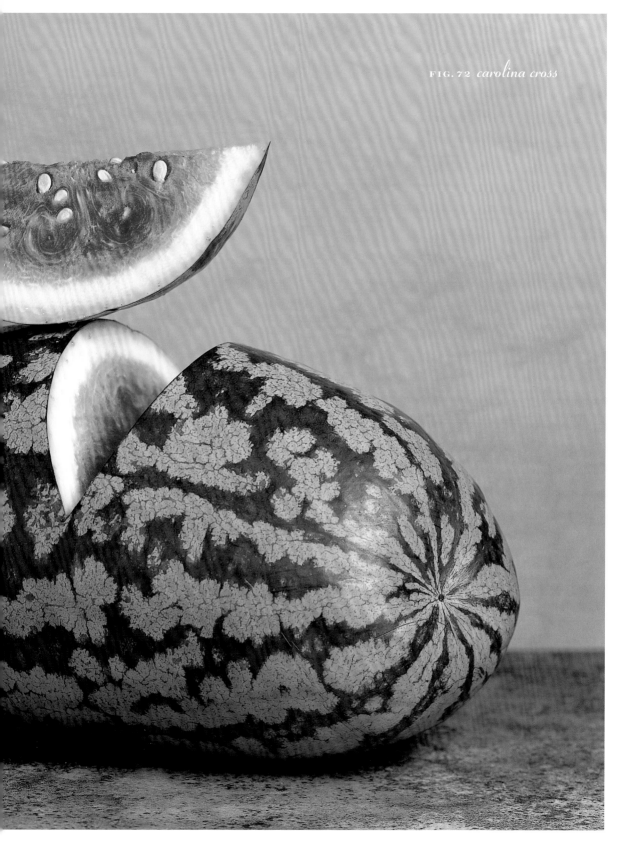

FIG. 72 *carolina cross*

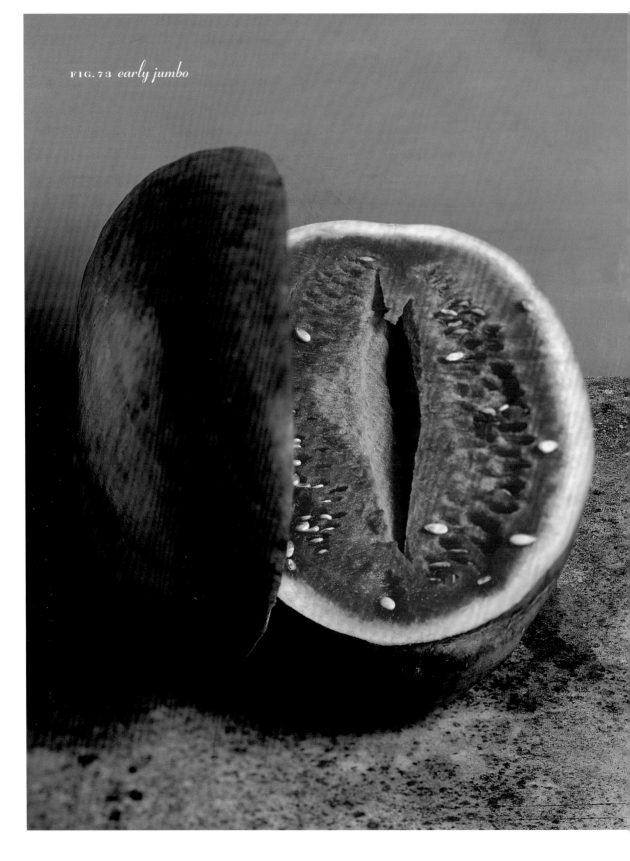

FIG. 73 *early jumbo*

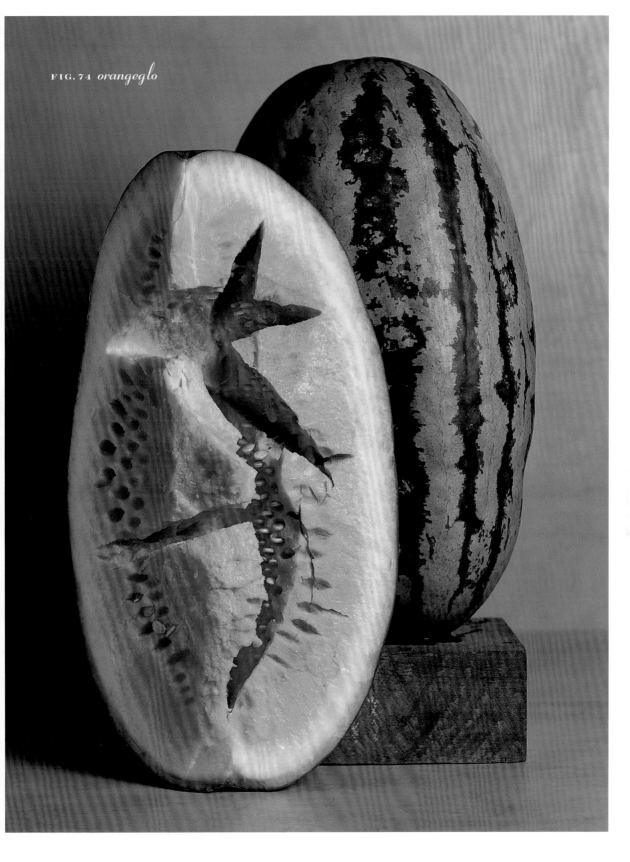

FIG. 74 *orangeglo*

watermelon

GOLDEN MIDGET

The Golden Midget is an outstanding little watermelon. More like
a lunchbox type than an icebox type, this melon in miniature
tastes as good as it looks. The brilliant pairing of penciled yellow
rind and salmon-pink flesh—so pleasantly sweet—brings to mind
tropical fruit. Big, monster watermelons invite a crowd; this one
is made for a more select few. Eat it yourself, or share it with
someone special.

Elwyn Meader and Albert Yeager had the golden touch when
it came to breeding watermelons. Working together at the University
of New Hampshire, they tried to produce a short-season variety with
a compact habit. When the breeder of the Sugar Baby watermelon,
M. Harden of Geary, Oklahoma, sent them a variety called Pumpkin
Rind for trial, it was the answer to the prayers of any watermelon
man. Crossed with the New Hampshire Midget (a 1948 Yeager
introduction), it produced the Golden Midget (1959), a watermelon
with a built-in ripeness indicator: It turns yellow when ripe.

Success wasn't immediate, of course. The first-generation melons
were all green-rinded. The recessive "golden" gene, *go,* which causes
the older leaves and mature fruit to turn yellow, didn't assert itself
until the second generation. Selections were made for table quality
and size over a period of years until Meader and Yeager had a Golden
Midget that could ripen anywhere with seventy frost-free days.

The Golden Midget was only one of scores of plant introductions
made by Elwyn Meader (1910–1996) during his illustrious career.
He was a generalist, often favorably compared to Luther Burbank.
Meader developed everything from blight-resistant chestnuts
to raspberries, lilacs, persimmons, and cucumbers—and never once
applied for a plant patent. Farmers and gardeners are grateful
to Meader for leaving his legacy of now heirloom varieties in the
public domain.

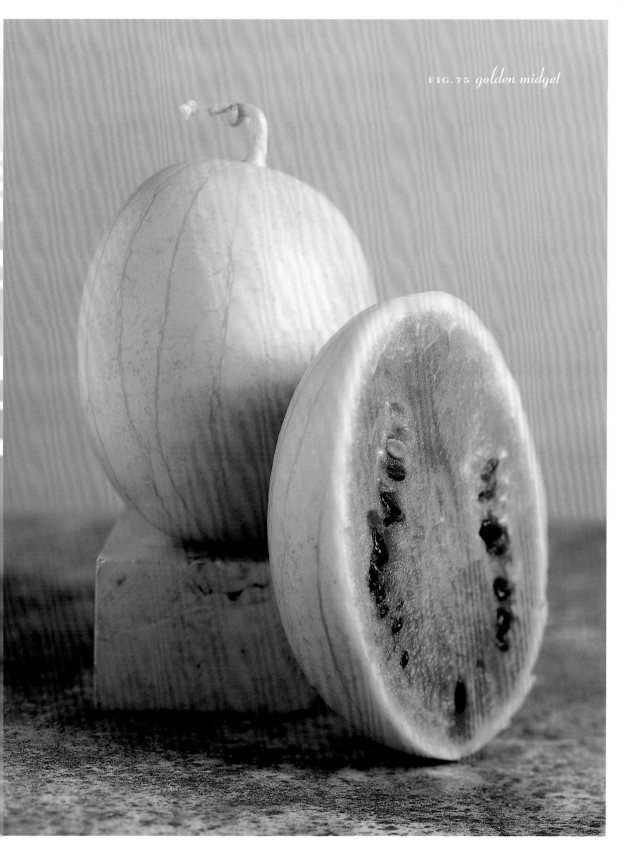

FIG. 75 *golden midget*

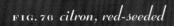

FIG. 76 *citron, red-seeded*

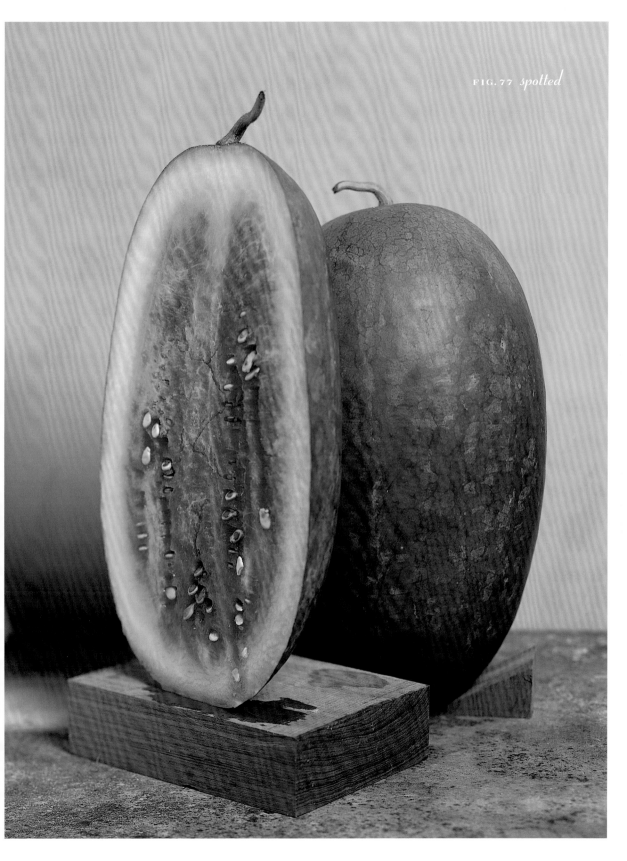

FIG. 77 *spotted*

watermelon

TOM WATSON

The Tom Watson is a good old-fashioned watermelon. It's the kind Allen Lacy (*A Gardener's Miscellany*, 1984) would call the food of Holy Communion. Lacy, well taught by his granddaddy, Roscoe Lee Surles, knew watermelon was meant to be shared by as many people as possible, so only a mammoth melon from Texas or Georgia, sweet and in season, would do.

The Tom Watson definitely makes the grade. The melon was introduced in 1906 by the Alexander Seed Company of Augusta. Georgia born and Georgia bred, this good old boy can reach weights in excess of a hundred pounds. It was one of the record-setting Hope watermelons (including Triumph and the Triumph-Watson hybrids) grown by the Laseter clan in Arkansas in the 1920s.

Size matters, but taste—known in the trade as "cutting quality"— is the bottom line. The Tom Watson is no slouch here, either: The vivid red flesh is crisp and scrumptious, not stringy, bitter, or caramely. Its superior flavor and hard rind made it the most popular shipping watermelon throughout the Great Depression. Archival photographs show these family-sized beauties, stacked on their blossom ends, being transported to railroad loading spurs on Model T trucks and horse-drawn wagons.

William Augustin "Top" Watson, a planter and tax collector in Thomson, Georgia, developed and named the watermelon in honor of his older brother, Thomas Edward Watson (1856–1922), a noted author, U.S. congressman, and later a senator. Thomas Watson is also lauded as the architect of the Rural Free Delivery mail system. Though his campaigns for the presidency were unsuccessful, the watermelon named in his honor was an uncontested winner.

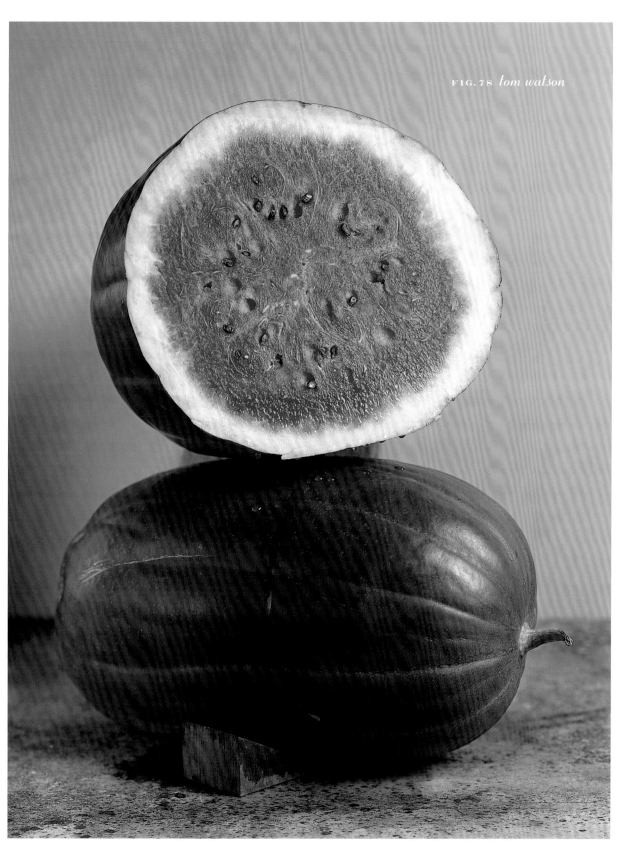

FIG. 78 *tom watson*

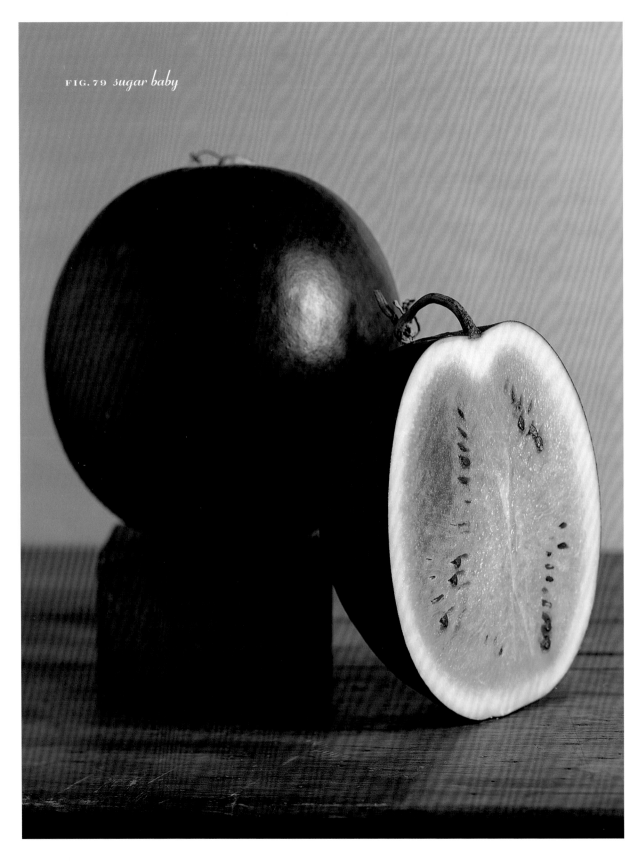

FIG. 79 *sugar baby*

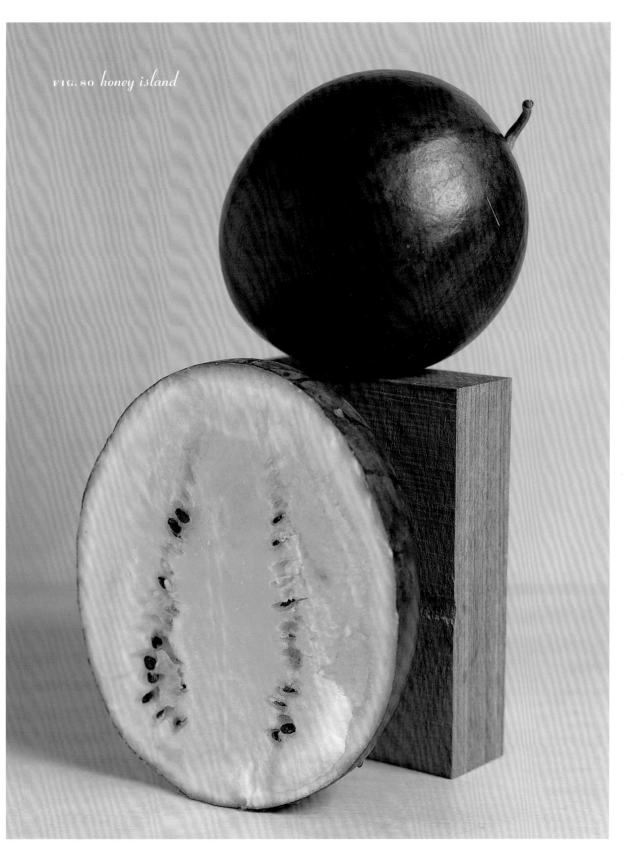

FIG. 80 *honey island*

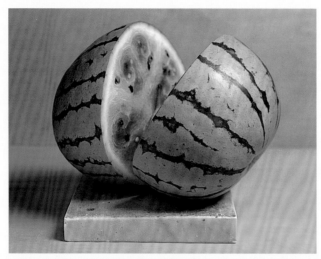

FIG. 81 *fairfax*

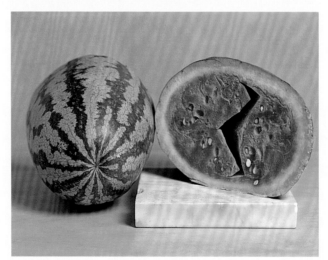

FIG. 82 *chris cross*

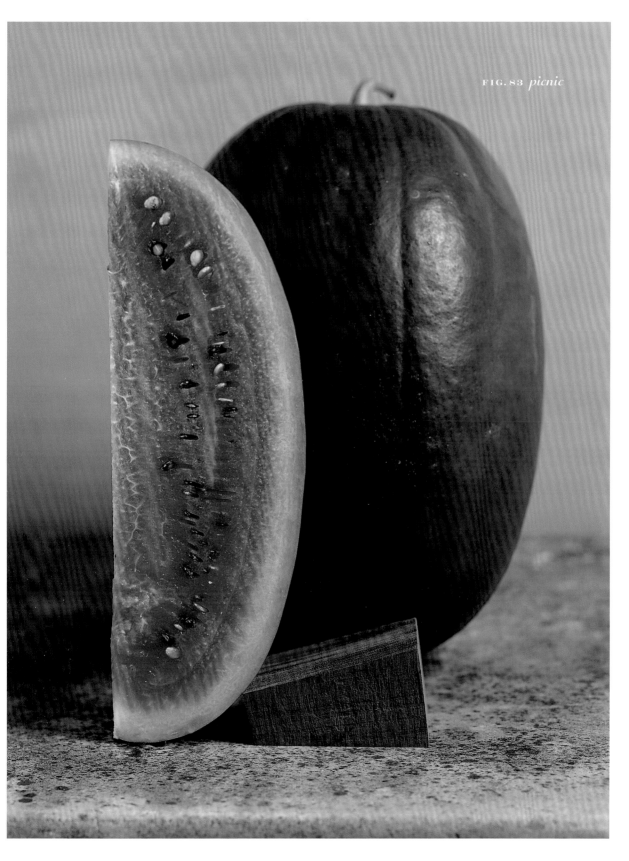

FIG. 83 *picnic*

watermelon

CITRON WATERMELON

Citron, an ancestor of the modern watermelon, is indigenous to South Central Africa, where it still grows in the wild. Though this melon, if it is known at all, is vilified in the West, its high-protein seeds and meat have fed "man and beast" in one form or another for millennia.

It is not like any other watermelon that you know. Rock hard and tasteless when raw, it is transformed by cooking. Twice-boiled in sugar, it makes a fabulous confection that rivals any Turkish delight. It was used for centuries by Europeans as a sweetmeat or preserving melon and later by American Colonists. The raw fruit lasts up to a year in storage; the candy tends to fly off the shelf.

Don't confuse the watermelon Citron with the true citron, a tree fruit after which it was undoubtedly named. *Citrus medica,* the tree fruit, is a long, warty, lemonlike fruit native to India; known to the Romans as Assyrian citron or Median apple, it is used to sate the sweet tooth in the form of candied peel. The decided advantage of the Citron watermelon is that the entire flesh can be used for preserves. Its unusually high level of pectin also makes it an excellent gelling agent.

The Citron is so vigorous and disease tolerant (I've never seen one felled by anything other than frost) that it has been used by watermelon breeders to confer wilt resistance by crossbreeding. These same assets can also be liabilities, and to many farmers it is a demon. The feral melon escapes into the wild in southern climates, overruns cotton and sorghum fields, and readily mates with other watermelons, contaminating the seed stock, although not the fruit on the vine. Be kind to your local farmer and use Citron with caution in the South.

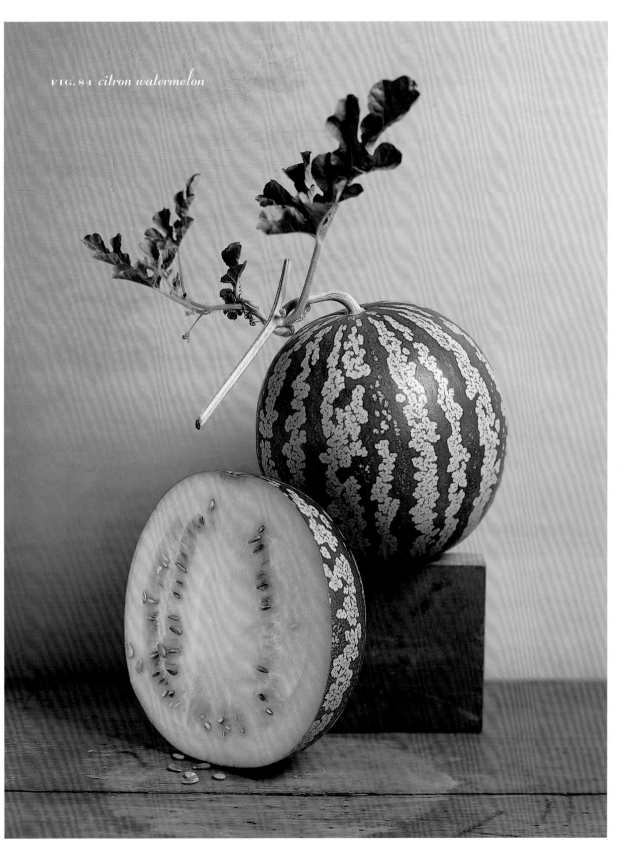

FIG. 84 *citron watermelon*

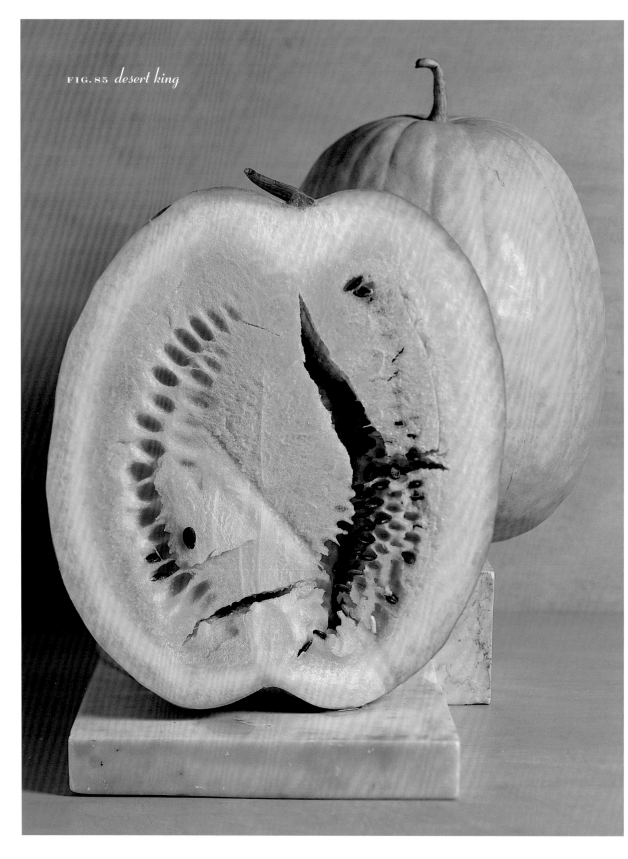

FIG. 85 *desert king*

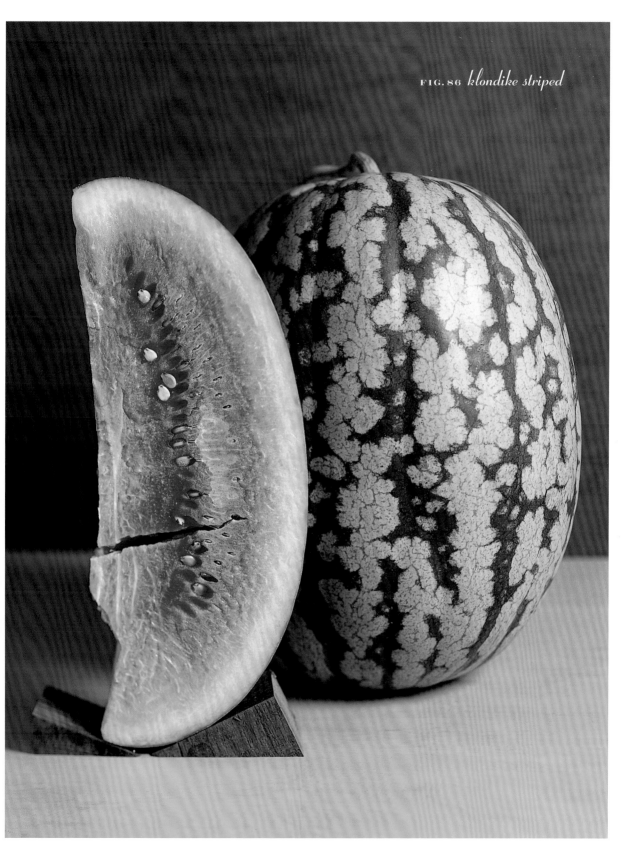

FIG. 86 *klondike striped*

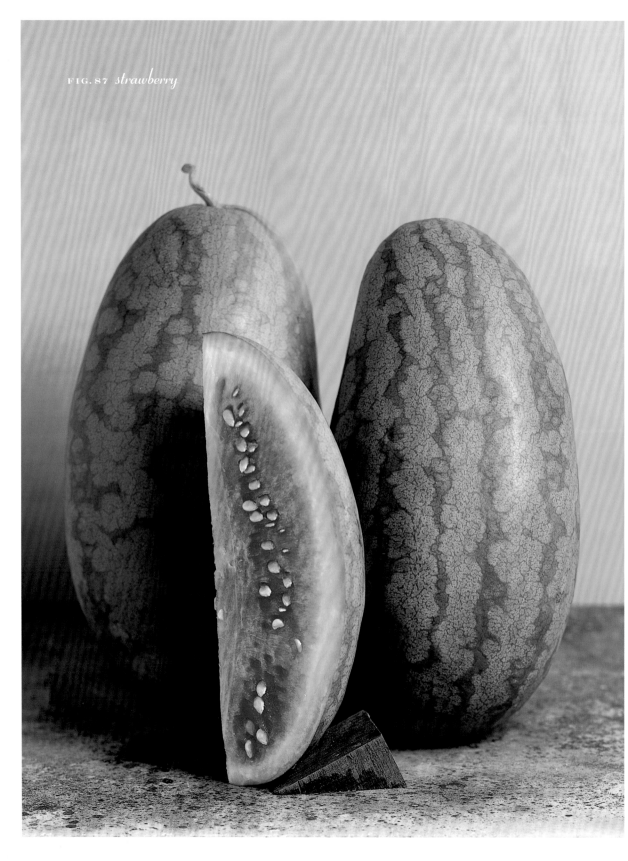

FIG. 87 *strawberry*

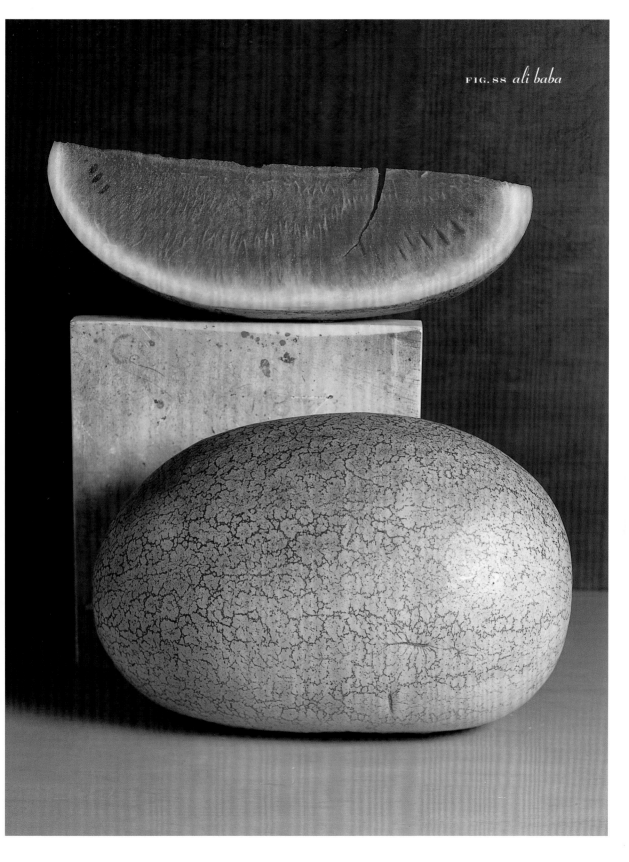

FIG. 88 *ali baba*

watermelon

BLACKTAIL MOUNTAIN

Blacktail Mountain is quintessential watermelon. This dark green cannonball is shot full of flavor: Its dense scarlet flesh is sweet, juicy, and crunchy. It also has good bones, with a geometry that is rounded and well balanced, and a glossy coat of dark green highlighted by faint stripes. In the race for the earliest watermelon, it always wins hands down. Blacktail is the gold standard by which my daughter and I judge all other watermelons.

That it tastes so good is pure happenstance. Blacktail Mountain is a created heirloom, bred by Glenn Drowns in the 1970s for early maturity and cold tolerance. Seventeen-year-old Glenn, as precocious as his fruit, was determined to get a watermelon to ripen in his garden in the mountains of northern Idaho. This is no mean feat in a place where summer nights average 43 degrees Fahrenheit. All he wanted was a watermelon with some red inside it—anyone who's ever known the heartache of cutting into a colorless (immature) one knows what drove him.

Inspired by the work of Gregor Mendel, Glenn spent four years crossing heirloom watermelons. One of the known parents was Red Sugar Lump, an icebox type no longer available commercially. He named his creation after the mountain in his backyard, not, as is falsely rumored, because the seeds have little black tails.

Glenn has always had a passion for watermelon and for gardening. As a child growing up in an extremely poor family, he savored watermelon just once a year, for his birthday at the end of August. His primers were seed catalogs, and his pastime was winning blue ribbons for vegetables at the county fair. Glenn is now a high school science teacher, 4-H judge, and seedsman extraordinaire in Calamus, Iowa. He moved to more fertile ground after growing weary of the cold and the mixed blessing of melon-pollinating rattlesnakes. Lucky for him, and for us, the Blacktail is just as much at home in hot, humid climes as in the chilly north.

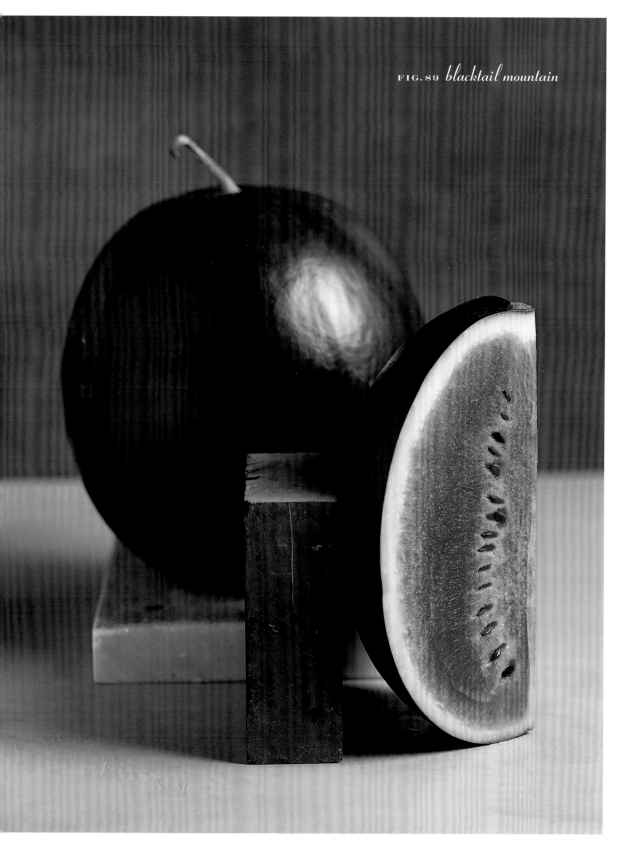

FIG. 89 *blacktail mountain*

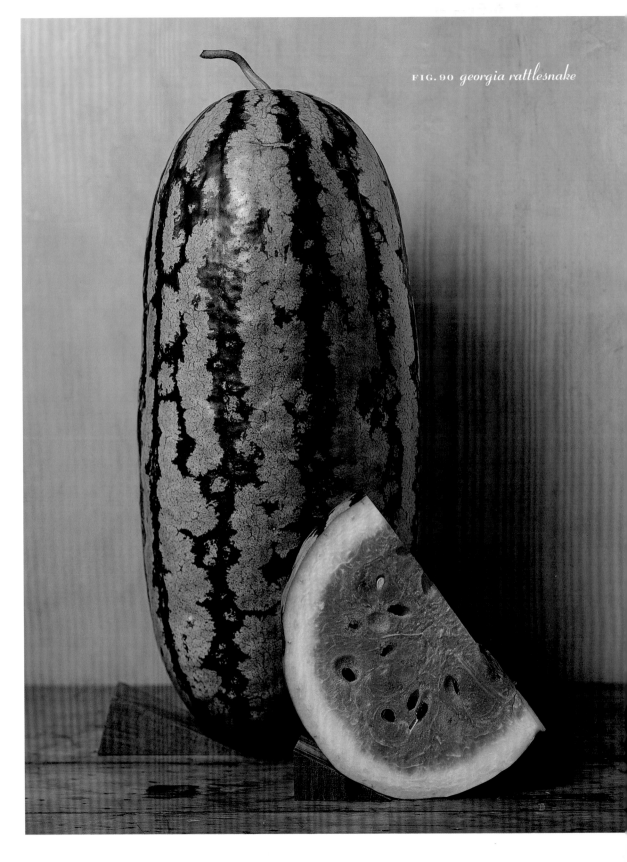

FIG. 90 *georgia rattlesnake*

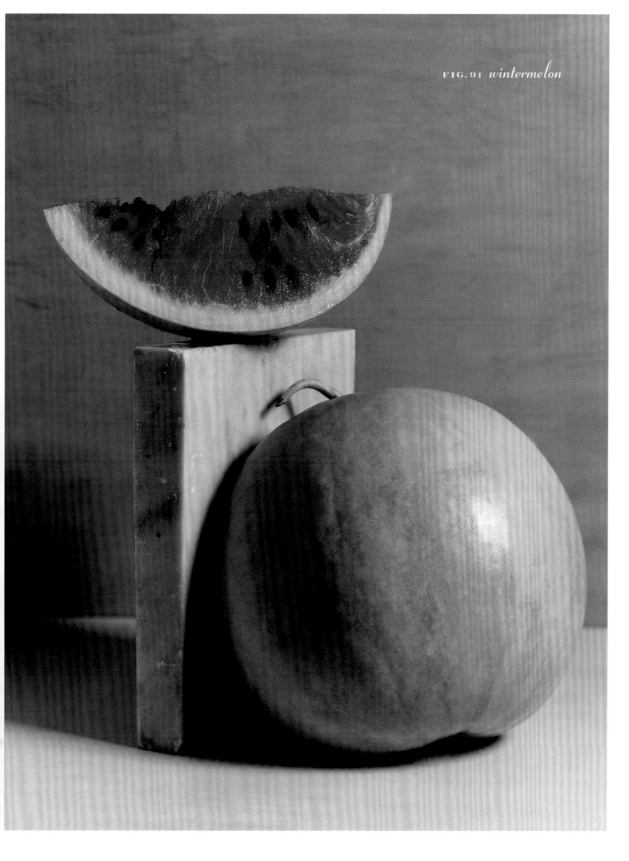

FIG. 91 *wintermelon*

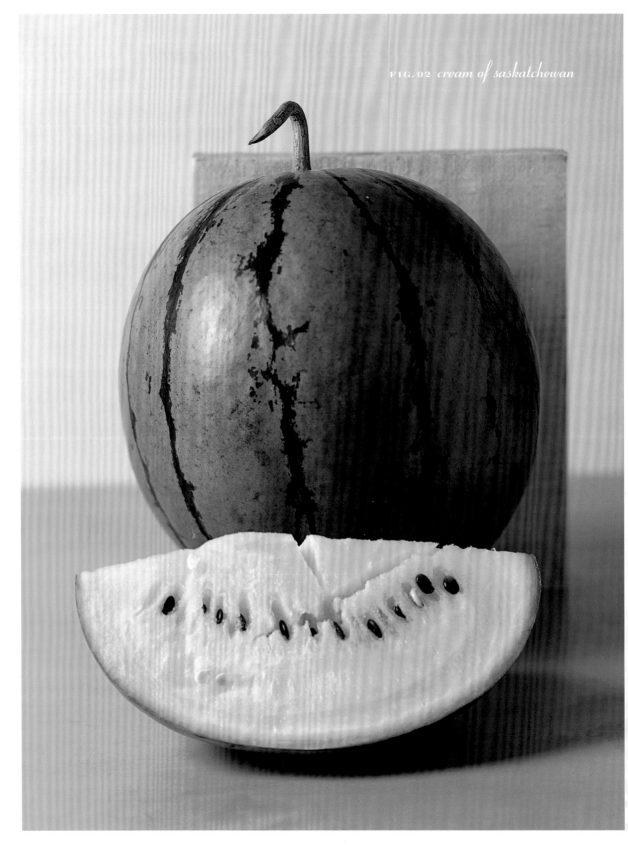

FIG. 92 *cream of saskatchewan*

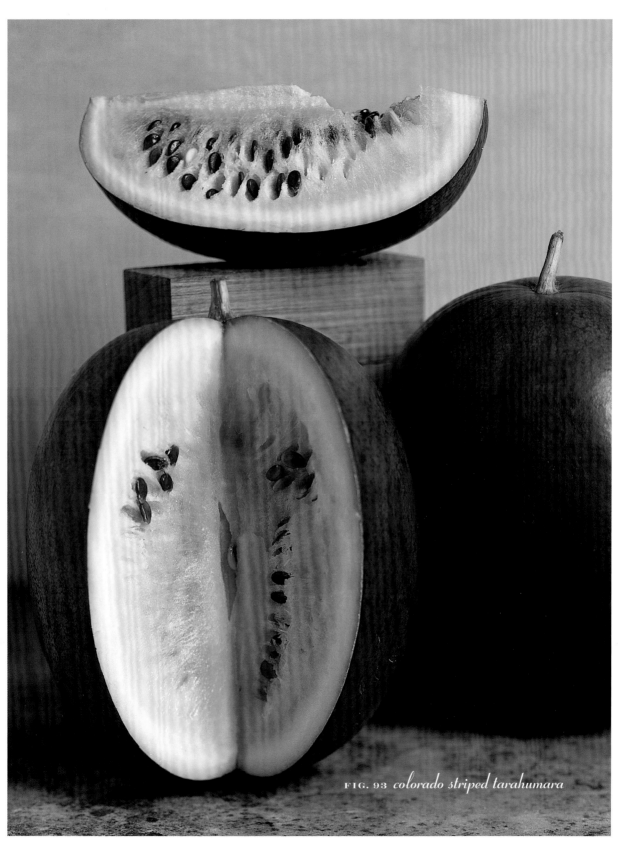

FIG. 93 *colorado striped tarahumara*

FIG. 94 *sugar lump yellow*

FIG. 95 *sweet siberian*

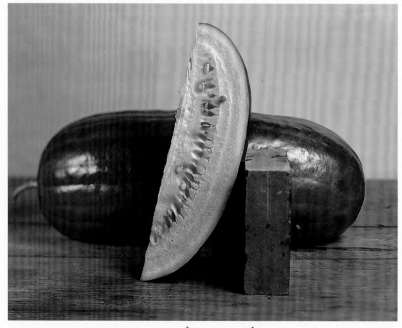

FIG. 96 *luscious golden*

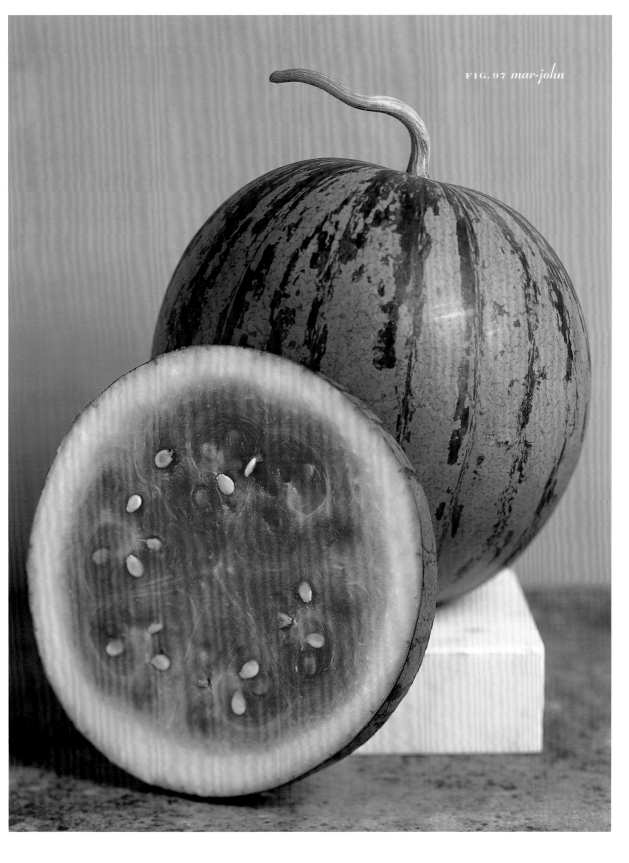

FIG. 97 *mar-john*

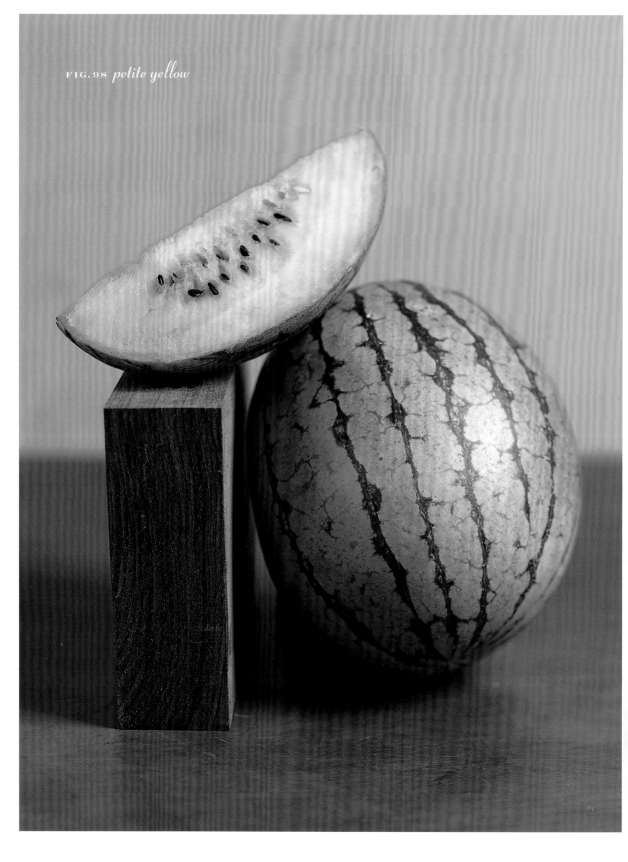

FIG. 98 *petite yellow*

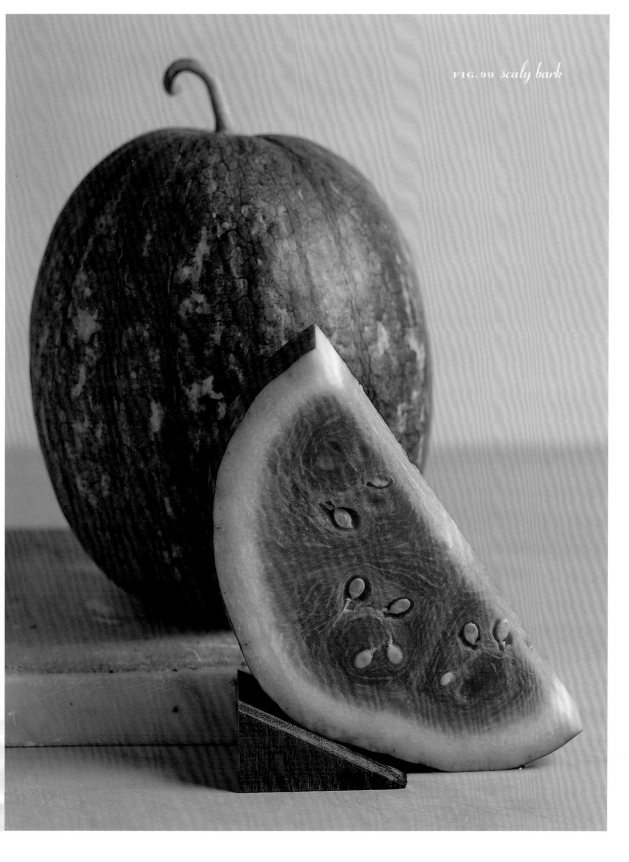

FIG. 99 *scaly bark*

watermelon

MOON AND STARS

The Moon and Stars watermelon is the poster child of the heirloom seed movement. Its buttery moons and constellations of stars are awe-inspiring. Unique among watermelons, both foliage and fruit are bedecked with heavenly bodies. You see what you want to see, almost as on a Rorschach test: a panorama of great bears, dragons, or hunters. The sky's the limit.

No matter how stellar the melon, the Moon and Stars almost slipped into a black hole. Its loss and recovery is a cautionary tale. Originally introduced as Sun, Moon, and Stars by Peter Henderson and Company in 1926, it was still alive and well a decade later, according to the J. D. Robinson Seed Company, which described the fruit as novel but not without merit. Later it was dropped from commercial production and vanished.

Kent Whealy, the cofounder of Seed Savers Exchange, didn't forget the melon. After years of fruitless searching, Kent found what he was looking for not far from home, near Macon, Missouri, where the watermelons grow. In the spring of 1981, Merle Van Doren saw Kent give an interview on local television. Merle wrote that he was keeping the melon and would have seed at harvesttime. "Some folks would give a pretty penny to get their hands on some of that melon seed," Merle said. Then he handed the melons over to Kent with a grin and a handshake when Kent paid him a visit at season's end.

Now widely disseminated, the Moon and Stars's future is assured. The fruits come in many shapes: round, oblong, or pyriform (pear-shaped). With flesh of pink, yellow, or red, all variants are star-studded. Or as Rudyard Kipling might put it: speckled and sprottled and spottled and dotted.

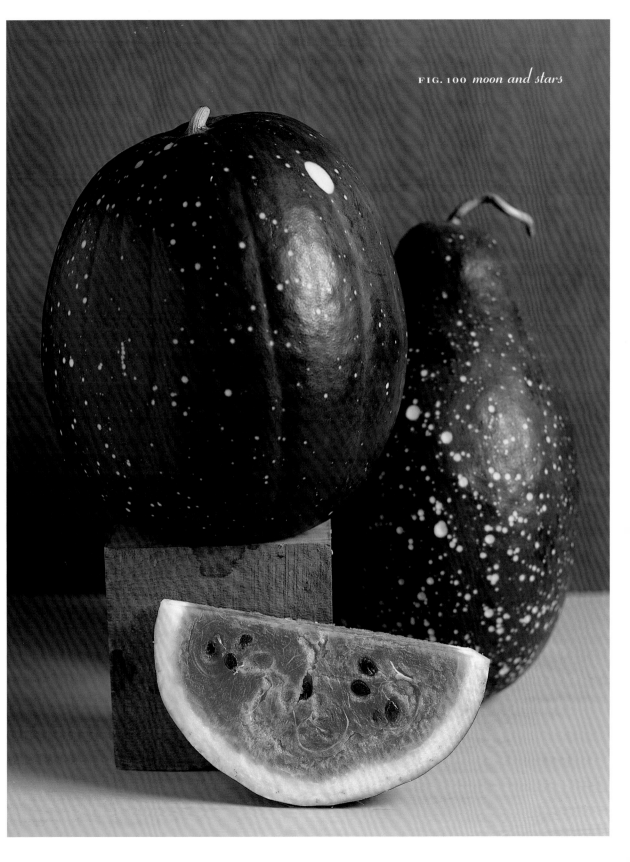

FIG. 100 *moon and stars*

FIESTA MELONS

In Benidorm there are melons,
Whole donkey-carts full

Of innumerable melons,
Ovals and balls,

Bright green and thumpable
Laced over with stripes

Of turtle-dark green.
Choose an egg-shape, a world-shape,

Bowl one homeward to taste
In the whitehot noon:

Cream-smooth honeydews,
Pink-pulped whoppers,

Bump-rinded cantaloupes
With orange cores.

Each wedge wears a studding
Of blanched seeds or black seeds

To strew like confetti
Under the feet of

This market of melon-eating
Fiesta-goers.

—Sylvia Plath

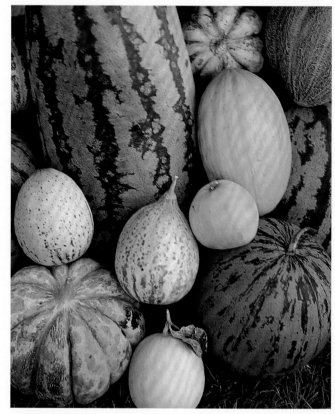

CLOCKWISE FROM UPPER LEFT:
Georgia Rattlesnake, Early Frame
Prescott, Canary, Cochiti Pueblo,
Orangeglo, Mar-John, Mango,
Sweet Freckles, Orange-Fleshed
Honeydew, and D'Alger.

ABOUT THE MELONS

This section contains identifying information about all melons featured in the book: melon group, size and weight, sugar content, days to maturity, synonyms, seed sources, as well as tidbits about those melons not treated to a full-scale verbal portrait. Note that maturity is counted from the date the plant is placed into the garden, not from the day seed was sown. Early varieties mature in 70 to 80 days; midseason varieties, 81 to 90 days; and late varieties take 90 or more days to bear fruit.

An index of melon sweetness is also provided, as measured in degrees Brix with a handheld refractometer. Melons with a Brix reading of 10 degrees or better are generally deemed good quality; however, values were based on a small sample size and may vary under different growing conditions.

Finally, seed sources are abbreviated and are limited to those in the United States and Canada, with one exception, Ter, a British seed supplier of several rare varieties. For a full listing of the names and addresses of commercial sources of seed, see page 164.

FIG. 1 DE BELLEGARDE
Cucumis melo var. *cantalupensis*
SIZE: 6" long by 7" wide
WEIGHT: 3 pounds
SUGAR CONTENT: 8° Brix
MATURITY: Midseason
SYNONYMS: Bellegarde, Melon Caboul, Melon Cantaloup à Queue Fine, Melon Prolifique de Trévoux
SEED SOURCE: Ter

Fluted like a cheese pumpkin; starts life as a speckled sort. Delicious. Noted in Vilmorin-Andrieux (1885).

FIG. 2 OBUS
Cucumis melo var. *cantalupensis*
SIZE: 7" long by 7" wide
WEIGHT: 4 pounds
SUGAR CONTENT: 13° Brix
MATURITY: Midseason
SYNONYM: Kroumir
SEED SOURCE: Ter

True cantaloupe with occasional bumps and warts. Some Obus are round, others oblong or misshapen. Top-tier melon, evidently descended from Noir des Carmes. Documented in Vilmorin-Andrieux (1904).

FIG. 3 NOIR DES CARMES
Cucumis melo var. *cantalupensis*
SIZE: 4½" long by 3¾" wide
WEIGHT: 1 pound
SUGAR CONTENT: 11° Brix
MATURITY: Early
SYNONYMS: Cantaloup Sucrin de Montreuil, Early Black Rock
SEED SOURCES: Bake, Horus, Prai, Ter

FIG. 4 CANTALUN
Cucumis melo var. *cantalupensis*
SIZE: 4½" long by 4½" wide
WEIGHT: 2 pounds
SUGAR CONTENT: 13½° Brix
MATURITY: Midseason
SYNONYM: Charentais

SEED SOURCE: None
From the venerable French seed house Vilmorin.

FIG. 5 VIEILLE FRANCE
Cucumis melo var. *cantalupensis*
SIZE: 7" long by 6" wide
WEIGHT: 3 pounds
SUGAR CONTENT: 8° Brix
MATURITY: Late
SYNONYM: Old France
SEED SOURCE: None

FIG. 6 EARLY FRAME PRESCOTT
Cucumis melo var. *cantalupensis*
SIZE: 5" long by 5¼" wide
WEIGHT: 2½ pounds
SUGAR CONTENT: 12¾° Brix
MATURITY: Midseason
SYNONYMS: Early Large Prescott, Prescott Petit Hâtif à Châssis
SEED SOURCE: Ter

FIG. 7 D'ALGER
Cucumis melo var. *cantalupensis*
SIZE: 9" long by 9" wide
WEIGHT: 11 pounds
SUGAR CONTENT: 6° Brix
MATURITY: Midseason
SYNONYMS: Cantaloup D'Alger, Cantaloup de Mai
SEED SOURCES: Bake, Hud, Ter

FIG. 8 PRESCOTT FOND BLANC
Cucumis melo var. *cantalupensis*
SIZE: 5" long by 9" wide
WEIGHT: 6½ pounds
SUGAR CONTENT: 12½° Brix
MATURITY: Late
SYNONYMS: Large Prescott White-Skinned Rock Melon, Melon Excelsior, Pariser Markt-Prescott-Melone
SEED SOURCES: Baker, Hud, Ter

FIG. 9 PETIT GRIS DE RENNES

Cucumis melo var. *cantalupensis*
SIZE: 4½" long by 4½" wide
WEIGHT: 2 pounds
SUGAR CONTENT: 14° Brix
MATURITY: Midseason
SEED SOURCE: Ter

FIG. 10 HA'OGEN

Cucumis melo var. *cantalupensis*
SIZE: 6" long by 6" wide
WEIGHT: 3 pounds
SUGAR CONTENT: 11° Brix
MATURITY: Midseason
SYNONYMS: Ogen, (Old) Israel
SEED SOURCES: Abu, Bou, Deep, SoC, Sow, Wind

FIG. 11 CHARENTAIS

Cucumis melo var. *cantalupensis*
SIZE: 4½" long by 4½" wide
WEIGHT: 2 pounds
SUGAR CONTENT: 12¼° Brix
MATURITY: Midseason
SYNONYM: Cavaillon
SEED SOURCES: Bake, Bou, Cook, Horus, Lan, LeJ, Nic, Und, Will

FIG. 12 PERSIAN

Cucumis melo var. *reticulatus*
SIZE: 5½" long by 5½" wide
WEIGHT: 2¾ pounds
SUGAR CONTENT: 11° Brix
MATURITY: Late
SYNONYM: Armenian
SEED SOURCES: Burr, Lan

Many similar types in Asia Minor. Can be harvested green for shipping. Persians are finely and abundantly netted, globe shaped, not ribbed or sutured.

FIG. 13 EDEN GEM

Cucumis melo var. *reticulatus*
SIZE: 4" long by 4" wide
WEIGHT: 1 pound
SUGAR CONTENT: 11½° Brix
MATURITY: Midseason
SYNONYMS: Eden's Gem, Gem of Eden, Rocky Ford Eden Gem
SEED SOURCES: Bake, Burr, Lan, Sand, SESE

One of my all-time favorites. May cause drooling. Spicy like curry; complex flavor. A "crate" melon for shipping. Developed in 1905 at Rocky Ford, Colorado.

FIG. 14 ROCKY FORD, POLLACK 10-25

Cucumis melo var. *reticulatus*
SIZE: 5" long by 5" wide
WEIGHT: 2 pounds
SUGAR CONTENT: 11½° Brix
MATURITY: Late
SYNONYMS: Perfecto, Improved Perfecto, Perfected Perfecto, Superfecto
SEED SOURCE: None

The modern muskmelon industry was based on this kind of melon. In 1895, J. P. Pollack began developing a new type from Burpee's Netted Gem; it was renamed Rocky Ford, after the place in Colorado. Pollack 10–25 was green-meated. Orange selections, such as this one, appeared in the 1920s and included the various Perfectos. It goes to show, you *can* improve on perfection.

FIG. 15 MINNESOTA MIDGET

Cucumis melo var. *reticulatus*
SIZE: 3¼" long by 3½" wide
WEIGHT: 12 ounces
SUGAR CONTENT: 11° Brix

MATURITY: Early
SEED SOURCES: Abund, Bake, Burg, ERS, Irish, Lan

The earliest melon I grow, and the only one that will produce two crops. Plant and fruit are both dwarf. Bred by the University of Minnesota at St. Paul in 1948; introduced by Farmer Seed and Nursery Company.

FIG. 16 TIGER

Cucumis melo var. *reticulatus*
SIZE: 10" long by 8½" wide
WEIGHT: 6 pounds
SUGAR CONTENT: 11° Brix
MATURITY: Midseason
SEED SOURCE: None

A fine specimen of melonhood. Yellow brown with parallel streaks, like a tiger. Not the same as the Tiger or Orange Ananas from Afghanistan, which has white skin and orange flesh. An English variety from Kings Crown Quality Seeds.

FIG. 17 MUSCATINE

Cucumis melo var. *reticulatus*
SIZE: 8" long by 6½" wide
WEIGHT: 6 pounds
SUGAR CONTENT: 11½° Brix
MATURITY: Midseason
SEED SOURCE: None

A childhood favorite of my friend M. Mark, who topped it off with butter brickle ice cream. From Muscatine, Iowa. Not to be confused with Pride of Muscatine, a watermelon developed by Porter and Melhus, in 1930, at the Iowa Agricultural Station.

FIG. 18 **HERO OF LOCKINGE**

Cucumis melo var. *reticulatus*
SIZE: 3½" long by 4½" wide
WEIGHT: 1 pound
SUGAR CONTENT: 10° Brix
MATURITY: Late
SYNONYMS: Lockinge Park, Sutton's Hero of Lockinge
SEED SOURCE: None

FIG. 19 **TIP TOP**

Cucumis melo var. *reticulatus*
SIZE: 8" long by 7" wide
WEIGHT: 4½ pounds
SUGAR CONTENT: 10¾° Brix
MATURITY: Late
SYNONYMS: Livingston's Tip Top, Mosley Tip Top, Nutmeg Tip Top
SEED SOURCE: Horus

Strong musky odor; fine ropelike netting. Still tip-top, after all these years. Introduced by A. W. Livingston's Sons, of Columbus, Ohio, in 1892. A keen-eyed gentleman from Lancaster County, Pennsylvania, with a nose for melons, discovered Tip Top by chance in a neighbor's field. The taste was astonishing— and the rest is history. Tip Top is a parent of the Bender and of Orange-Fleshed Honeydew, among other melons of fine repute.

FIG. 20 **HEALY'S PRIDE**

Cucumis melo var. *reticulatus*
SIZE: 12" long by 6" wide
WEIGHT: 6 pounds
SUGAR CONTENT: 7° Brix
MATURITY: Late
SEED SOURCE: None

Introduced in 1952 by Elmer James Healy of St. Francisville, Illinois. The melon's parents were (Banana × Condon's Perfection) × (Pride of Wisconsin). Netting is similar to Pride of Wisconsin, but Banana genes make it bigger. Lowell Beaudoin, Jr., of Geneva, Ohio, lives for this melon.

FIG. 21 **JENNY LIND**

Cucumis melo var. *reticulatus*
SIZE: 5" long by 6½" wide
WEIGHT: 2½ pounds
SUGAR CONTENT: 9° Brix
MATURITY: Early
SYNONYMS: Extra Early Jenny Lind, Jersey Button, Shipper's Delight
SEED SOURCES: Bake, Fed, Fox, Heir, Horus, Land, Pine, Shaw, Shum, SSHS, Ver, Wind

FIG. 22 **PIERCE VIRES**

Cucumis melo var. *reticulatus*
SIZE: 15" long by 7" wide
WEIGHT: 9 pounds
SUGAR CONTENT: 11¼° Brix
MATURITY: Late
SEED SOURCE: None

An uncommon form, from Charles Vires of Pittsburg, Oklahoma. The narrowing at the stem end is known as bottleneck; this may be due to poor pollination—note the absence of seeds in the neck.

FIG. 23 **OLD-TIME TENNESSEE**

Cucumis melo var. *reticulatus*
SIZE: 12½" long by 6" wide
WEIGHT: 9½ pounds
SUGAR CONTENT: 12½° Brix
MATURITY: Midseason
SYNONYM: Giant Tennessee
SEED SOURCE: Horus

This is an amazing melon, but it's strictly garden-to-table. At the peak of perfection, it tastes like lichee and roses and pepper. Stephen Kolpan, coauthor of *Exploring Wine* (2001), says that Old-Time Tennessee would make a nice, light sweet wine, at about 6% to 7% alcohol, in the style of a muscat from Italy.

FIG. 24 **BANANA**

Cucumis melo var. *reticulatus*
SIZE: 22" long by 7" wide
WEIGHT: 10½ pounds
SUGAR CONTENT: 9½° Brix
MATURITY: Late
SYNONYMS: Banana Citron, Cuban Banana, Mexican Banana
SEED SOURCES: Bake, Burg, Heir, Lan, Meyer, Saun, Shum, SU, Will

FIG. 25 **MAINE**

Cucumis melo var. *reticulatus*
SIZE: 8" long by 4½" wide
WEIGHT: 2¾ pounds
SUGAR CONTENT: 4° Brix
MATURITY: Early
SEED SOURCE: None

Maine is one of the first melons of summer. It has everything going for it but flavor.

FIG. 26 **SPEAR**

Cucumis melo var. *reticulatus*
SIZE: 9½" long by 6½" wide
WEIGHT: 6 pounds
SUGAR CONTENT: 10° Brix
MATURITY: Late
SYNONYMS: Oregon Delicious, Speer
SEED SOURCES: Abund, Sand, Ter, Wind

Looks like a dirigible. Popular in Oregon for at least seventy years. First listed with Seed Savers Exchange by Clarence Holdridge of Talent, Oregon; once carried by Gill Brothers Seeds. Possible hybrid of Banana.

FIG. 27 FORDHOOK GEM

Cucumis melo var. *reticulatus*
SIZE: 6" long by 5" wide
WEIGHT: 2 pounds
SUGAR CONTENT: 12° Brix
MATURITY: Early
SEED SOURCE: None

FIG. 28 COCHITI PUEBLO

Cucumis melo var. *reticulatus*
SIZE: 8" long by 7½" wide;
10" long by 6½" wide
WEIGHT: 6 pounds
SUGAR CONTENT: 13° Brix
MATURITY: Late
SEED SOURCE: None

The sweetest orange-fleshed muskmelon I know. Collected at Cochiti Pueblo in New Mexico, near Santa Fe. The melon is a "stable genetic mix" with either oval or round fruits that are identical in taste.

FIG. 29 HOLLYBROOK LUSCIOUS

Cucumis melo var. *reticulatus*
SIZE: 9½" long by 8" wide
WEIGHT: 8 pounds
SUGAR CONTENT: 9° Brix
MATURITY: Late
SEED SOURCE: SSHS

These muskmelons can assume enormous proportions (the one pictured on page 65 is small). Hollybrook Luscious was introduced in 1905 by T. W. Wood and Sons of Richmond, Virginia, and named for the firm's seed farm. Similar to Lewis Perfection.

FIG. 30 VERT GRIMPANT

Cucumis melo var. *reticulatus*
SIZE: 3½" long by 4½" wide
WEIGHT: 1 pound
SUGAR CONTENT: 12¾° Brix
MATURITY: Late
SYNONYMS: Green Climbing,
Melon Vert à Rames
SEED SOURCES: Bake, Hud

Fabulous. One of my top ten for taste. Because of its long stem and small size, the melon, according to Vilmorin-Andrieux (1883), could be grown on a slight incline, or even an espalier stake, if provided with something to cling to. In my experience, Vert Grimpant is not an easy climber. Best to let it sprawl on the ground, like its *confrères*. Smaller melons, such as Queen Anne's Pocket, easily outclimb it.

FIG. 31 ANANAS

Cucumis melo var. *reticulatus*
SIZE: 9" long by 6" wide
WEIGHT: 5 pounds
SUGAR CONTENT: 10½° Brix
MATURITY: Late
SYNONYMS: Israeli, Persian,
Pineapple, Sharlyn
SEED SOURCES: Bake, Fox,
Lan, Sow, Will

This Ananas, or Pineapple, is not the same as the Green- or Red-Fleshed Pineapple melons described in Vilmorin-Andrieux (1885), which are smaller, rounder, and ribbed. A number of Ananas "market types" have been bred in Israel (for example, Ananas 'En Dor and Ananas Yoqne'am) and given place names; hybrids also exist.

FIG. 32 EARLY HANOVER

Cucumis melo var. *reticulatus*
SIZE: 4¾" long by 6" wide
WEIGHT: 2¾ pounds
SUGAR CONTENT: 10° Brix
MATURITY: Early
SYNONYM: Extra Early Hanover
SEED SOURCE: SSHS

One of the earliest muskmelons. At one time immensely popular in Virginia. Originated near Richmond; introduced by T. W. Woods and Sons in 1895.

FIG. 33 EMERALD GEM

Cucumis melo var. *reticulatus*
SIZE: 5" long by 5" wide
WEIGHT: 2 pounds
SUGAR CONTENT: 12¼° Brix
MATURITY: Late
SYNONYMS: Burpee's Emerald
Gem, Mary Daisy
SEED SOURCE: SSHS

FIG. 34 BLENHEIM ORANGE

Cucumis melo var. *reticulatus*
SIZE: 7½" long by 5½" wide
WEIGHT: 4 pounds
SUGAR CONTENT: 10½° Brix
MATURITY: Late
SYNONYM: Blenheim Orange
Superlative
SEED SOURCES: Bou, Ter

Blenheim Orange was developed in 1881 by Thomas Crump, the Duke of Marlborough's head gardener, at Blenheim Palace in Oxfordshire. Blenheim Orange was also the name of an apple that originated near Blenheim, circa 1740. The melon was grown in frames and hothouses, but it performs admirably in the garden. Cited in Vilmorin-Andrieux (1883).

FIG. 35 OKA

Cucumis melo var. *reticulatus*
SIZE: 5" long by 7" wide
WEIGHT: 4¼ pounds
SUGAR CONTENT: 9° Brix
MATURITY: Late
SEED SOURCES: Prai, SSHS

A Canadian heirloom, rediscovered on Ile-Bizard, a St. Lawrence River island between Montreal and LeValle. Bred around 1912 by the Reverend Father Athanase of the Trappist monastery at Oka, Montreal, Quebec. Father Athanase crossed the green-meated Montreal Market Melon with the orange Banana. The Montreal Market, from which Oka takes its form, was introduced to Americans in 1881 by W. Atlee Burpee; he became enamored of the fruit when he saw it at St. Ann's market in Montreal. That melon has gone by the wayside—even though fastidious customers in New York once demanded daily shipments from Canada.

FIG. 36 ANNE ARUNDEL

Cucumis melo var. *reticulatus*
SIZE: 6" long by 6½" wide
WEIGHT: 5 pounds
SUGAR CONTENT: 10° Brix
MATURITY: Midseason
SEED SOURCES: Bake, Sand, Shaw

FIG. 37 RETATO DEGLI ORTOLANI

Cucumis melo var. *reticulatus*
SIZE: 5" long by 4" wide
WEIGHT: 1½ pounds
SUGAR CONTENT: 9° Brix
MATURITY: Midseason
SYNONYM: Gardener's Melon
SEED SOURCE: None

FIG. 38 ANANAS D'AMÉRIQUE À CHAIR VERTE

Cucumis melo var. *reticulatus*
SIZE: 4" long by 5" wide
WEIGHT: 1½ pounds
SUGAR CONTENT: 11° Brix
MATURITY: Late
SYNONYMS: Green-Fleshed Pineapple, Jersey Green Citron
SEED SOURCES: Bake, LeJ

Documented in Vilmorin-Andrieux (1883). A few lines from "Le Melon," written by seventeenth-century poet Marc Antoine de Gérard Saint-Amant, capture the essence of Ananas:

O manger précieux!
Délice de la bouche!
Oh! Beaucoup mieux que l'or,
Chef-d'oeuvre d'Apollon!
O fleur de tous les fruits!
O ravissant melon!

O precious food!
Delicacy for the mouth!
Oh! much better than gold,
Apollo's masterpiece!
O prime of all fruits!
O enchanting melon!

FIG. 39 SCHOON'S HARD SHELL

Cucumis melo var. *reticulatus*
SIZE: 6½" long by 6½" wide
WEIGHT: 6 pounds
SUGAR CONTENT: 12° Brix
MATURITY: Midseason
SYNONYM: New Yorker
SEED SOURCES: Bake, Burr, Shaf, Will

FIG. 40 NECTAR

Cucumis melo var. *inodorus*
WEIGHT: 3 pounds
SUGAR CONTENT: 9° Brix
MATURITY: Midseason
SEED SOURCE: None

Breeder and vendor: New Hampshire Agricultural Experiment Station, Durham. Parents: Kimmaka ¥ Jaune Canary. Modified honeydew type, adapted to the north.

FIG. 41 CAVAILLON ESPAGNOL

Cucumis melo var. *inodorus*
SIZE: 9" long by 6¼" wide
WEIGHT: 6 pounds
SUGAR CONTENT: 11¼° Brix
MATURITY: Late
SEED SOURCE: Bake

Similar to a Rochet melon from Spain, but more heavily netted and yellow. Resembles the Melon de Tripolitza featured in Jacquin (1832).

FIG. 42 SWEET FRECKLES

Cucumis melo var. *inodorus*
SIZE: 7½" long by 6" wide
WEIGHT: 4 pounds
SUGAR CONTENT: 10¾° Brix
MATURITY: Late
SEED SOURCE: None

A Crenshaw (Cranshaw) melon bred by Peters Seed and Research (PSR Breeding) of Myrtle Creek, Oregon. Has lots of freckles and a tough-rinded stem end that looks like a nose. Exquisite taste. Similar to Crane and Northern Arizona.

FIG. 43 DE ALMERÍA

Cucumis melo var. *inodorus*
SIZE: 9" long by 7" wide
WEIGHT: 6½ pounds
SUGAR CONTENT: 12½° Brix
MATURITY: Late
SYNONYM: Almería
SEED SOURCE: None

Habit-forming. A white Tendral type of Spanish melon from Almería.

FIG. 44 ORANGE-FLESHED HONEYDEW

Cucumis melo var. *inodorus*
SIZE: 6" long by 5½" wide
WEIGHT: 3 pounds
SUGAR CONTENT: 13° Brix
MATURITY: Late
SYNONYMS: Honeydew Pink Flesh, Yellow-Fleshed Honeydew
SEED SOURCES: Bake, Burr, Green, Lan, Mor, Ros, SU

FIG. 45 ASHKHABAD

Cucumis melo var. *inodorus*
SIZE: 7" long by 6½" wide
WEIGHT: 6½ pounds
SUGAR CONTENT: 12° Brix
MATURITY: Late
SEED SOURCE: None

When the former Soviet Union collapsed, Turkmenistan was one of the new nations formed. This melon hails from the Turkmen capital of Ashkhabad (formerly Ashgabat), on the lip of the Kara-Kum Desert. This specimen caught the measles, a melon disease in which excess salts accumulate where the skin exudes moisture, forming sunken, darkened lesions, from high relative humidity. Similar to Boule d'Or.

FIG. 46 CANARY

Cucumis melo var. *inodorus*
SIZE: 7" long by 6" wide
WEIGHT: 5 pounds
SUGAR CONTENT: 12° Brix
MATURITY: Late
SYNONYMS: Amarillo, Canary Yellow, Jaune de Canary (des Canaries)
SEED SOURCE: Will

Canary melons were named for their color, not for the Canary Islands (whose name is derived from *canis*, the Latin for "dog"), or the native yellow birds that were bred there for singing.

FIG. 47 CRANE

Cucumis melo var. *inodorus*
SIZE: 7" long by 6" wide
WEIGHT: 3½ pounds
SUGAR CONTENT: 10° Brix
MATURITY: Late
SYNONYM: Crenshaw (Cranshaw)
SEED SOURCE: SSHS

Similar to Northern Arizona and Sweet Freckles.

FIG. 48 TENDRAL VERDE

Cucumis melo var. *inodorus*
SIZE: 8" long by 6" wide
WEIGHT: 5 pounds
SUGAR CONTENT: 14° Brix
MATURITY: Late
SEED SOURCE: None

Way up there on the sweetness scale; every increase over 12° Brix seems exponential. There are five major kinds of Spanish melons: Amarillo, Blanco, Piel de Sapo, Rochet, and Tendral. This is a typical Tendral, with green, wrinkled, hard rind and firm, white flesh. Tendral Verde displays no visible signs of ripeness, except a crack or two.

FIG. 49 OLIVIN

Cucumis melo var. *inodorus*
SIZE: 9" long by 7" wide
WEIGHT: 5½ pounds
SUGAR CONTENT: 5° Brix
MATURITY: Midseason
SYNONYM: Oliwin
SEED SOURCE: Ter

One of the first honeydews of the season; from Poland.

FIG. 50 BOULE D'OR

Cucumis melo var. *inodorus*
SIZE: 7" long by 9" wide
WEIGHT: 6½ pounds
SUGAR CONTENT: 12° Brix
MATURITY: Late
SYNONYMS: Golden Ball, Golden Perfection
SEED SOURCE: None

A marvelous melon; aptly named. Described in Vilmorin-Andrieux (1883).

FIG. 51 KAZAKH

Cucumis melo var. *inodorus*
SIZE: 5" long by 4½" wide
WEIGHT: 2 pounds
SUGAR CONTENT: 12° Brix
MATURITY: Midseason
SEED SOURCES: Abund, Prai, Wind

Brought to the United States by an academic doing research in Kazakhstan. Introduced commercially by Gurney's Seed and Nursery Company of Yankton, South Dakota. Similar to Collective Farm Woman.

FIG. 52 SANTA CLAUS

Cucumis melo var. *inodorus*
SIZE: 8½" long by 5" wide
WEIGHT: 4 pounds
SUGAR CONTENT: 9° Brix
MATURITY: Late
SYNONYMS: Bursa Turkey, Christmas
SEED SOURCES: Bake, Burr, SU

FIG. 53 CHRISTMAS

Cucumis melo var. *inodorus*
SIZE: 8" long by 4" wide
WEIGHT: 3¾ pounds
SUGAR CONTENT: 9° Brix
MATURITY: Late
SYNONYM: Santa Claus
SEED SOURCE: Will

Similar to Santa Claus. Matures two weeks later.

FIG. 54 PIEL DE SAPO

Cucumis melo var. *inodorus*
SIZE: 9½" long by 5½" wide
WEIGHT: 5 pounds
SUGAR CONTENT: 13¼° Brix
MATURITY: Late
SYNONYM: Frog Skin
SEED SOURCE: Bake

From a sensational group of Spanish melons, with frog-skin rinds. Piel de Sapos vary from rounded to oval to long; they can be smooth or wrinkled, netted or sutured. They come in all shades of green on green.

FIG. 55 AMARILLO ORO

Cucumis melo var. *inodorus*
SIZE: 6" long by 5" wide
WEIGHT: 3½ pounds
SUGAR CONTENT: 14° Brix
MATURITY: Late
SYNONYMS: Amarelo Auro, Amarillo Oro de Valencia, Canary, Spanish
SEED SOURCE: SSHS

FIG. 56 COLLECTIVE FARM WOMAN

Cucumis melo var. *inodorus*
SIZE: 4¾" long by 5" wide
WEIGHT: 2 pounds
SUGAR CONTENT: 13½° Brix
MATURITY: Late
SEED SOURCES: Hud, SSHS

Similar to Kazakh.

FIG. 57 BIDWELL CASABA

Cucumis melo var. *inodorus*
SIZE: 14" long by 9" wide
WEIGHT: 14 pounds
SUGAR CONTENT: 10° Brix
MATURITY: Late
SYNONYM: California Casaba
SEED SOURCE: None

FIG. 58 GIANT CHRYSANTHEMUM

Cucumis melo var. *conomon* Mak.
SIZE: 2¾" long by 3½" wide
WEIGHT: 9 ounces
SUGAR CONTENT: 7½° Brix
MATURITY: Early
SYNONYM: Ogatakiku
SEED SOURCE: None

Ogatakiku means "Giant Chrysanthemum" in Japanese. Like a small, squat pumpkin. A tough sell on taste.

FIG. 59 CHINESE

Cucumis melo var. *conomon* Mak.
SIZE: 5" long by 3" wide
WEIGHT: 14 ounces
SUGAR CONTENT: 7° Brix
MATURITY: Early
SEED SOURCE: None

May be var. *chinensis* Pangalo. *Makuwa* melons come in many fruit colors and often have a turban at their blossom ends, rather like Chinese porcelain baluster vases with domed covers.

FIG. 60 AO SHIMA

Cucumis melo var. *conomon*
SIZE: 12" long by 4" wide
WEIGHT: 4 pounds
SUGAR CONTENT: 3½° Brix
MATURITY: Early
SEED SOURCE: None

Japanese for "green stripes."

FIG. 61 SHIMAURI STRIPE

Cucumis melo var. *conomon*
SIZE: 13½" long by 4½" wide
WEIGHT: 4½ pounds
SUGAR CONTENT: 3¾° Brix
MATURITY: Early
SYNONYMS: Green Striped, Oriental Pickler
SEED SOURCE: Ever

Typical Asian pickling melon. Common throughout Japan, China, India, Pakistan, and Bangladesh.

FIG. 62 KATSURA GIANT

Cucumis melo var. *conomon*
SIZE: 14" long by 4" wide
WEIGHT: 4½ pounds
SUGAR CONTENT: 3° Brix
MATURITY: Early
SYNONYMS: Melon Blanc du Japon, Uri, Yueh Kua
SEED SOURCE: None

FIG. 63 SAKATA'S SWEET

Cucumis melo var. *conomon* Mak.
SIZE: 3" long by 3½" wide
WEIGHT: 8 ounces
SUGAR CONTENT: 14½° Brix
MATURITY: Midseason
SEED SOURCE: None

FIG. 64 EARLY SILVER LINE

Cucumis melo var. *conomon* Mak.
SIZE: 4" long by 3" wide
WEIGHT: 1 pound
SUGAR CONTENT: 10° Brix
MATURITY: Early
SEED SOURCE: None

Similar to Ginsen. Introduced by Burpee's. Prolific and very early, with luminous silver stripes.

FIG. 65 **HONEY GOLD #9**

Cucumis melo var. *conomon* Mak.
SIZE: 4" long by 3" wide
WEIGHT: 14 ounces
SUGAR CONTENT: 6° Brix
MATURITY: Early
SEED SOURCE: Horus

Thought to be the Oh-gon 9 gou melon bred in 1931 at the Chiba Agricultural Experiment Station in Japan. Similar to other *makuwa uri*. This type of melon is a gold mine for plant breeders searching for resistance to pests and diseases such as Cucumber Mosaic Virus and Melon Necrotic Spot Virus.

FIG. 66 **GREEN SNAKE**

Cucumis melo var. *flexuosus*
SIZE: 24" long by 2½" wide
WEIGHT: 3 pounds
SUGAR CONTENT: 3° Brix
MATURITY: Early
SYNONYMS: Armenian Cucumber or Melon, Duke, Guta, Serpent Cucumber, Snake Cucumber, Yard Long
SEED SOURCE: None

FIG. 67 **STRIPED SNAKE**

Cucumis melo var. *flexuosus*
SIZE: 24" or longer by 2½" wide
WEIGHT: 2½ pounds
SUGAR CONTENT: 3° Brix
MATURITY: Midseason
SYNONYMS: Armenian Cucumber or Melon, Painted Serpent, Serpent or Snake Cucumber
SEED SOURCE: Shep ·

Differences between Striped Snake and Green Snake are only skin deep.

FIG. 68 **MANGO**

Cucumis melo var. *chito*
SIZE: 3½" long by 3" wide
WEIGHT: 9 ounces

SUGAR CONTENT: 5° Brix
MATURITY: Midseason
SYNONYMS: Chito Melon, Garden Lemon, Glass Melon, Lemon Cucumber, Melon Apple, Melon Peach, Melon de Quito, Melon de Grenade, Orange Melon, Vine Orange, Vine Peach
SEED SOURCES: Burg, Dom, Hud, Lan, Shum

It's truly in a class of its own: *chito*. Documented by Charles Morren in *La Belgique horticole* in 1851; his seed stock came from Havana, Cuba. For sweet pickles, pies, or preserving, "They have no equal," according to *Vaughn's Seeds Illustrated* of 1896.

FIG. 69 **COB**

Cucumis melo var. *momordica*
SIZE: 5½" long by 5" wide
WEIGHT: 2 pounds
SUGAR CONTENT: 10½° Brix
MATURITY: Early
SYNONYMS: Apple Core, Ice Cream, Phoot, Phut, Snap
SEED SOURCE: Horus

Momordica melons have proven useful for breeding resistance to pests and diseases such as aphids, Zucchini Yellow Mosaic Virus, and Watermelon Mosaic Virus.

FIG. 70 **QUEEN ANNE'S POCKET MELON**

Cucumis melo var. *dudaim*
SIZE: 3½" long by 2½" wide
WEIGHT: 9 ounces
SUGAR CONTENT: 4° Brix
MATURITY: Early
SYNONYMS: Abu Shammam, Dwarf or Vine Pomegranate, Khorsan, Plum Granny
SEED SOURCES: Bake, SSHS

FIG. 71 **WILL'S SUGAR**

Citrullus lanatus
SIZE: 9" long by 9" wide
WEIGHT: 12 pounds
SUGAR CONTENT: 9° Brix
MATURITY: Midseason
SEED SOURCE: Sand

Introduced by the Oscar H. Will Seed Company of Bismarck, North Dakota, in 1889. Adapted to the northern Great Plains.

FIG. 72 **CAROLINA CROSS**

Citrullus lanatus
SIZE: 23" long by 12" wide
WEIGHT: 48 pounds
SUGAR CONTENT: 9° Brix
MATURITY: Late
SYNONYM: Weeks North Carolina Giant
SEED SOURCES: Ers, Jun, Shu, Ter

Edward Weeks, founder of the Weeks Seed Company, of Greenville, North Carolina, bred the Carolina Cross—the world's biggest watermelon variety. He holds four Guinness world records for vegetables. Edward's father grew giant watermelons and passed the seed to his son; Edward in turn perfected the variety in the 1960s through careful selection and crossing, naming it Weeks North Carolina Giant. Cobb Gem and Georgia Rattlesnake are two of the melon's parents.

Renamed Carolina Cross, the watermelon has set records for weight since 1979, when the Bright family of Hope, Arkansas, first broke the 200-pound barrier. The Brights had apparently crossed the Weeks melon with Cobb Gem. The melon to beat is the 262-pounder grown by Bill Carson of Arrington, Tennessee, in 1990.

FIG. 73 **EARLY JUMBO**
Citrullus lanatus
SIZE: 16" long by 9" wide
WEIGHT: 16 pounds
SUGAR CONTENT: 8° Brix
MATURITY: Midseason
SEED SOURCE: None

FIG. 74 **ORANGEGLO**
Citrullus lanatus
SIZE: 16½" long by 9½" wide
WEIGHT: 21 pounds
SUGAR CONTENT: 10° Brix
MATURITY: Midseason
SEED SOURCES: Bake, Will

The cracking and separation of flesh we see on page 123 is atypical. This disorder, known as hollow heart, occurs more often in the first or crown-set fruits; it's also more common in seedless (triploid) types than seeded (diploid).

FIG. 75 **GOLDEN MIDGET**
Citrullus lanatus
SIZE: 6" long by 5" wide
WEIGHT: 3½ pounds
SUGAR CONTENT: 9° Brix
MATURITY: Early
SYNONYM: Early Golden Midget
SEED SOURCES: Horus, Sand

FIG. 76 **CITRON, RED-SEEDED**
Citrullus lanatus var. *citroides*
SIZE: 7" long by 7" wide
WEIGHT: 6 pounds
SUGAR CONTENT: 2° Brix
MATURITY: Late
SYNONYMS: Preserving Citron or Melon, Red-Seeded Round
SEED SOURCES: Prai, Sand, Terra, West

FIG. 77 **SPOTTED**
Citrullus lanatus
SIZE: 14" long by 8" wide
WEIGHT: 13 pounds
SUGAR CONTENT: 8½° Brix
MATURITY: Late
SEED SOURCE: None

Derives its name from spotted seeds. Rind has small cloud formations.

FIG. 78 **TOM WATSON**
Citrullus lanatus
SIZE: 18" long by 9½" wide
WEIGHT: 16 pounds
SUGAR CONTENT: 12° Brix
MATURITY: Late
SYNONYMS: Blue Rind Watson, Burrell's Red Heart Watson, Famous Watson
SEED SOURCES: Bake, Fox, Heir, Lan, Shaf, Shum

FIG. 79 **SUGAR BABY**
Citrullus lanatus
SIZE: 7" long by 7" wide
WEIGHT: 6 pounds
SUGAR CONTENT: 9° Brix
MATURITY: Midseason
SYNONYMS: Icebox, Tough Sweets
SEED SOURCES: Abund, Allen, Bou, Burg, Burr, Clif, Com, Cros, Dan, DeB, DeG, Early, ERS, Fed, Fox, Gaze, Green, Hali, Har, John, Jor, Kil, Lan, Led, LeJ, Lin, Mel, Meyer, Out, Park, Peace, Pine, Plan, Prai, Rdi, Red, Ros, Saun, SESE, Shaf, Shum, Sieg, Silv, Sow, Stoke, SWSG, Sury, Territ, TTS, Twi, Und, Ver, Vesey, Vict, Wet, Will, Wind

Developed by M. Hardin of Geary, Oklahoma, in 1955; introduced by the Woodside Seed Company. A selection from Tough Sweets, inbred for thirteen years. Standard icebox type. Early and widely adapted.

FIG. 80 **HONEY ISLAND**
Citrullus lanatus
SIZE: 8½" long by 8¾" wide
WEIGHT: 9 pounds
SUGAR CONTENT: 10° Brix
MATURITY: Late
SEED SOURCE: None

Kent Whealy of Seed Savers Exchange preferred this one above others in a taste test of my produce. Dropped from commercial production in the early 1980s.

FIG. 81 **FAIRFAX**
Citrullus lanatus
SIZE: 20" long by 9" wide
WEIGHT: 26 pounds
SUGAR CONTENT: 11° Brix
MATURITY: Late
SEED SOURCES: Bake, Sand

Pink like bubble gum and just as sweet. Introduced by the USDA's Southeastern Vegetable Breeding Lab, Charleston, South Carolina, in 1952. Pedigree: Garrison × (African × Iowa Belle) × (Leesburg × Hawkesbury).

FIG. 82 **CHRIS CROSS**
Citrullus lanatus
SIZE: 11" long by 9" wide
WEIGHT: 17 pounds
SUGAR CONTENT: 8° Brix
MATURITY: Midseason
SEED SOURCE: None

The "Chris" is Chris Christenson. The "Cross" is Hawksbury × Dixie Queen. The place and time, Montrose, Iowa, 1950.

FIG. 83 **PICNIC**

Citrullus lanatus

SIZE: 12" long by 7½" wide

WEIGHT: 13 pounds

SUGAR CONTENT: 8½° Brix

MATURITY: Midseason

SEED SOURCE: None

Breeder and Vendor: Asgrow Seed Company, 1972. Similar to Improved Peacock.

FIG. 84 **CITRON WATERMELON**

Citrullus lanatus var. *citroides*

SIZE: 8" long by 8" wide

WEIGHT: 9 pounds

SUGAR CONTENT: 2½° Brix

MATURITY: Late

SYNONYMS: Colorado Preserving, Green-Seeded Citron

SEED SOURCES: Land, Old, Prai, Sand

FIG. 85 **DESERT KING**

Citrullus lanatus

SIZE: 13" long by 12" wide

WEIGHT: 30 pounds

SUGAR CONTENT: 10° Brix

MATURITY: Late

SEED SOURCES: Ers, Green, Mor, Ros, SU, Will

So named by Willhite Seeds, of Poolville, Texas, because of its remarkable ability to withstand drought. Unusual combination of colors. Crunchy and coarse.

FIG. 86 **KLONDIKE STRIPED**

Citrullus lanatus

SIZE: 14" long by 9" wide

WEIGHT: 21 pounds

SUGAR CONTENT: 10° Brix

MATURITY: Late

SYNONYMS: Blue Ribbon Klondike, Klondike Striped Blue Ribbon, Klondike Sugar

SEED SOURCE: Lan

Bred at the University of California at Davis around 1936. This is one of the many descendants of Klondike, which appeared, from unknown origin, a hundred years ago and once dominated the California market.

FIG. 87 **STRAWBERRY**

Citrullus lanatus

SIZE: 11" long by 7" wide

WEIGHT: 8 pounds

SUGAR CONTENT: 9° Brix

MATURITY: Late

SEED SOURCE: SESE

Of thirty watermelon varieties exhibited at the New York State Agricultural Fair, Strawberry was judged the sweetest, according to Burpee's 1885 farm annual.

FIG. 88 **ALI BABA**

Citrullus lanatus

SIZE: 12½" long by 8½" wide

WEIGHT: 16 pounds

SUGAR CONTENT: 10° Brix

MATURITY: Late

SEED SOURCE: Bake

The flavor is wonderful, the plant prolific and disease resistant, and the gray rind impervious to sunscald. Ali Baba came from Iraq, via a French seed saver. It strongly resembles Gray Monarch or Long Light Icing (circa 1888).

FIG. 89 **BLACKTAIL MOUNTAIN**

Citrullus lanatus

SIZE: 9" long by 9" wide

WEIGHT: 13 pounds

SUGAR CONTENT: 10½° Brix

MATURITY: Early

SEED SOURCES: Bake, Sand, SESE, SSHS, Und

FIG. 90 **GEORGIA RATTLESNAKE**

Citrullus lanatus

SIZE: 22" long by 9" wide

WEIGHT: 43 pounds

SUGAR CONTENT: 10° Brix

MATURITY: Late

SYNONYMS: Augusta Rattlesnake, Gypsy, Rattlesnake, Southern, Striped Gypsy

SEED SOURCES: Bake, Fox, Green, Heir, Lan, SSHS

An old southern favorite with rattlesnake stripes. Introduced about 1870 by M. W. Johnson of Atlanta, Georgia. The watermelon that made Georgia famous.

FIG. 91 **WINTERMELON**

Citrullus lanatus

SIZE: 9" long by 9" wide

WEIGHT: 12 pounds

SUGAR CONTENT: 10° Brix

MATURITY: Late

SYNONYMS: Aggeler and Musser Winter Melon, King and Queen Winter Melon

SEED SOURCE: Shum

The palest of them all. Striking pink-lemonade flesh with black seeds. Can easily be mistaken for a small white citron watermelon. The Aggeler and Musser Seed Company of Los Angeles, California, praised the new melon in 1923 as "a thing of great luxury. . . entirely distinct." Long shelf life.

FIG. 92 **CREAM OF SASKATCHEWAN**

Citrullus lanatus

SIZE: 8" long by 8" wide
WEIGHT: 10 pounds
SUGAR CONTENT: 10° Brix
MATURITY: Early
SEED SOURCES: Fed, Horus, Irish, Jung, Lan, Prai, Sand, SSHS, SWSG, Terra, Up, Wind

White-fleshed watermelons are rare. The origin of this one is unknown; Curtis Showell of Bishopsville, Maryland, was the first to list it with Seed Savers Exchange, in 1984. Saskatchewan ripens early and is good for short-season areas. The only drawback is the explosive rind gene, *e*, which causes the thin, tender rind to burst open at the slightest provocation.

FIG. 93 **COLORADO STRIPED TARAHUMARA**

Citrullus lanatus

SIZE: 8" long by 7" wide
WEIGHT: 7 pounds
SUGAR CONTENT: 10° Brix
MATURITY: Midseason
SEED SOURCE: None

Unusual bicolor flesh. Very seedy. Tarahumara Indians are native to Mexico. Known as expert farmers and legendary "foot throwers" or runners, they upset the competitors in Colorado's Leadville hundred-mile ultramarathon race in 1993, by running in tire-soled sandals and winning first, second, and fourth places.

FIG. 94 **SUGAR LUMP YELLOW**

Citrullus lanatus

SIZE: 8" long by 8" wide
WEIGHT: 9 pounds
SUGAR CONTENT: 8° Brix
MATURITY: Midseason
SEED SOURCES: Bake, Sand

FIG. 95 **SWEET SIBERIAN**

Citrullus lanatus

SIZE: 13" long by 7" wide
WEIGHT: 11 pounds
SUGAR CONTENT: 10° Brix
MATURITY: Midseason
SEED SOURCES: Horus, Sand, SSHS

Collected in Russia, evaluated by the New Hampshire Agricultural Experiment Station in 1901. First introduced by the Oscar H. Will Seed Company of Bismarck, North Dakota. Surprising flesh color and tan seeds. On the chewy side.

FIG. 96 **LUSCIOUS GOLDEN**

Citrullus lanatus

SIZE: 18" long by 8½" wide
WEIGHT: 16 pounds
SUGAR CONTENT: 11° Brix
MATURITY: Midseason
SEED SOURCE: Sand

From the USDA collection. Luscious and golden.

FIG. 97 **MAR-JOHN**

Citrullus lanatus

SIZE: 8" long by 8" wide
WEIGHT: 9 pounds
SUGAR CONTENT: 8° Brix
MATURITY: Late
SEED SOURCE: None

From the Institute of Vegetables at Baku, Azerbaijan.

FIG. 98 **PETITE YELLOW**

Citrullus lanatus

SIZE: 7½" long by 6½" wide
WEIGHT: 5 pounds
SUGAR CONTENT: 10° Brix
MATURITY: Late
SEED SOURCE: None

My favorite yellow-fleshed watermelon; icebox size—less than twelve pounds.

FIG. 99 **SCALY BARK**

Citrullus lanatus

SIZE: 9" long by 8" wide
WEIGHT: 9 pounds
SUGAR CONTENT: 9° Brix
MATURITY: Midseason
SEED SOURCES: Horus, Shum

First exhibited at the Atlanta Exposition in 1881; carried by Burpee's in 1885. Mottled like the bark of a tree.

FIG. 100 **MOON AND STARS**

Citrullus lanatus

SIZE: 15" long by 8½" wide
WEIGHT: 20 pounds
SUGAR CONTENT: 10° Brix
MATURITY: Late
SYNONYMS: Amish; Cherokee; Long Milky Way; Yellow-Fleshed Moon and Stars; Sun, Moon, and Stars; Van Doren's Moon and Stars
SEED SOURCES: Abund, Bake, Berl, Bon, Cook, Fed, Heir, Horus, Lan, Park, Pine, Redw, Rohr, Sand, SESE, Shaw, Shep, SoC, SSHS, Up, Wind

COMMERCIAL SOURCES

ABUND ABUNDANT LIFE
SEED FOUNDATION
abundant@olypen.com,
www.abundantlifeseed.org
PO Box 772
1029 Lawrence Street
Port Townsend, WA 98368
Phone: 360-385-5660
*$2 for catalog, $30 suggested donation
for membership includes seed catalog
and book list plus periodic newsletters and
10% discount on purchases. Specializes
in rare and heirloom vegetables; herbs,
flowers, and Pacific Northwest natives
are also included.*

ALLEN ALLEN, STERLING
AND LOTHROP
191 US Route 1
Falmouth, ME 04105
Fax: 207-781-4143
*$1 for catalog, refundable. Specializes
in vegetable seeds adapted to northern
New England. Company founded in 1911.
Retail only.*

BAKE BAKER CREEK
HEIRLOOM SEEDS
www.rareseeds.com
2278 Baker Creek Road
Mansfield, MO 65704
Phone: 417-924-8917
*Free catalog. Sells only nonhybrid seeds.
Specializes in heirloom seeds, including
many rare types and Asian and European
varieties. Outstanding melon collection.
Mainly retail, but catalog includes a page
of wholesale offerings.*

BERL BERLIN SEEDS
5371 County Road 77
Millersburg, OH 44654
Free catalog. Retail only.

BOU BOUNTIFUL GARDENS
bountiful@sonic.net,
www.bountifulgardens.org
18001 Schaefer Ranch Road
Willits, CA 95490
Phone: 707-459-6410
*Free catalog in U.S. Retail and wholesale
varieties are listed in the same catalog.
Sole U.S. distributor for Chase Seeds of
England. Offers untreated heirlooms.*

BURG BURGESS SEED AND
PLANT CO.
905 Four Seasons Road
Bloomington, IL 61701
*$1 for catalog. Unique and popular
vegetable seeds and plants since 1913.*

BURR D. V. BURRELL SEED GROWERS
PO Box 150
Rocky Ford, CO 81067
Phone: 719-254-3318
Fax: 719-254-3319
*Free catalog. Family-owned business
founded in 1900. Fine collection
of cantaloupe, watermelon, vegetable,
flower, and herb seeds.*

CLIF CLIFTON SEED COMPANY
2586 NC 403 West
PO Box 206
Faison, NC 28341
Phone: 910-267-2690
*Free catalog. Family business founded
in 1928. Separate retail and wholesale
catalogs with identical offerings.*

COM COMSTOCK, FERRE AND CO.
263 Main Street
Wethersfield, CT 06109
Phone: 860-571-6590
*Free price list, $3 for catalog. Established
in 1820, offers 320 vegetable varieties,
numerous heirlooms, annuals, herbs,
and perennials.*

COOK THE COOK'S GARDEN
info@cooksgarden.com,
catalog@cooksgarden.com,
www.cooksgarden.com
PO Box 535
Londonderry, VT 05148
Phone: 800-457-9703
*Free catalog, which lists heirloom culinary
vegetable seeds from around the world.
Retail only. Also many herbs, cut flowers,
and annual vines, plus some seed-saving
books and supplies.*

CROS CROSMAN SEED CORP.
PO Box 110
East Rochester, NY 14445
Phone: 716-586-1928
*Free catalog. Specializes in "tried and true"
varieties for the home gardener. Retail only.*

DAN DAN'S GARDEN SHOP
info@dansgardenshop.com,
www.dansgardenshop.com
5821 Woodwinds Circle
Frederick, MD 21703
Phone: 301-695-5966
*Produces no printed catalog;
on-line sales only.*

DEB DE BRUYN SEED CO.
debruynseed@eaglenet.com
101 East Washington Avenue
Zeeland, MI 49464
Phone: 616-772-2316
*Specializes in sweet corn and pumpkins.
Separate but identical free retail and
wholesale price lists.*

DEEP DEEP DIVERSITY,
A PLANETARY GENE POOL
RESOURCE
PO Box 15700
Santa Fe, NM 87506-5700
*$6 for catalog. Specializes in varieties that
are organically grown, open pollinated,
and heirlooms. Formerly Peace Seeds.
Retail only.*

DEG DEGIORGI SEED CO.
6011 N Street
Omaha, NE 68117-1634
Phone: 800-858-2580
*Free catalog. Specializes in vegetables that
are unusual or hard to find. Retail catalog;
bulk pricing on request for specific items.*

DOM DOMINION SEED HOUSE
PO Box 2500
Georgetown, ON L7G 5L6, Canada
*$2 for catalog. Canadian orders only.
In business since 1928.*

DOWN DOWN ON THE FARM SEED
PO Box 184
Hiram, OH 44234
*Mail order only (no phone, fax, or
e-mail); $1 for catalog, refundable with
order. Specializes in heirloom, open-
pollinated, untreated seeds. Retail only.*

EARLY EARLY'S FARM AND
GARDEN CENTRE, INC.
2615 Lorne Avenue
Saskatoon, SK S7J 0S5, Canada
Phone: 306-931-1982
Fax: 306-931-7110
*$2 for catalog to U.S. addresses,
free within Canada. Founded in 1907.
Specializes in vegetables for cool or
northern climates. Retail price list, with
quantity prices, available on request.*

ERS E AND R SEED
E 200 S
Monroe, IN 46772
*Free catalog. Separate retail and wholesale
catalogs, each offering more than 1,000
varieties of vegetable and flower seeds,
including many open-pollinated and
heirloom varieties.*

EVER EVERGREEN Y. H. ENTERPRISES
eeseeds@aol.com
PO Box 17538
Anaheim, CA 92817
Phone: 714-637-5769
Fax: 714-637-5769
*$2 for catalog. Specializes in more than
230 varieties of Asian vegetable seeds.
Retail and wholesale prices are listed in
the same catalog.*

FED FEDCO SEEDS
PO Box 520
Waterville, ME 04903
*$2 for catalog. Specializes in selections
for cold climates and short growing
seasons. Offers vegetable, herb, flower, cover
crop, and green manure seeds. All seeds
are untreated. Retail and wholesale prices
are listed in the same catalog.*

FOX FOX HOLLOW HERBS AND
HEIRLOOM SEED CO.
PO Box 148
McGrann, PA 16236
Phone: 724-548-SEED
*Free catalog. Specializes in open-
pollinated, heirloom, untreated varieties,
including many vegetable seeds that
are certified organic. Retail only.*

GAZE GAZE SEED COMPANY LTD.
PO Box 640
St. John's, NF A1C 5K8, Canada
Phone: 709-772-4590
$3 for catalog. Retail only. Canada only.

GREEN GREEN THUMB SEEDS
17011 West 280th Street
Bethany, MO 64424
*Free catalog. Separate retail and whole-
sale catalogs, each containing varieties
not in the other.*

HALI HALIFAX SEED COMPANY LTD.
info@halifaxseed.ca,
www.halifaxseed.ca
PO Box 8026
5860 Kane Street
Halifax, NS B3K 5L8, Canada
*Catalog is free within Atlantic Canada,
$1 elsewhere in Canada. Sales to Canada
only. "Serving the Maritime Gardener
Since 1866." Retail and wholesale prices
are listed in the same catalog.*

HAR HARRIS SEEDS
60 Saginaw Drive
PO Box 22960
Rochester, NY 14692-2960
Phone: 800-514-4441
Fax: 716-442-9386
*Free catalog. Separate retail and whole-
sale catalogs, each containing varieties
not in the other.*

HEIR HEIRLOOM SEEDS
mail@heirloomseeds.com,
www.heirloomseeds.com
PO Box 245
West Elizabeth, PA 15088-0245
Phone: 412-384-0852
Fax: 412-384-0852
*$1 for catalog, refundable with order.
Small family-run seed house selling only
open-pollinated vegetable and flower seeds,
many first introduced in 1700s and 1800s.*

HORUS HORUS BOTANICALS
HCR Route 82, Box 29
Salem, AR 72576
Phone: 870-895-3174
*$2 for catalog. Specializes in heirlooms.
Retail only.*

HUD J. L. HUDSON, SEEDSMAN
Star Route 2, Box 337
La Honda, CA 94020
Phone: 408-236-3728
*$1 for catalog. Specializes in seeds of rare
and unusual plants, Zapotec varieties, and
seeds of useful wild and cultivated plants.
Established in 1911, successors to Harry
Saier. Stresses open-pollinated, nonhybrid*

*seeds and preservation of biological and
cultural diversity, since 1973.*

IRISH IRISH EYES AND GARDEN
CITY SEEDS
PO Box 307
Thorp, WA 98946
Phone: 509-964-7000
Fax: 406-961-4877
*$1 for catalog. Specializes in vegetables
that are trialed and tasted to ensure
quick maturity, good flavor, and vigor.
Retail and wholesale prices are listed
in the same catalog.*

JOHN JOHNNY'S SELECTED SEEDS
info@johnnyseeds.com,
www.johnnyseeds.com
2580 Foss Hill Road
R.R. 1, Box 2580
Albion, ME 04910-9731
Phone: 207-437-4301
Fax: 800-437-4290
*Free catalog. Retail only. Vegetable,
flower, herb, and farm seed for northern
climates. Many heirlooms and new
introductions. Extensive trial grounds
throughout North America.*

JOR JORDAN SEEDS, INC.
6400 Upper Afton Road
Woodbury, MN 55125-1146
Phone: 612-738-3422
*Free catalog. Retail and wholesale prices
are listed in the same catalog.*

JUNG J. W. JUNG SEED CO.
info@jungseed.com,
www.jungseed.com
335 South High Street
Randolph, WI 53957-0001
Phone: 800-247-5864
Fax: 800-692-5864
*Free retail catalog; wholesale price
information available by request. Quality
seeds since 1907. Specializes in seeds and
nursery stock suitable for northern climates.*

KIL KILGORE SEED CO.
1400 West First Street
Sanford, FL 32771
Phone: 407-323-6630
$1 catalog cost, refundable on first order.

KIT KITAZAWA SEED COMPANY
kitaseed@pacbell.net,
www.kitazawaseed.com
PO Box 13220
Oakland, CA 94661-3220
Phone: 510-595-1188
Fax: 510-595-1860
*Specializing in Asian vegetables
since 1917.*

LAN D. LANDRETH SEED CO.
seeds@landrethseeds.com,
www.landrethseeds.com
PO Box 6426
180 West Ostend Street
Baltimore, MD 21230
Phone: 410-727-3922
Fax: 410-244-8633
*Free catalog. Founded in 1784, the oldest
seed house in the U.S. Retail and wholesale
prices are listed in the same catalog.*

**LAND LANDIS VALLEY HEIRLOOM
SEED PROJECT**
Landis Valley Museum
www.landisvalleymuseum.org
2451 Kissel Hill Road
Lancaster, PA 17601
Phone: 717-569-0401
Fax: 717-560-2147
*Specializes in heirloom Pennsylvania
German varieties.*

LED LEDDEN BROTHERS
seeds@leddens.com,
www.leddens.com
195 Center and Atlantic
Sewell, NJ 08080
Phone: 856-468-1002
Fax: 856-464-0947
*Free catalog. Separate but identical retail
and wholesale catalogs. Founded in 1864,
purchased by Orol Ledden in 1904.*

LEJ LE JARDIN DU GOURMET
orderdesk@artisticgardens.com,
www.artisticgardens.com
PO Box 75
St. Johnsbury Center, VT 05863
Phone: 802-748-1446
Fax: 802-748-9592
*$.50 for catalog. Specializes in shallots
and gourmet seeds. Offers $.25 sample
packets of herbs, vegetables, and flowers.
Retail only.*

LIN LINDENBERG SEEDS LIMITED
lindenbergr@lindenbergseeds.mb.ca,
www.lindenbergseeds.mb.ca
803 Princess Avenue
Brandon, MB R7A 0P5, Canada
Phone: 204-727-0575
Fax: 204-727-2832
*$2 for catalog. Specializes in seeds selected
for success during the short, sunny prairie
growing season.*

MEL MELLINGER'S, INC.
mellgarden@aol.com,
www.mellingers.com
2310 West South Range Road
North Lima, OH 44452
Phone: 330-549-9861 or 800-321-7444
Fax: 330-549-3716
*Free catalog within the U.S. containing
4,000 items, including seeds (vegetable,
tree, herb), bulbs, perennials, trees,
shrubs, and lawn/garden supplies.
Retail and wholesale prices are listed
in the same catalog.*

MEYER MEYER SEED CO.
600 South Caroline Street
Baltimore, MD 21231
Phone: 410-342-4224
Fax: 410-327-1469
*Free catalog. Retail and wholesale prices
are listed in the same catalog. Quality
seeds since 1911.*

MOR MORGAN COUNTY WHOLESALE
18761 Kelsay Road
Barnett, MO 65011-3009
Phone: 573-378-2655
*$3 for catalog, refundable with first order.
Retail and wholesale prices are listed
in the same catalog.*

NIC NICHOLS GARDEN NURSERY
nichols@gardennursery.com,
www.nicholsgardennursery.com
1190 North Pacific Highway
Albany, OR 97321
Phone: 541-928-9280 or 800-422-3985
Fax: 800-231-5306
*Free catalog. Retail and wholesale prices
are listed in the same catalog.*

OLD OLD STURBRIDGE VILLAGE
www.osvgifts.org
One Old Sturbridge Village Road
Sturbridge, MA 01566
Phone: 508-347-3362, ext. 270
Fax: 508-347-0369

*$1 for catalog. Specializes in vegetables,
flowers, and herbs that are appropriate
for gardeners re-creating early 19th-
century gardens.*

ONT ONTARIO SEED COMPANY
PO Box 7
Waterloo, ON N2J 3Z6, Canada
Phone: 519-886-0557
Fax: 519-886-0605
*Catalog and sales to Canada only.
Since 1913. Specializes in untreated,
heirloom, open-pollinated seeds.
Retail and bulk prices listed in the same
catalog. Retail store open to the public.*

PARK PARK SEED CO.
info@parkseed.com,
www.parkseed.com
1 Parkton Avenue
Greenwood, SC 29647-0001
Phone: 800-845-3369
Fax: 864-941-4206
*Free catalog. Separate retail and wholesale
catalogs; retail catalog contains additional
varieties. Flower seed specialists since 1868.
Also offers a full line of vegetables and a
number of small fruit varieties.*

**PEACE PEACEFUL VALLEY
FARM SUPPLY**
contact@groworganic.com,
www.groworganic.com
PO Box 2209
Grass Valley, CA 95945
Phone: 888-784-1722
Fax: 530-272-4794
*Tools and supplies for organic gardeners
and farmers since 1976. Free catalog with
2,000 items, including fertilizers, vegetable
and cover crop seeds, weed and pest
controls, beneficial insects, irrigation,
and (in fall) bulbs, garlic, onions,
potatoes, and fruit trees.*

PINE PINETREE GARDEN SEEDS
superseeds@superseeds.com,
www.superseeds.com
PO Box 300
New Gloucester, ME 04260
Phone: 207-926-3400
Fax: 888-527-3337
*Free catalog. Specializes in flavorful
varieties for home gardeners and offers
300 gardening books plus tools and bulbs.
Mail order only.*

PLAN PLANTS OF THE SOUTHWEST
contact@plantsofthesouthwest.com,
www.plantsofthesouthwest.com
Agua Fria, Route 6, Box 11A
Santa Fe, NM 87501-9806
Phone: 505-438-8888
Fax: 505-438-8800
*$3.50 for color retail catalog; call for
wholesale prices. Specializes in south-
western native plants, including berry-
and nut-producing trees and shrubs.
Catalog also includes native grasses, wild-
flowers, and ancient and drought-tolerant
vegetables, including little-known Native
American crops.*

PRAI PRAIRIE GARDEN SEEDS
prairie.seeds@sk.sympatico.ca
PO Box 118
Cochin, S0M 0L0, Canada
Phone: 306-386-2737
*Within Canada, send four first-class stamps
or $2 for catalog; $2 (U.S.) for U.S.
customers. Specializes in open-pollinated
vegetable and flower varieties grown without
agricultural chemicals and in short-season
dryland growing. Offers many heirloom
varieties. Retail only.*

RED REDWOOD CITY SEED CO.
www.ecoseeds.com
PO Box 361
Redwood City, CA 94064
Phone: 650-325-7333
*Free catalog. Specializes in seeds of
endangered traditional varieties (all open-
pollinated or nonhybrid), plus pamphlets
and books for the gardener. Two annual
catalog supplements on the Internet, listing
seasonal or rare items when they have only
a dozen packets available. All seeds offered
are listed on the Internet. Separate but
identical retail and wholesale catalogs.*

ROHR P. L. ROHRER AND BRO. INC.
info@rohrerseeds.com,
www.rohrerseeds.com
PO Box 250
Smoketown, PA 17576
Phone: 717-299-2571
Fax: 717-299-5347 or 800-468-4944
*Free catalog. Retail only. Quality farm
and garden seeds since 1918. Seeds and
bulbs for 950 varieties of vegetables,
flowers, herbs, cover crops, and lawn
grasses. Many organic and heirloom seeds.*

ROS ROSWELL SEED CO.
PO Box 725
115–117 South Main Street
Roswell, NM 88202-0725
Phone: 505-622-7701
Fax: 505-623-2885
*Free catalog. Established in 1900.
Specializes in vegetable, flower, field, and
lawn seeds adapted to the Southwest.
Retail and wholesale prices are listed in
the same catalog.*

**SAND SAND HILL PRESERVATION
CENTER, HEIRLOOM SEEDS AND
POULTRY**
1878 230th Street
Calamus, IA 52729
Phone: 563-246-2299
*Free catalog. All varieties are open-
pollinated and grown on site. Excellent
melon selection. Retail only.*

SAUN SAUNDERS SEED CO., INC.
101 West Broadway
Tipp City, OH 45371
Phone: 937-667-2313
*Send SASE for price list. Separate whole-
sale and retail price lists, each containing
varieties not in the other. Retail list offers
quantities from 1 oz. to 1 lb.*

**SESE SOUTHERN EXPOSURE
SEED EXCHANGE**
PO Box 460
Mineral, VA 23117
Phone: 540-894-9480
Fax: 540-894-9481
*$2 for catalog. Offers more than 500
open-pollinated varieties of heirloom and
traditional vegetables, flowers, and herbs.
Many are suited to hot, humid, and disease-
prone areas. Seed is untreated, and much of
it is grown organically. Retail and wholesale
prices are listed in the same catalog.*

**SHAF SHAFFER SEED AND
SUPPLY CO.**
1203 East Tuscarawas Street
Canton, OH 44707
Phone: 330-452-8866
Separate retail and wholesale catalogs.

SHAW SHAWNEE SEED COMPANY
944 Cedar Creek Road
Makanda, IL 62958
Phone: 618-457-0114
*Free seed list. Specializes in select heirloom
varieties. Retail only.*

SHEP SHEPHERD'S GARDEN SEEDS
custserv@whiteflowerfarm.com,
www.shepherdseeds.com
30 Irene Street
Torrington, CT 06790-6658
Phone: 860-482-3638 or 800-503-9624
Fax: 860-482-0532
Free catalog.

SHUM R. H. SHUMWAY, SEEDSMAN
www.rhshumway.com
PO Box 1
Graniteville, SC 29829
Phone: 803-663-9771
Fax: 888-437-2733
*Free catalog. Separate retail and wholesale
catalogs, each containing varieties not
in the other. Specializes in heirloom, and
open-pollinated seeds.*

SIEG SIEGERS SEED CO.
siegers@siegers.com,
www.siegers.com
8265 Felch Street
Zeeland, MI 49464
Phone: 800-962-4999
Fax: 616-772-0333
*Free catalog. Specializes in treated seed
for commercial growers (untreated
seed may be available, by request only).
Retail and wholesale prices are listed
in the same catalog.*

SILV SILVER CREEK SUPPLY
R.D. 1, Box 70
Port Trevorton, PA 17864
Phone: 717-374-8010
Free catalog. Retail only.

SOC SEEDS OF CHANGE
gardener@seedsofchange.com,
www.seedsofchange.com
PO Box 15700
Santa Fe, NM 87506-5700
Phone: 888-762-7333
Fax: 800-392-2587
*Free catalog. Specializes in vegetables,
flowers, and herbs that are all 100%
certified organic and open pollinated.
Wide selection of traditional and heir-
loom varieties. Separate retail and
wholesale catalogs, each containing
varieties not in the other.*

SOW SOW ORGANIC
organic@organicseed.com,
www.organicseed.com
1130 Tetherow Road
Williams, OR 97544
Phone: 541-846-7173 or 888-709-7333
Free catalog. Specializes in open-pollinated varieties grown and processed by the company and certified organic by the Oregon Tilth Certified Program. Formerly Southern Oregon Organics. Retail and wholesale prices are listed in the same catalog.

SSHS SEED SAVERS' HEIRLOOM SEEDS AND GIFTS
sse@rconnect.com,
www.seedsavers.org
3076 North Winn Road
Decorah, IA 52101
Phone: 563-382-5990
Fax: 563-382-5872
Free 80-page color catalog offers a unique selection of vegetables, flowers, and herbs, including many family heirlooms from the Seed Savers Exchange and traditional varieties from Eastern Europe and the former Soviet Union. Project-related revenue from seed sales is used to permanently maintain Heritage Farm's vast seed collections of 20,000 rare varieties. Retail catalog (430 varieties) also contains wholesale prices (285 varieties) for specialty growers, truck gardeners, CSA (Community Supported Agriculture) growers, and other seed companies.

STOKE STOKES SEEDS, INC.
stokes@stokeseeds.com,
www.stokeseeds.com
PO Box 548
Buffalo, NY 14240-0548
Phone: 800-396-9238
Fax: 888-834-3334
Free catalog. Retail and wholesale prices are listed in the same catalog. Specializes in short-season vegetables.

SU SEEDS UNIQUE
1125 Barboa Court
Belen, NM 87002
Phone: 505-861-0146
$1 for catalog. Specializes in rare vegetable varieties. Retail only.

SWSG SEEDS*WEST GARDEN SEEDS
seeds@nmia.com,
www.seedswestgardenseeds.com
317 14th Street NW
Albuquerque, NM 87125
Phone: 505-843-9713
Fax: 505-843-9713
$2 for catalog. Specializes in open-pollinated heirloom and gourmet European hybrid vegetable seeds selected for performance in hot, dry, short-season growing conditions of the West and Southwest, all untreated and many organic and regionally grown. Also many Native American varieties; large chile pepper and tomato selection. Retail catalog, wholesale by special arrangement.

SWY SEEDWAY
info@seedway.com,
www.seedway.com
1225 Zeager Road
Elizabethtown, PA 17022-9427
Phone: 800-952-7333
Fax: 717-367-0387
Free catalog. Retail only.

TER TERRE DE SEMENCES
Ripple Farm
Crundale
Canterbury Kent CT 4 7EB, England
Phone: 44 9 66 444379
Specializes in rare seed varieties that might otherwise be unobtainable.

TERRA TERRA EDIBLES
kdwright@intranet.ca
PO Box 164
Foxboro ON K0K 2B0, Canada
Phone: 613-968-8238
Fax: 613-968-6369
$1 for catalog. Specializes in heirlooms, edible landscaping plants, and varieties that require little space or are extra nutritious. Retail only.

TERRIT TERRITORIAL SEED CO.
tertrl@territorialseed.com,
www.territorialseed.com
PO Box 158
Cottage Grove, OR 97424-0061
Phone: 541-942-9547
Fax: 888-657-3131
Free catalog. Specializes in varieties for maritime climate (west of the Cascades), all grown without chemical pesticides and using only organic fertilizers. Also produces

a separate "national" catalog that has a host of good-tasting open-pollinated varieties for short-season climates.

TTS T AND T SEEDS, LTD.
PO Box 1710
Winnipeg, MB R3C 3P6, Canada
Phone: 204-895-9962
$3 for catalog. Offers seeds of hardy prairie plants, vegetables, herbs, flowers, bulbs, and nursery stock (spring and fall).

TWI OTIS TWILLEY SEED CO.
PO Box 4000
Hodges, SC 29653
Phone: 800-622-7333
Fax: 864-227-5108
Free catalog. Specializes in sweet corn and watermelons. Retail and wholesale prices are listed in the same catalog.

UND UNDERWOOD GARDENS
info@underwoodgardens.com,
www.underwoodgardens.com
1414 Zimmerman Road
Woodstock, IL 60098
Fax: 888-382-7041
$3 for catalog. Retail sales, with bulk seed available depending on harvest. Specializes in hard-to-find, untreated, open-pollinated, and heirloom seeds, many of which are organically grown.

UP UPPER CANADA SEEDS
uppercanadaseeds@home.com
8 Royal Doulton Drive
Don Mills, ON M3A 1N4, Canada
Offers top-quality, untreated, organically grown seeds that are suitable for the climatic conditions of eastern Canada and northeastern U.S. All seeds are open pollinated and many are heirlooms that disappeared from most seed catalogs long ago.

VER VERMONT BEAN SEED CO.
info@vermontbean.com,
www.vermontbean.com
PO Box 150
Vaucluse, SC 29850
Phone: 803-663-0217
Fax: 888-437-2733
Free catalog. Retail and wholesale prices are listed in the same catalog. Known for having the world's largest selection of beans, plus gourmet specialties and rare and unusual flowers. All seeds are untreated.

SEED-SAVING GROUPS

ASSOCIATION KOKOPELLI
kokopelli.assoc@wanadoo.fr
Quartier Saint Martin
07200 Aubenas, France
Phone: 33 4 75 93 53 34
Fax: 33 4 75 93 37 75

**HENRY DOUBLEDAY
RESEARCH ASSOCIATION**
enquiry@hdra.org.uk
Ryton Organic Gardens
Coventry CV8 3LG, England
Phone: 44 24 7630 8210

**HERITAGE SEED CURATORS
ASSOCIATION**
han.HSCA@b150.aone.net.au
PO Box 113
Lobethal, SA, 5241, Australia
Phone: 61 8 8389 8649

IRISH SEED SAVER ASSOCIATION
issa@esatclear.ie
Capparoe, Scariff
Co. Clare, Ireland
Phone: 353 61 921866

KOANGA GARDENS
R.D.2, Maungaturoto
Northland Aotearoa, New Zealand
Phone: 64 9 4312 145
Fax: 64 9 4312 745

NATIVE SEEDS/SEARCH
info@nativeseeds.org,
www.nativeseeds.org
526 North 4th Avenue
Tucson, Arizona 85705
Phone: 928-622-5561
Fax: 928-622-5591

PRO SPECIE RARA
obst@psrara.org
Pfrundweg 14
CH-5000 Aarau, Switzerland
Phone: 41 62 823 50 30
Fax: 41 62 823 50 25

SEED SAVERS EXCHANGE
sse@seedsavers.org,
www.seedsavers.org
3076 North Winn Road
Decorah, IA 52101
Phone: 563-382-5990
Fax: 563-382-5872

SEED SAVERS' NETWORK
info@seedsavers.net
PO Box 975
Byron Bay 2481, Australia
Phone: 61 2 6685 6624

SEEDS OF DIVERSITY CANADA
mail@seeds.ca
PO Box 36, Station Q
Toronto, ON M4T 2L7
Canada
Phone: 905-623-0353

VESEY VESEY'S SEEDS LTD.
veseys@veseys.com,
www.veseys.com
PO Box 9000
Calais, ME 04619-6102
Phone: 800-363-7333
Fax: 800-686-0329
*Canadian address is Vesey's Seeds Ltd.,
PO Box 9000, Charlottetown, PE, Canada,
C1A 8K6. Free catalog. Specializes in
quality vegetable and flower seeds for short-
growing-season areas. Visitors are welcome
to tour their trial gardens. Retail catalog,
but offers many varieties to commercial
customers that are not in the retail catalog.*

VICT THE VICTORY SEED COMPANY
inquiries@victoryseeds.com,
www.victoryseeds.com
PO Box 192
Molalla, OR 97038
Phone and Fax: 503-829-3126
*Catalog is available for $2 (refunded with
order) or on-line. Family-owned and
-operated retail packet seed company selling
only open-pollinated varieties.*

WEST WEST COAST SEEDS
info@westcoastseeds.com,
www.westcoastseeds.com
PO Box 1448
Point Roberts, WA 98281
Phone: 604-952-8820
Fax: 604-952-8828 or 877-482-8822
*Canadian seed company with a
Washington address for U.S. customers.
Canadian address is West Coast Seeds,
3925 64th Street, R.R. #1, Delta, BC,
Canada, V4K 3NE. All prices are in
Canadian dollars.*

WET WETSEL SEED CO., INC.
PO Box 791
Harrisonburg, VA 22801
Phone: 540-434-6001
*Free catalog. Separate retail and whole-
sale catalogs; wholesale catalog contains
additional varieties.*

WIL WILLHITE SEED INC.
PO Box 23
Poolville, TX 76487
Phone: 800-828-1840
Fax: 817-599-5843
*Free color catalog. Extensive collection
of watermelons and cantaloupes;
many are their own introductions.
Separate retail and wholesale
catalogs with identical varieties.*

**WIND WINDMILL POINT FARM
AND NURSERY**
2103 Perrot Boulevard,
N.D. Ile Perrot PQ J7V 8P4, Canada
Phone: 514-453-9757
*$4 for catalog. Specializes in "tough and
tasty" vegetables that can adapt to
climate extremes and optimize flavor when
grown organically. Formerly S.O.S. Seeds.
Retail and wholesale prices are
listed in the same catalog.*

PHOTOGRAPH BY SANDI FELLMAN

A gardener's life means callused hands, dirty fingernails, and an aching back. Yet the satisfaction runs deep. Yesterday, in anticipation of the season's first frost, I spent the day in the garden harvesting every tender vegetable I could find; this morning an enormous mountain of homegrown produce covers most of the kitchen floor. I can rest secure knowing these melons, squashes, and so much more will feed me and my loved ones body and soul. I'll stock my larder with carrot bread and potato leek soup, fill basement shelves with ripening fruits and vegetables, and save seeds from those same crops for future harvests. It's a good life.

Later today I'll step out into the autumn air and make my way into one of two gardens to forage for cold-hardy vegetables. Even now, I can treat myself to a snack of parsnips or carrots made sweet by the frost. Myriad kale still thrive in the cool, filtered light, along with chicory, radicchio, rosettes of lettuce, and long, white, crisp radishes. If I get chilled, I can always take refuge in my greenhouse, a steamy tropical paradise filled with plants.

These days, there's an enormous disconnect between most Americans and nature. Everyone in the world is utterly dependent on the green plants that grow, yet we are at times blithely indifferent to their fate, and there are deeply disturbing changes afoot. In the name of feeding the world, the "gene giants," the biotech industry, have taken us—and our plants—by storm. Through a series of legal maneuvers, patents, and seed-sterilizing technologies, industry is cordoning off the seed, which is both the germ of life and the grains that come from it, calling it their own.

Those who control the seed, of course, control the food supply. Traditionally, seeds have been in the hands of farmers and gardeners. Let's not forget that it was our farming ancestors who, over the course of twelve thousand years, domesticated all our major food crops and passed the seeds along to the next generation.

In the new scenario, however, agrochemical giants view seed saving as theft of proprietary property. Last year, Canadian farmer Percy Schmeiser was branded a criminal for using his own canola seeds. For decades he had been perfecting a pure strain of canola that was ruined—probably by windblown genetically modified pollen from neighboring farms or seeds from passing trucks. Not only is he a victim of genetic pollution; he is a victim of the legal system as well: A Canadian federal court ordered Schmeiser to pay tens of thousands of dollars for using a patented technology without paying a licensing fee.

Hybrids may seem benign by comparison to genetically modified crops, but they've done more than their fair share of damage. Hybridization was the first in a long line of corporate attempts to prevent farmers and gardeners from saving seeds. Seed companies that do the original crossbreeding and keep the parent lines secret can cash in when customers come back for more. Though it's true that hybridizing corn can result in new and improved varieties, for most other crops, the driving force behind hybridization is profit.

The dwindling of agricultural biodiversity, the use of genetically uniform crops and hybrids and the common practice of mono-culture, is a recipe for disaster. One need look no further than the Great Hunger in Ireland in the 1840s: Millions died because there was only one egg in the basket. The Lumper potato's fatal flaw was susceptibility to *Phytophthora infestans,* or potato late blight.

Obviously, to survive we need agricultural biodiversity. The extinction rates for most food crops are tragic, but for melons the losses are mind-boggling. To say that melons have been decimated is a gross understatement. Over 90 percent of the open-pollinated varieties available one hundred years ago are now extinct. Consolidation in the seed industry, the advent of modern hybrids, and the simple passage of time have done them in.

This book is a showcase of the genetic diversity that remains in melons. We need to reverse the trend that privatizes, monopolizes, sterilizes, and even causes seeds to kill their own embryos. Seeds are sacred and worthy of reverence: They are in fact the very stuff and staff of life. As Rachel Carson lay dying, she pondered the mystery of a growing seed and found strength in the beauty of the natural world. She echoed the sentiments of Henry David Thoreau when he said, "Convince me that you have a seed there, and I am prepared to expect wonders." Cultivating a garden can teach us to cultivate a sense of wonder as well.

ACKNOWLEDGMENTS

I'm deeply grateful to the following people who played a major role in the evolution of this book: Ann Bramson, Stephen Doyle, Glenn and Linda Drowns, M. Mark, Victor Schrager, Emma Sweeney, and Kent and Diane Whealy.

Thanks also go to: Liz Ahrens, Jacques Aubourg, Fran Avirgan, Glen Crawford, Pat Crill, Deena Decker-Walters, Eve Felder, Noriyuki Fujishita, Alan and Jackie Gear, Daniele Gespert, Jeremiath Gettle, Rachel Godfrey, Maria-Luisa Gómez-Guillamon, Mark Henning, Edwynn Houk, Molly Jahn, Minoru Kanda, Joseph Kirkbride, Jr., Stephen Kolpan, Dick and Ellen Levine, James D. McCreight, Michael Magliari, Carolyn Male, Anne and Ikuo Matsui, Donald Maynard, Samuel Mendlinger, George Moriarty, Henry Munger, Neil Munro, Nancy Murray, Amanda Neill, Timothy Ng, Harry Paris, Barbara Peragine, Kathleen Reitsma, Judy and Lillian Remmick, Marie-Thérèse Rescan, James Stephens, Jim Ternier, Joanne Thuente, Kim Tripp, Mimi Tucker, Edward Weeks, Todd Wehner, and Deborah Weiss Geline.

BIBLIOGRAPHY

Ashworth, Suzanne. *Seed to Seed: Seed Saving Techniques for the Vegetable Gardener*. Decorah, IA: Seed Savers Exchange, 2002; distributed by Chelsea Green.

Batson, W. A., ed. *The Cucurbits Illustrated*. Waterloo, NE: J. C. Robinson Seed Co., 1937.

Blake, Leonard W. "Early Acceptance of Watermelon by Indians of the United States." *Journal of Ethnobiology* 1, 2 (December 1981): 193–199.

Burr, Fearing, Jr. *The Field and Garden Vegetables of America*. Chillicothe, IL: The American Botanist, 1988; original edition 1863.

Carson, Rachel. *The Sense of Wonder*. New York: HarperCollins, 1998; first published in 1965.

Deppe, Carol. *Breed Your Own Vegetable Varieties: The Gardener's and Farmer's Guide to Plant Breeding and Seed Saving*. White River Junction, VT: Chelsea Green, 2000.

Doolittle, S. P. et al. *Muskmelon Culture*. Washington, DC: U.S. Department of Agriculture, Agriculture Handbook No. 216, 1961.

Evensen, Kathleen B. "Effects of Maturity at Harvest, Storage Temperature, and Cultivar on Muskmelon Quality." *Hortscience* 18, 6 (December 1983): 907–908.

Fowler, Cary, and Pat Mooney. *Shattering: Food, Politics, and the Loss of Genetic Diversity*. Tucson: University of Arizona Press, 1990.

Grigson, Jane. *Jane Grigson's Fruit Book*. London: Penguin Books, 1982.

Hassib, Mohammed. *Cucurbitaceae in Egypt*. Cairo: F. E. Noury et Fils, 1938.

Hedrick, U. P. *A History of Horticulture in America to 1860*. Portland, OR: Timber Press, 1988; original edition 1950.

Irving, Washington. *The Life and Voyages of Christopher Columbus*. Philadelphia: David McKay, 1892; original edition 1828.

Jacquin, Pierre-Joseph. *Monographie complète du melon*. Paris: Rousselon, 1832.

Kraft, Ken. *Garden to Order: The Story of Mr. Burpee's Seeds and How They Grow*. Garden City, NY: Doubleday, 1963.

Lack, H. Walter. *Garden Eden*. Cologne: Taschen, 2001.

Lacy, Allen. *A Gardener's Miscellany*. New York: Farrar, Straus & Giroux, 1984.

Lloyd, John William. *Muskmelon Production*. New York: Orange Judd, 1928.

Maynard, Donald N., ed. *Watermelons: Characteristics, Production, and Marketing*. Alexandria, VA: ASHS Press, 2001.

Nuez, F. et al. *Catálogo de semillas de melón*. Madrid: Ministerio de Agricultura, Pesca y Alimentación, 1996.

Paillieux, A., and D. Bois. *Le Potager d'un curieux*. Paris: Librairie Agricole de la Maison Rustique, 1892.

Pitrat, M., M. Chauvet, and C. Foury. "Diversity, History and Production of Cultivated Cucurbits." *Acta Horticulturae* 492 (1999): 21–27.

Pitrat, M., P. Hanelt, and K. Hammer. "Some Comments on Infraspecific Classification of Cultivars of Melon." *Acta Horticulturae* 510 (2000): 29–36.

Robinson, R. W., and D. S. Decker-Walters. *Cucurbits*. New York: CAB International, 1997.

Root, Waverly. *Food: An Authoritative and Visual History and Dictionary of the Foods of the World*. New York: Konecky & Konecky, 1980.

Stepansky, A., I. Kovalski, and R. Perl-Treves. "Intraspecific Classification of Melons (*Cucumis melo L.*) in View of Their Phenotypic and Molecular Variation." *Plant Systematics and Evolution* 217 (1999): 313–332.

Thoreau, Henry D. *Faith in a Seed*. Washington, DC: Island Press, 1993.

Vilmorin-Andrieux. *Les Plantes potagères*. Paris: Vilmorin-Andrieux, 1883, 1891, 1904.

———. *The Vegetable Garden: Illustrations, Descriptions, and Culture of the Garden Vegetables of Cold and Temperate Climates*, trans. W. Miller. London: John Murray Ltd., 1885.

Weaver, William Woys. *Heirloom Vegetable Gardening: A Master Gardener's Guide to Planting, Growing, Seed Saving, and Cultural History*. New York: Henry Holt, 1997.

Whealy, Kent, ed. *Garden Seed Inventory*. 5th ed. Decorah, IA: Seed Savers Exchange, 1999.

Whitaker, T. W., and G. N. Davis. *Cucurbits: Botany, Cultivation, and Utilization*. New York: Interscience Publishers, 1962.

Whitaker, T. W., and I. C. Jagger. *Breeding and Improvement of Cucurbits*. Washington, DC: U.S. Department of Agriculture, Yearbook of Agriculture, 1937.

Wyllie, S. Grant et al. "Key Aroma Compounds in Melons: Their Development and Cultivar Dependence." In *Fruit Flavors: Biogenesis, Characterization, and Authentication*, edited by Russell L. Rouseff and Margaret M. Leahy. Washington, DC: American Chemical Society, 1995.

Ziegler, Philip. *The Black Death*. Bridgend, England: Alan Sutton Publishing Limited, 1969.

INDEX

Page numbers in **boldface** refer to photos.

AMY GOLDMAN, a self-described "melon maniac with a mission," works to preserve the agricultural heritage and genetic diversity of the world's fruits and vegetables. Known to viewers of Martha Stewart and PBS, she has written for *Garden Design* and been profiled in such publications as *Country Living Gardener, Good Housekeeping, House & Garden, and Organic Gardening* magazines. She lives in New York City and Rhinebeck, N.Y.

VICTOR SCHRAGER's photographs have been featured in solo and group exhibitions in the United States, Europe, and Japan over the last twenty years. His photographs are also included in numerous public and private collections around the world, including The Museum of Modern Art, Whitney Museum of American Art, San Francisco Museum of Modern Art, and Houston Museum of Fine Arts.